Bald Eagles

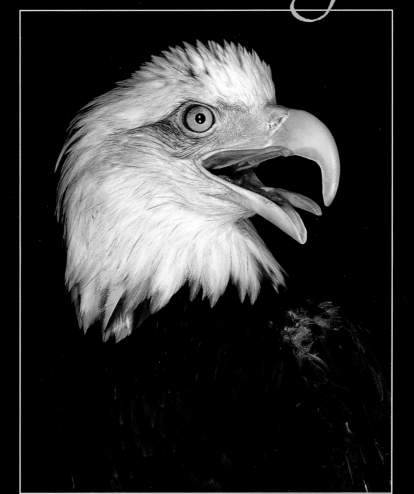

ALSO BY ART WOLFE

Indian Baskets of the Northwest Coast (1978)

The Imagery of Art Wolfe (1984)

Alakshak, The Great Country (1989)

The Kingdom (1990)

Owls: Their Life and Behavior (1990)

Chameleons, Dragons in the Trees (1991)

Light on the Land (1991)

The Souls of Animals (1991)

Masters in Disguise (1992)

Bears: Their Life & Behavior (1992)

An eagle perches on
a precipitous cliff
on Unalaska Island,
Alaska.

PREVIOUS PAGE:
A bald eagle portrait,
Washington.

Bald
Eagles

THEIR LIFE
AND BEHAVIOR IN
NORTH AMERICA

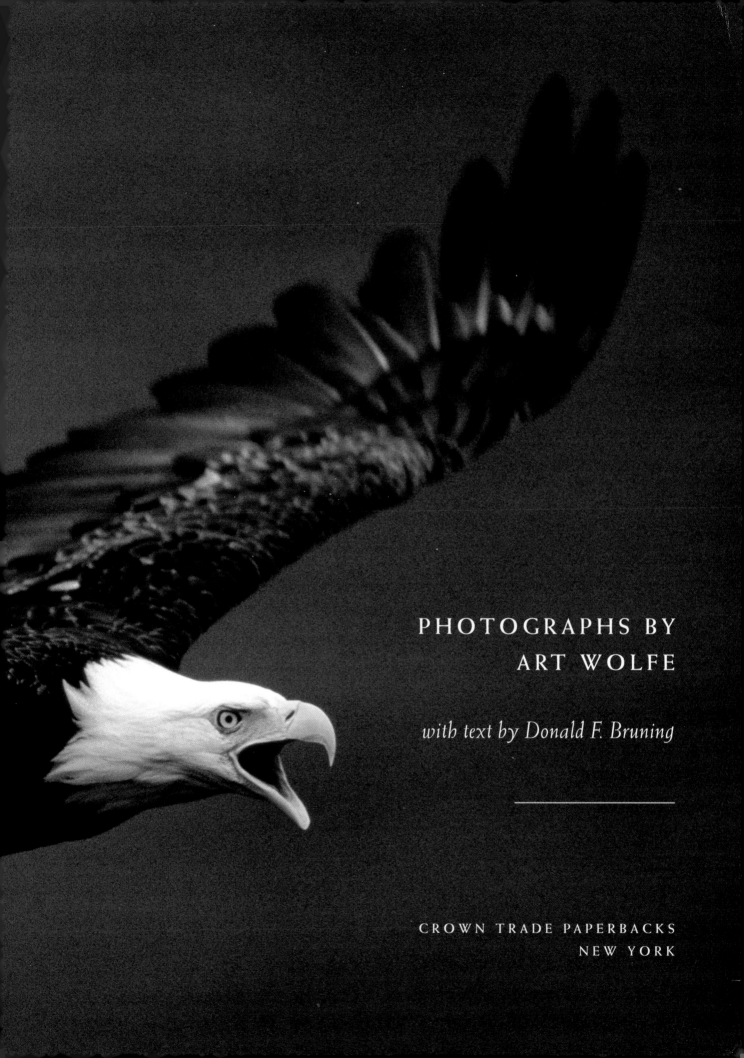

PHOTOGRAPHS BY
ART WOLFE

with text by Donald F. Bruning

CROWN TRADE PAPERBACKS
NEW YORK

A bald eagle roosts amid
snow-laden branches of
a cottonwood tree.
Chilkat River Valley,
Alaska.

PREVIOUS PAGES:

An eagle in flight over
Unalaska Island, Alaska.

Photographs copyright © 1997 by Art Wolfe
Text copyright © 1997 by Donald F. Bruning

Published by Crown Trade Paperbacks, 201 East 50th Street, New York, New York
10022. Member of the Crown Publishing Group.

Random House, Inc. New York, Toronto, London, Sydney, Auckland

http://www.randomhouse.com/

CROWN TRADE PAPERBACKS and colophon are trademarks of Crown
Publishers, Inc.

Printed in Hong Kong

Design by June Bennett-Tantillo

Library of Congress Cataloging-in-Publication Data

Wolfe, Art.
 Bald eagles / photographs by Art Wolfe; with text by Donald Bruning.
 —1st pbk.ed.
 Includes bibliographical references and index.
 1. Bald eagle. 2. Bald eagle—Pictorial works. I. Bruning, Donald. II. Title.
 QL696.F32W64 1997
 598.9'0222—dc21 96-47911
 CIP

ISBN 0-517-88163-2

10 9 8 7 6 5 4 3 2 1

First Edition

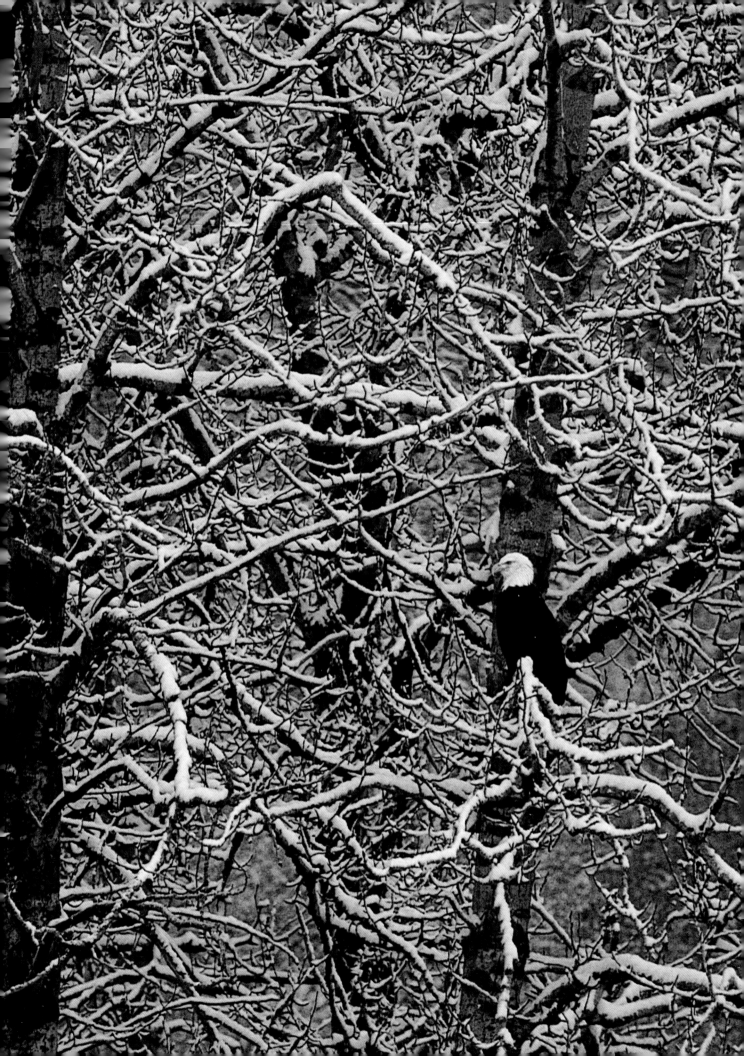

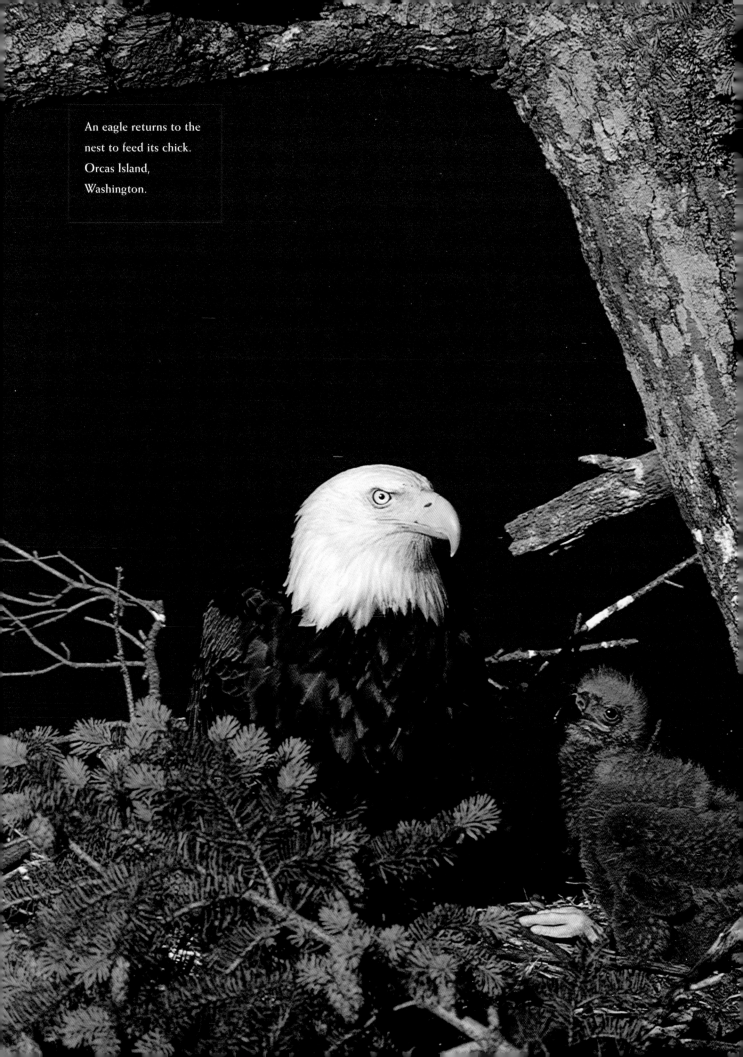

An eagle returns to the
nest to feed its chick.
Orcas Island,
Washington.

ACKNOWLEDGMENTS

A warm thank-you to my staff: Mel Calvan, Christine Eckhoff,

Gavriel Jecan, Ray Pfortner, Craig Scheak, and

Deirdre Skillman—they are the wind beneath my wings.

A.W.

Without the support of my wife and family it would have

been impossible to find the time to write the text for this book.

Many helpful suggestions were offered by my family as well as

by the staff at the Wildlife Conservation Society.

Most of all I would like to thank my daughter Cynthia.

She provided me with valuable suggestions, edited my draft text,

and helped me organize the material in this book.

D.B.

CONTENTS

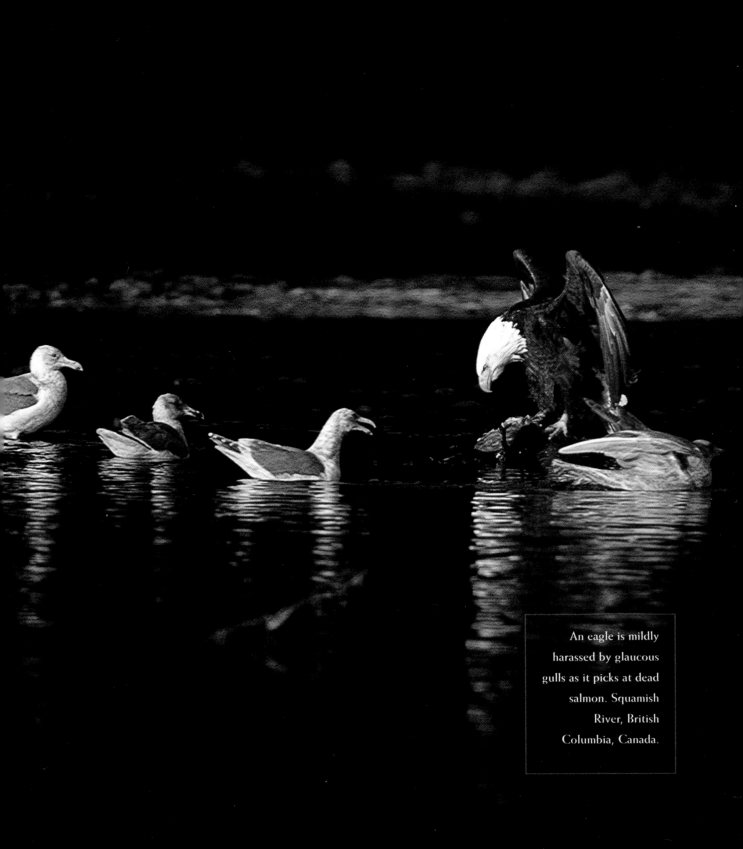

An eagle is mildly
harassed by glaucous
gulls as it picks at dead
salmon. Squamish
River, British
Columbia, Canada.

Eagle Myths and Folklore

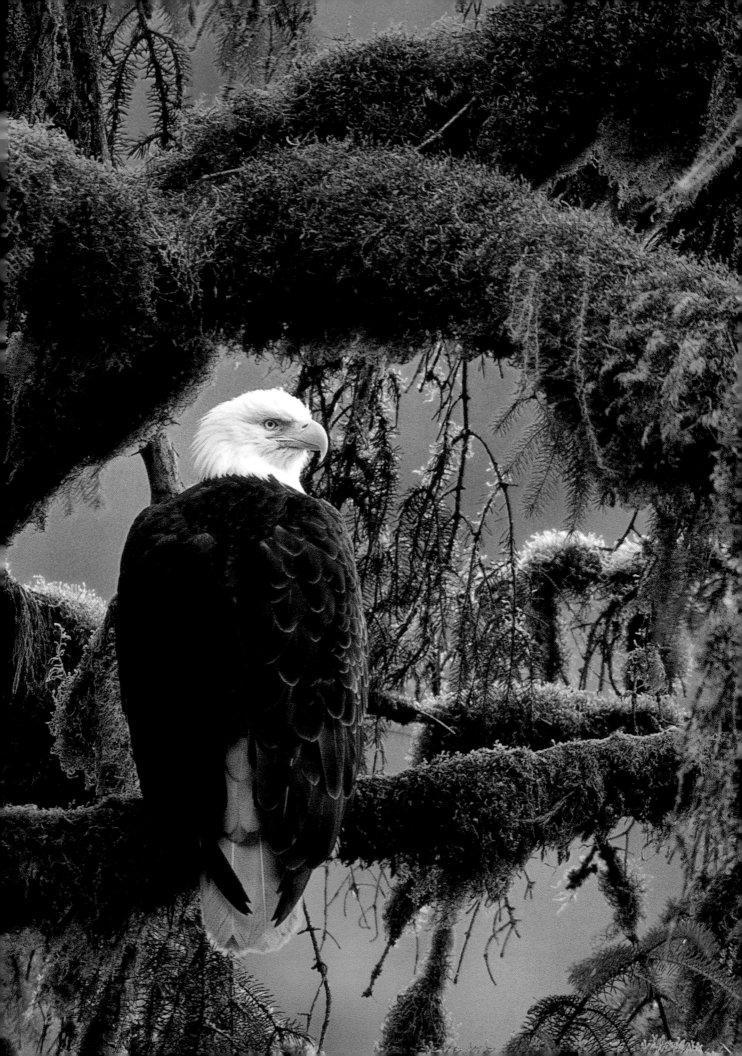

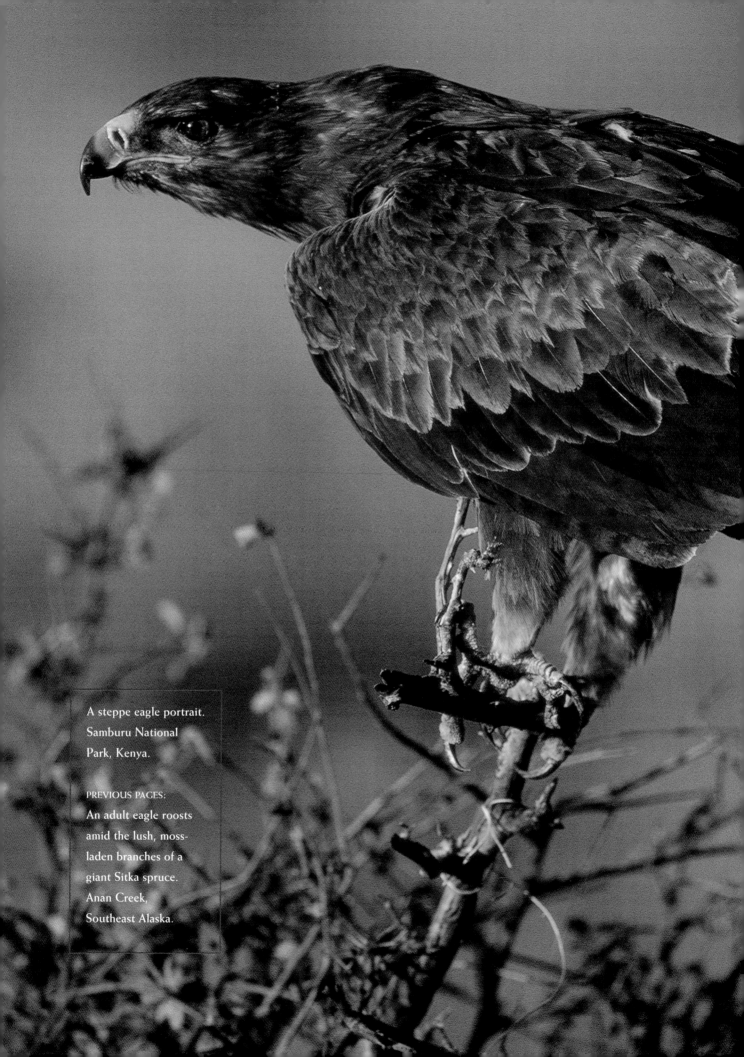

A steppe eagle portrait.
Samburu National
Park, Kenya.

PREVIOUS PAGES:
An adult eagle roosts
amid the lush, moss-
laden branches of a
giant Sitka spruce.
Anan Creek,
Southeast Alaska.

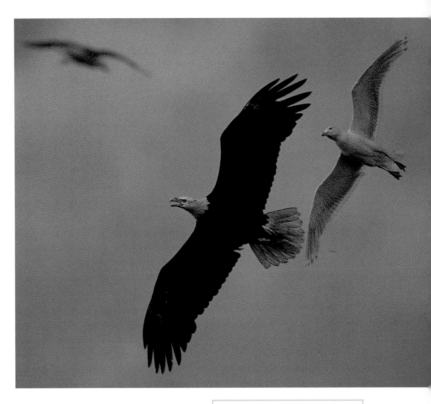

Eagles have been a vital part of history from primitive eras to modern times. These majestic birds have been symbols not only of powerful nation-states but also of potent religious ideas. From the earliest historical records, eagles have been given attributes far greater than any other animal. They have been symbols not only of power, courage, conquest, freedom, and independence but also of truth, the soul or its bearer, and immortality. Eagles have been the messenger of the king of Olympus and the carrier of his thunderbolts, the standard of the legions of Rome, and even the bearer of emperors to heaven. In this century, eagles are also the symbol of the earth's fragile environment; they show us we can reverse our destruction and pollution of the world.

The eagle as symbol dates back at least six thousand years. Its image as companion to the gods first appeared in Sumeria and ancient Mesopotamia. Somewhere between five and six thousand years ago, Lagash was an important city in southern Mesopotamia, near the head of the Persian Gulf in present-day Iraq, in an area later called Babylonia. The eagle was the tutelary divinity of Lagash and was typically represented in a

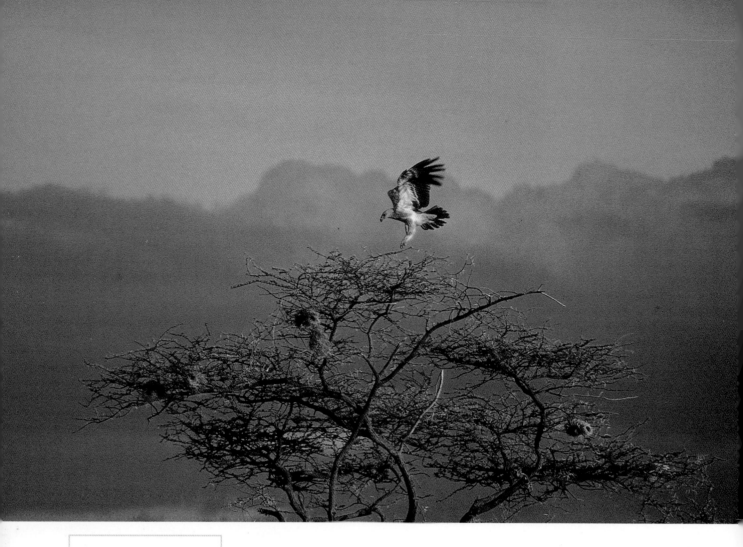

A steppe eagle lands
upon an acacia tree.
Samburu National
Park, Kenya.

heraldic, or displayed, attitude four thousand years before heraldry came
into existence. Lagash survived two Semitic conquests, the falls of
Babylonia and of Assyria, to become a great center of Asian art and reli-
gion, as well as a major crossroads of ancient civilizations. Even when
Babylon became the dominant city of the region, the Lagash eagle and the
myth of Etana persisted.

An ancient Mesopotamian epic, the myth of Etana concerns an
eagle who devoured a young snake. When an adult snake seized the eagle
by its tail and was about to kill it, the peasant Etana saved the bird. Out of
gratitude to Etana, the eagle carried him to heaven. This ascension of
Etana on the back of the king of birds is the first recorded mention of
eagle as symbol, and it became the prototype for how any good soul
might reach heaven. The later legend of Ganymede, borne away by Zeus
disguised as an eagle, helped keep the story alive and became yet another
symbol of ascension of the soul to the heavens. The idea of the eagle as
bearer of the soul and as messenger of the gods probably owes its origin to

Chaldean astrology, but was passed on to Egypt, then to Greece, and on to Rome and the rest of the world.

The exploits of eagles were inscribed on seal cylinders in Babylonia, and as a result many Babylonian gentlemen carried a personal or family seal portraying an eagle. An elaborate eagle cult arose, and it persisted during the time the Hittites were in power. The dominant goddess cult of Hitti, regularly depicted in sculpture and artwork, shows the goddess sitting astride a double-headed eagle. Indeed, the double-headed eagle appears to have been the popular image on seals from Babylonia to Egypt until around 2000 B.C., and later on the scarab.

Even with the decline of Babylonia, the symbol of the eagle persisted. Throughout Syria, the figure of an eagle with uplifted wings, along with a circular disk and a crown or wreath, became the symbol of the sun and thereby chief of the gods, the "bird of fire." Eagle images spread all the way to the Indus River, carried far and wide by the Egyptians, Greeks, and Romans. The extent to which the eagle symbol infiltrated Greek thought is illustrated by its prominence in Aesop's fables, from around 600 B.C. In most of these fables the eagle is a powerful and noble creature that others try to outsmart or deceive.

While Rome may not have originated the idea of the eagle as carrier of the soul, it developed the concept to its maximum, using it to convey everything from great power to immortality. And Christianity incorporated some of the pagan ideas, among them the symbol of the eagle, depicted most commonly in the funerary pose with uplifted wings. Appearing in many forms of art, from paintings to chalices like the great chalice of Antioch, discovered in 1910, the eagle became a prominent Christian symbol.

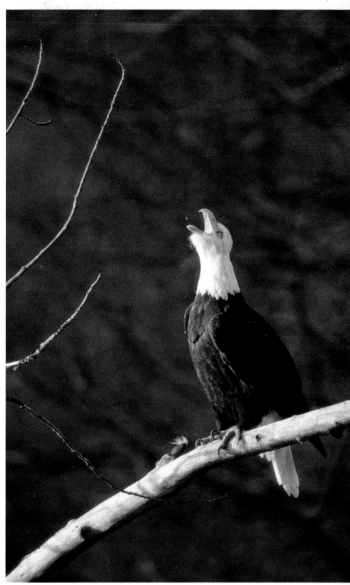

A bald eagle calling. Chilkat River Valley, Alaska.

A bald eagle in flight
over the Alaska Range.

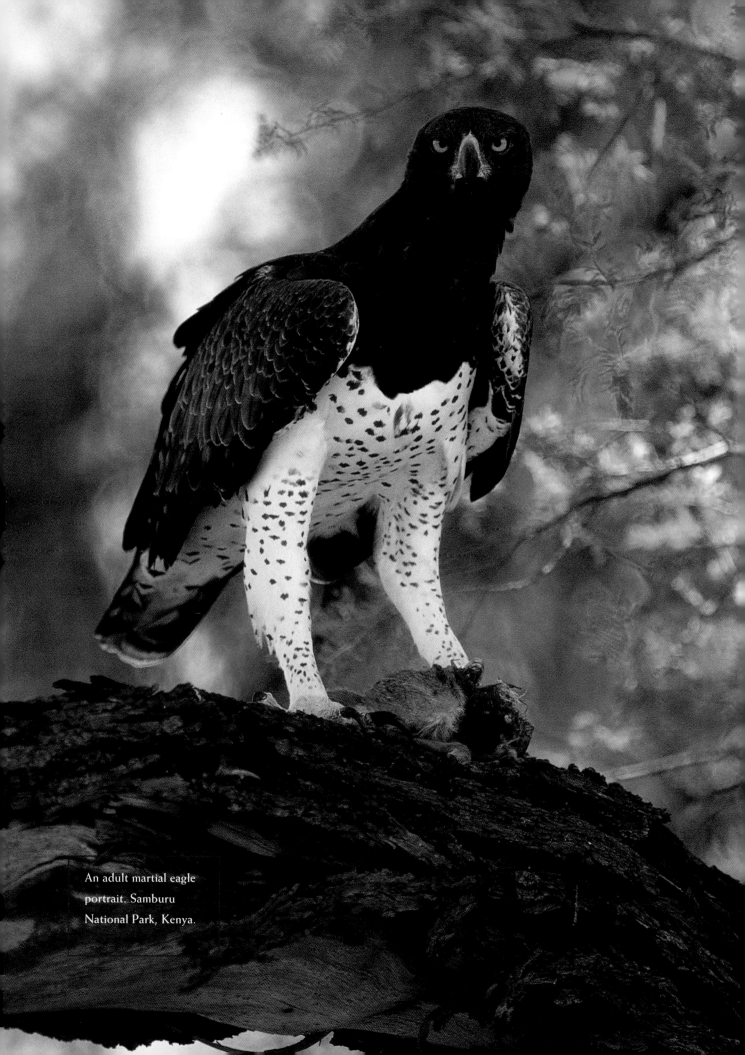

An adult martial eagle
portrait. Samburu
National Park, Kenya.

The Bible makes numerous references to the power and nobility of the eagle, including comments about being swept up as on the wings of a eagle. In the early Christian Church, the eagle was still closely connected to the sun. An old fable suggests that the eagle alone among animals could gaze upon the sun, and that it tested the legitimacy of its offspring by exposing them to the sun's rays, destroying any that flinched, since that made them unworthy of their high position. Saint Augustine is quoted as saying "The sun invigorates the eyes of eagles, but injures our own" (*Sol aquilorum oculos vegetat, nostros sauciat*).

The eagle with two heads—the double-sovereignty idea—is best known from the Middle Ages, when the image was used by the Eastern or Byzantine Empire centered at Constantinople. The image didn't originate there, though, and why it was adopted by the Byzantine monarchs is not clear.

A symbol of Syrians or Hittites of Asia Minor, the double-headed eagle was the emblem of the famous city of Pteria, ancient capital of northern Cappadocia, about one hundred miles east of Ankara, the current capital of Turkey. Between three and four thousand years ago, Pteria was a stop on the much-traveled highway between East and West. It was a renowned center of Hittite religion and art, where an entire priesthood and eagle cult developed. Natural rock chambers, open to the sky with vertical walls on which these double-headed eagles were depicted, can still be seen in this region today.

How long the eagle hovered as a symbol over the armies of Eastern monarchs is hard to say, but it was used by the Persians to achieve victories as early as the fifth century B.C. The Romans probably borrowed their eagle from their favorite god. On the Capitoline Hill in Rome, Jupiter, the serene ruler of the sky, was depicted seated in a curule chair with a thunderbolt in the right hand and a scepter in the left, and with the eagle, his messenger, at his feet. The legions of Rome were always led by a pair of eagle standards, initially in silver and some later in gold. Certainly the fact that history's most successful armies used the eagle as a symbol has encouraged other ambitious leaders and countries to do the same.

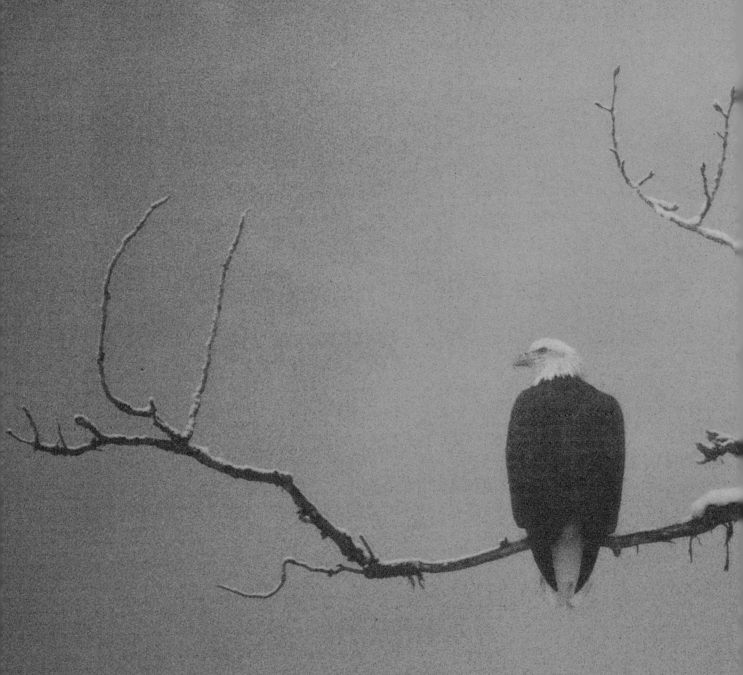

A bald eagle on cotton-
wood tree branch.
Chilkat River Valley,
Alaska.

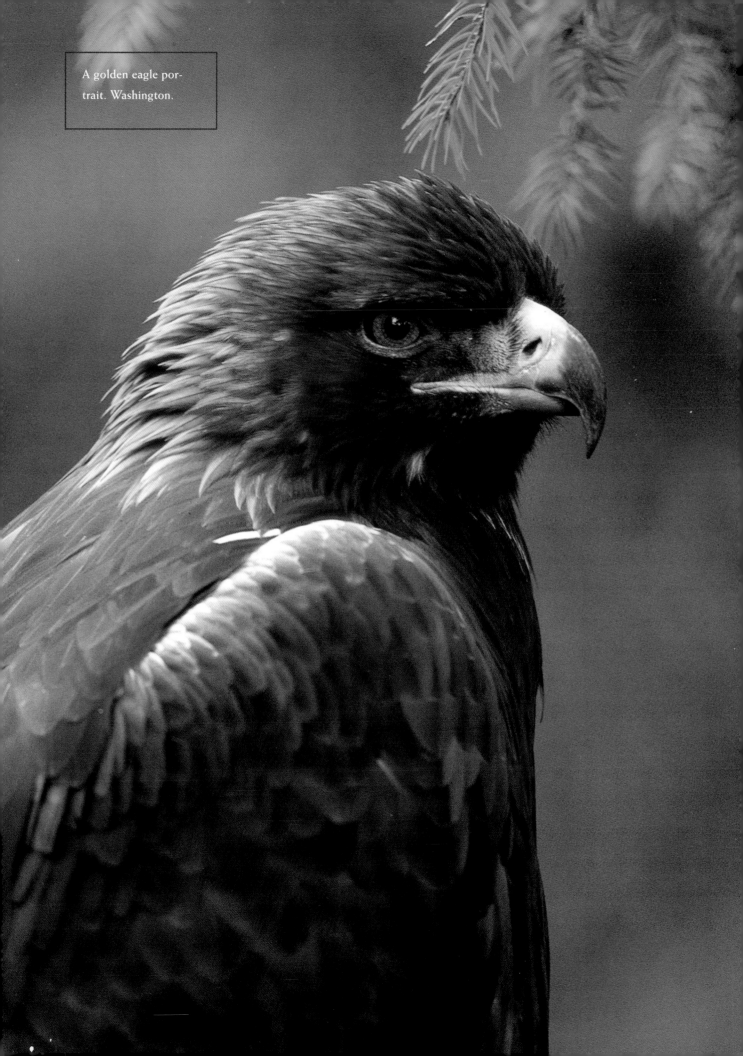

A golden eagle por-
trait. Washington.

So the eagle regularly appeared on shields, seals, and coats of arms throughout the Middle Ages and later. The Prussian eagle was the mark of the Teutonic knights and Crusaders. Napoleon revived the symbolic eagle in France and it remained in use until the French Revolution. The black Imperial eagle, with a red bill and talons on a gold field, remained the emblem of the German Republic until 1933.

The double-headed eagle is known to have first appeared in North America with the Mound Builders of the Hopewell culture in what is now Ohio. The Plains Indians also used the eagle as a symbol and bore shields marked with the Thunderbirds, which were supposed to attract the arrows of their enemies, thus protecting the warriors.

Some North American Indian tribes believed that the feathers of eagles and hawks possessed magical powers. For many Plains Indians, seeing an eagle in a vision meant the eagle would be a special protector, so the possession of even a feather would put the individual in good stead with the gods. The Pawnee believed that the eagle was a fertility symbol as well, since the bird built such large nests high off the ground for protection and the adults were such strong and valiant defenders of the nest and young. The eagle was honored, revered, and in some societies worshipped in song, chant, and dance. In the Pacific Northwest, the eagle as a totem was powerful.

The eagle was also a major symbol with the Aztec and related tribes in Mexico. At least through 1450, when the Aztec established themselves in the valley of Mexico, the eagle remained a strong symbol, with

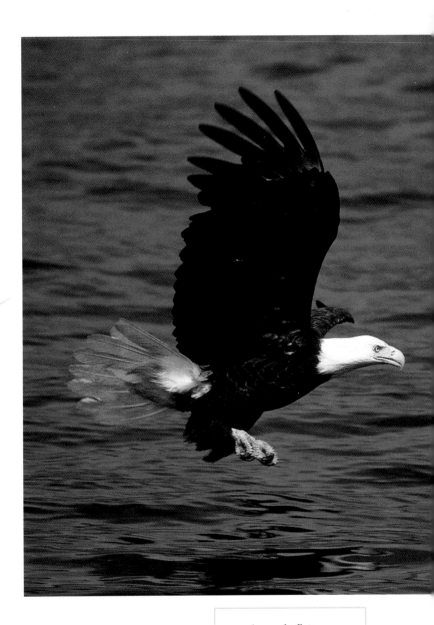

An eagle flying over the fish-rich waters of Southeast Alaska.

feathers used by that society's elite. The bird was also the symbol and emblem of the elite Knights of the Eagle, a powerful soldier society of the Aztec. The Aztec solar calendar shows great respect for the eagle by using it as a symbol for one of the days of the week. But most of all, the eagle was the badge of the Aztec noble, who was dedicated to war.

An eagle perched on a cactus, holding a snake, was an ancient symbol of the Mexica Indians that persists today in Mexico's seal and coat of arms. This image is linked to the beginnings of Mexico City, seven hundred years ago when the Mexica Indians were defeated by their neighbors and driven from their homes. Their leader, Duran, told them to look for an eagle holding a snake on a prickly pear cactus. When they spotted such an eagle on a small island in the middle of a shallow lake, Tenochtitlán, they knew where to settle, as the eagle stretched its wings toward the sun's rays and basked in the warmth of the morning sun. According to legend, the Mexica humbled themselves on the ground, and the eagle, upon seeing them, bowed his head in their direction, at which point the people began to weep with contentment. The lake provided them shelter from their enemies and a supply of food, and the Mexica thrived. Part of modern-day Mexico City is situated on the bed of that ancient lake, and the eagle is still a powerful symbol there.

In Asia, the origin of all mythical eaglelike creatures probably traces back to the Garuda, a symbol which has persisted since the eleventh century in Hindu Bali and Java. "This bird of life . . . destroyer of all, and creator of all," was extremely powerful. The Garuda shows how any creature that becomes a god or becomes godlike is slowly anthropomorphized to take on features of humans. As the Garuda legend spread south and east from India, it took on human characteristics until it reached Bali, where the modern version (half human, half bird) of Garuda emerged. Mythical birds have been worshipped from Tibet to Mesopotamia and the Nile valley as the wind, stars, sun, or storms. In Tibetan legend, an immense golden-winged bird flies to the great northern ocean, where it flaps its great wings, pushing the waves aside and killing the spirits of the water, which are holding the water. This results in the release of the rains.

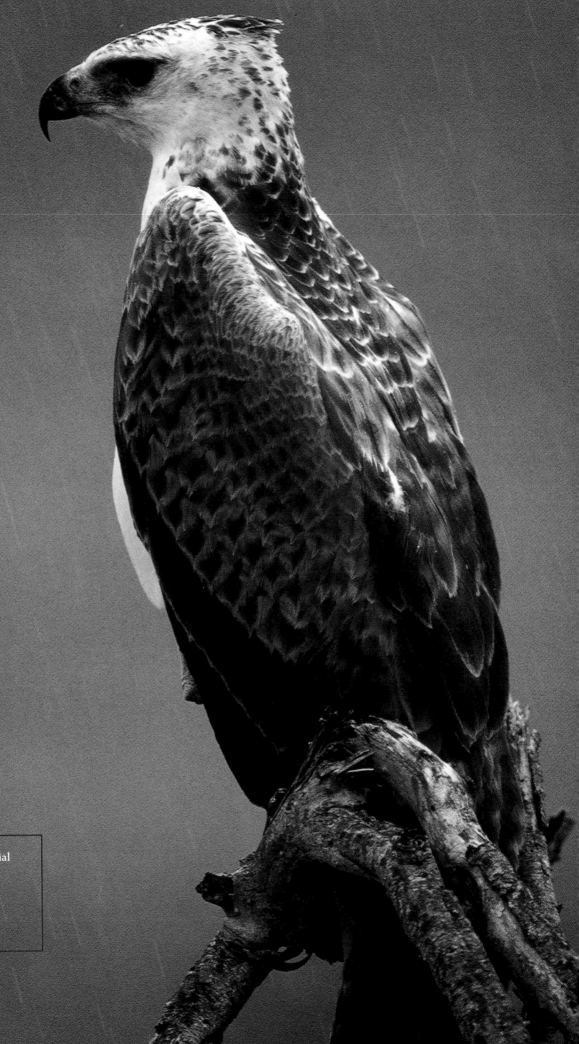

An immature martial
eagle portrait.
Samburu National
Park, Kenya.

2

The Eagle:

Its Majesty
and Power

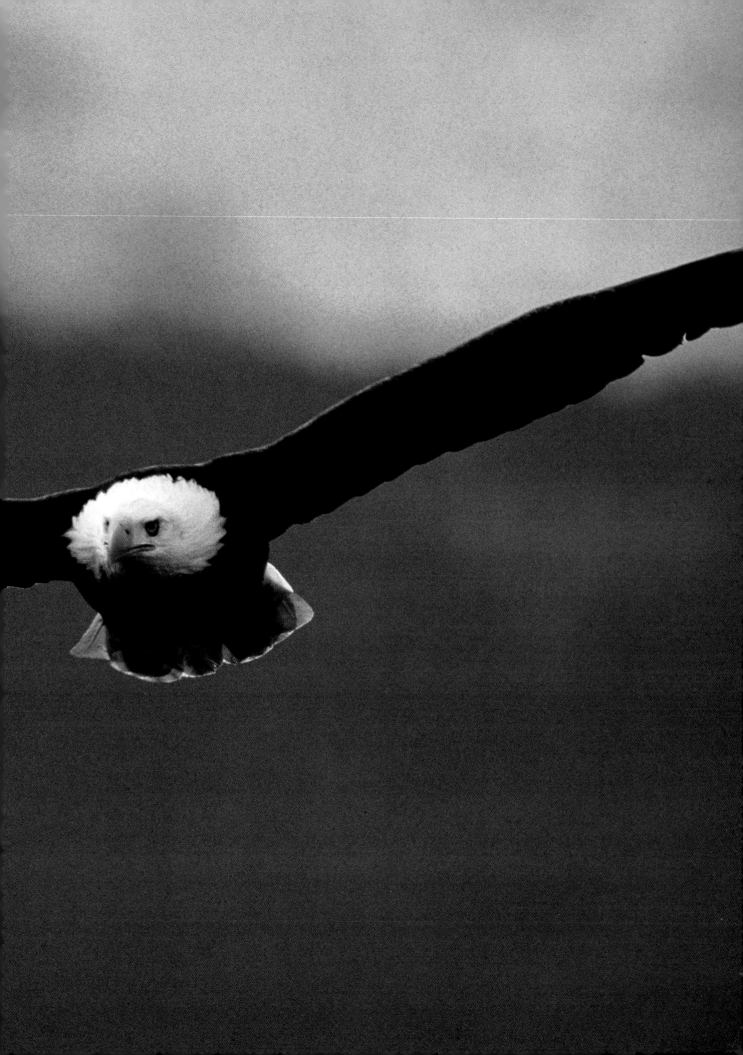

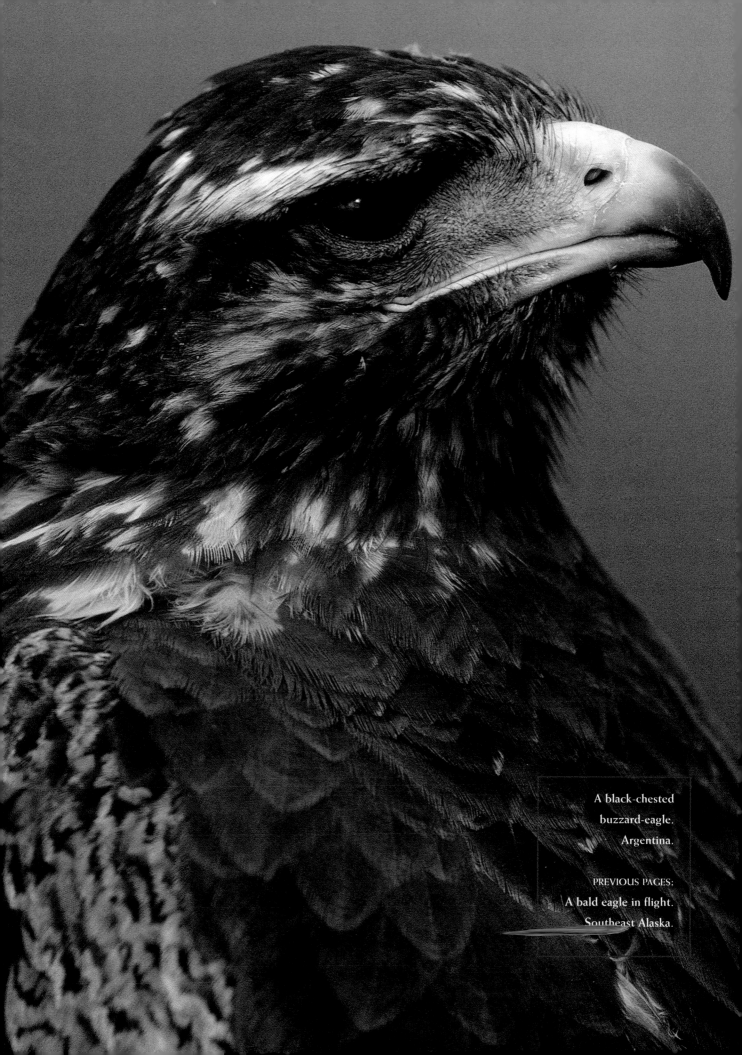

A black-chested
buzzard-eagle.
Argentina.

PREVIOUS PAGES:
A bald eagle in flight.
Southeast Alaska.

T he *Eagle* has landed." These words mark one of humankind's greatest triumphs as the U.S. astronauts landed on the surface of the moon. The naming of their landing craft after the eagle was not a matter of chance but indicative of the prestige and power that go along with the name.

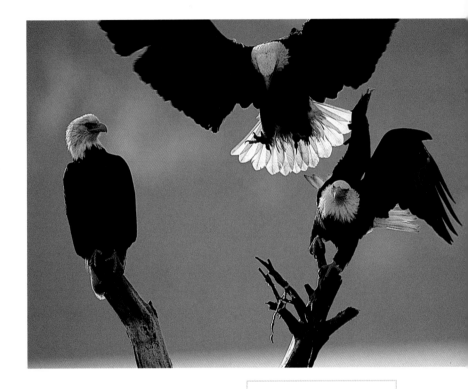

Bald eagles congregate on the beach along Homer Spit, Alaska.

The word *eagle* and what it stands for has carried varied meanings around the world and throughout time. Everything from fear to awe to power to speed to royalty enter into images the word raises in minds of people everywhere. The eagle is not just another bird of prey; it is the ultimate, the king of birds, in both a positive and a negative sense.

What is an eagle? How can it be distinguished from a hawk or some other bird of prey? These are not easy questions to answer, since the differences between birds are often subtle and even some scientists disagree on the definitive elements. Generally speaking, eagles are the largest members of the hawk family. They have long and broad wings, a large and heavy curved bill, and relatively short tails. They spend most of their airborne time in gliding flight. Yet if they are well fed, eagles will perch for

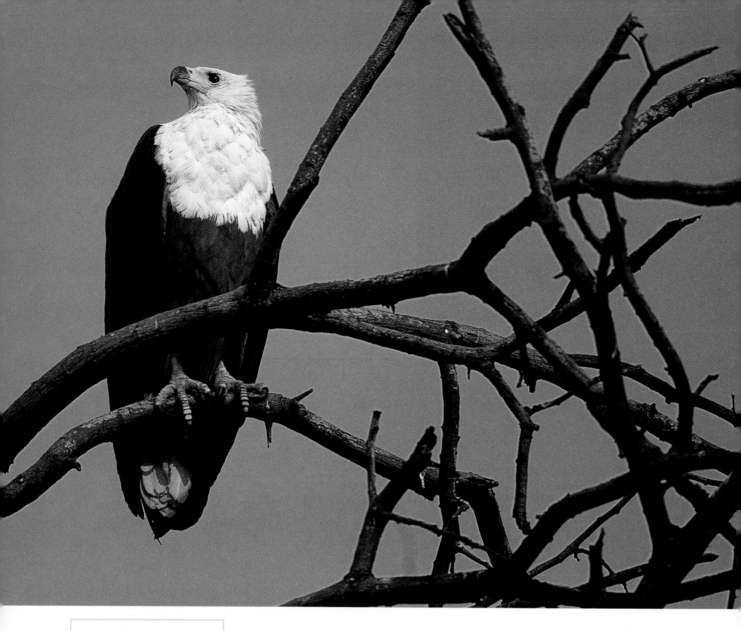

An African fish-eagle portrait. Okavango River, Botswana.

hours on their nests or on an open branch near or above a large body of water or stream. Eagles have heavy and sharply hooked talons, which can be formidable weapons when used for defense or hunting.

While the largest members of the hawk family generally are eagles, not all eagles are among the largest birds of prey. In fact, eagles range in size from the largest of the hawk family to some of the smallest. For example, some tropical eagles weigh less than two pounds and have a wingspan of less than three feet, making them much smaller than many hawks, buzzards, and kites. Yet some eagles weigh up to eight or ten pounds and have a wingspan up to seven or eight feet. In comparison, condors, the largest birds of prey, may weigh fifteen to eighteen pounds and have a wingspan of ten to eleven feet.

Eagles are generally the most powerful of the birds of prey, with

strong wings and powerful bills and talons. The largest and strongest eagles can kill prey that weighs as much as three or four times their weight. Leslie Brown, author of numerous books and articles on birds of prey, describes how a crowned eagle killed a healthy thirty- to thirty-five-pound bush-buck, but then could carry off only a rela-tively small piece of two to three pounds to its nest and young. Even the largest eagles generally cannot carry off any prey larger than two and a half to three pounds. The bald eagle is no exception, and can probably carry away prey that weighs less than three pounds.

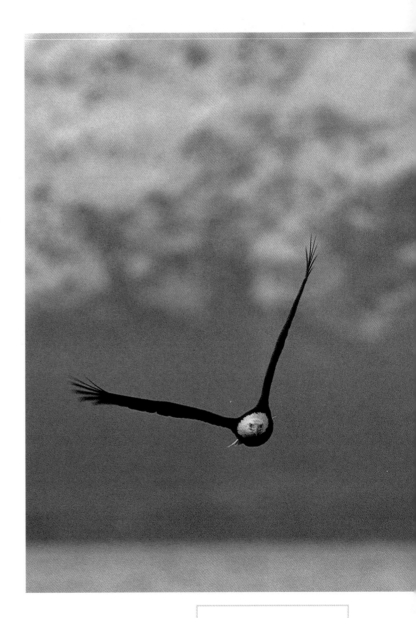

A bald eagle in flight.
Cook Inlet, Alaska.

The sight of an eagle arouses as many differ-ent feelings as there are people. Few birds—in fact, few other animals—elicit such strong emotions. Like all predators, eagles have been both revered and persecuted by humans. Eagles have a way of getting peo-ple's attention.

My first memory of the bald eagle dates back to when I was eight or nine years old and my family and I visited Jackson Hole, Wyoming. The huge stick nest we saw near the top of a tree alongside the Snake River was impressive, as was the pair of large black birds with white heads and tails. However, what I couldn't understand, and I was most impressed by, was how the birds could build such a huge nest and why the stick nest stayed in the tree.

I also remember watching the birds fish along the Yellowstone River and in Yellowstone Lake. And I recall seeing an eagle circle high overhead, then suddenly spiral wide out over the lake and swoop down in

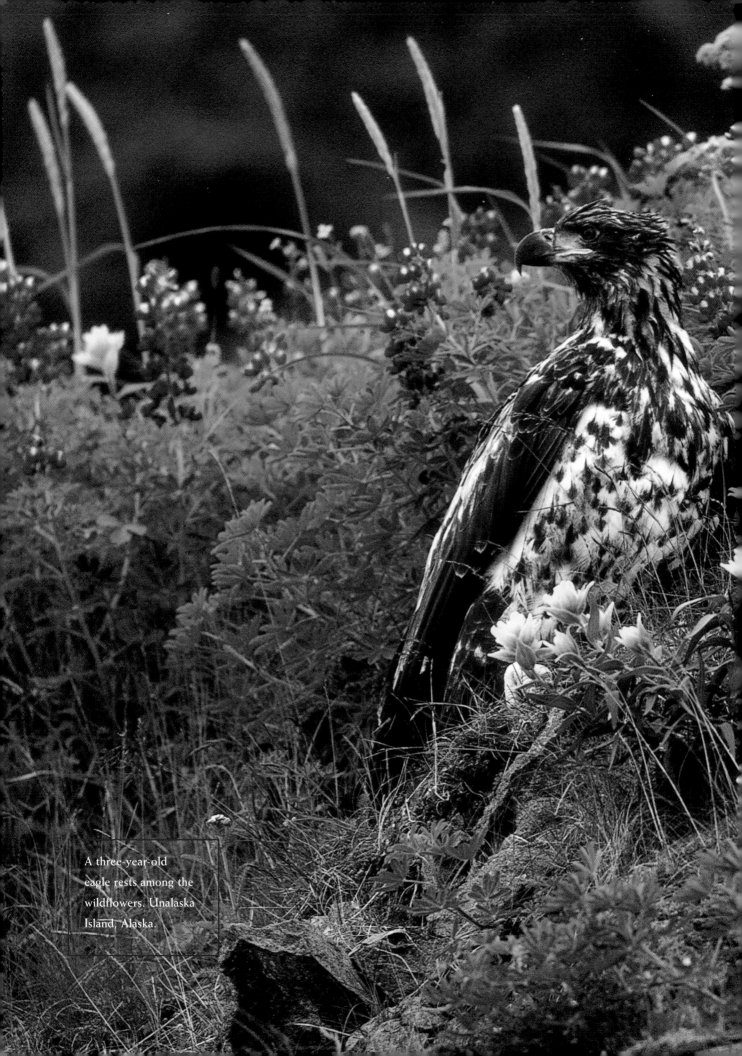

A three-year-old
eagle rests among the
wildflowers. Unalaska
Island, Alaska.

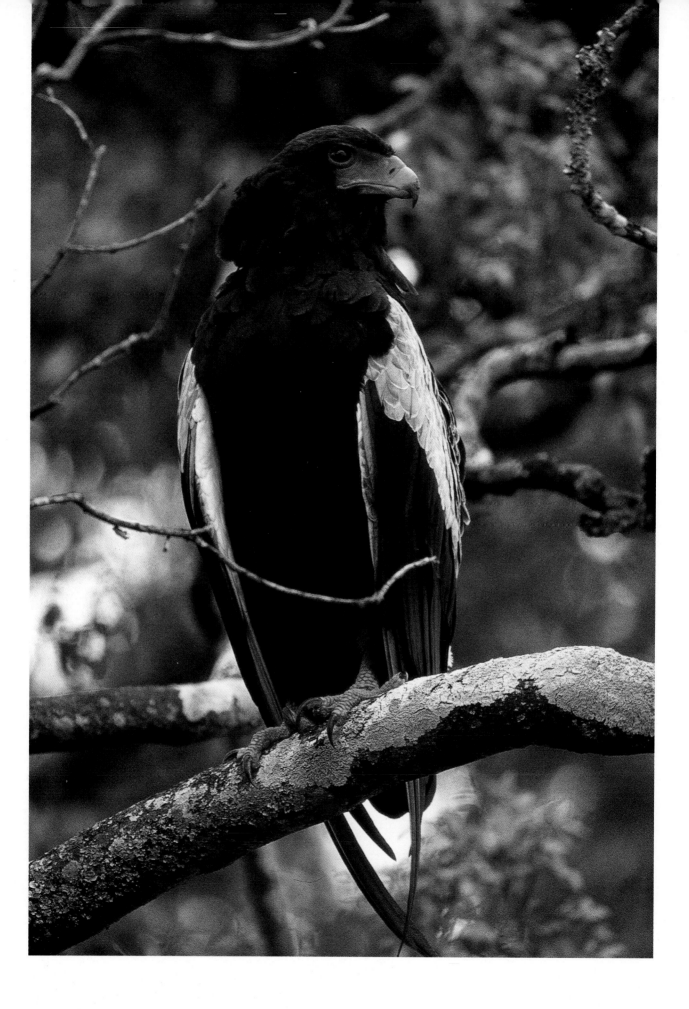

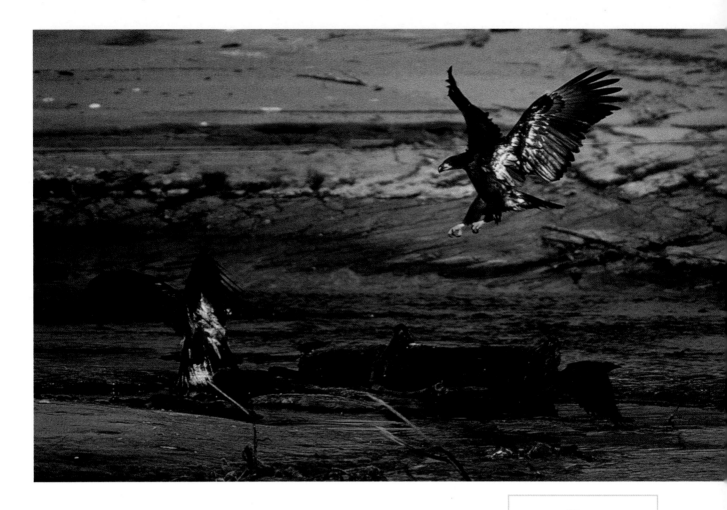

a long, graceful arch over the water. The bird extended its legs and opened its talons as it approached the water, then it gave a sudden jerk as its talons sank into a fish that had been swimming just under the surface. As it flew off with its catch held tightly in its talons, I asked my father how the eagle had known the fish was there. He told me that the eagle had very good eyesight and could see the fish from high in the sky. I was impressed, and I never forgot about the eagle's eyesight or the extraordinary catch. For years my dream was to fly like an eagle, to see everything in such detail, and to catch fish by swooping out of the sky like the bald eagle I had watched that day in Yellowstone National Park.

It is quite easy to understand how and why people around the world from times of man's distant past right up to the present have idolized the eagle. The imagery of the bird's majestic flight, its hunting prowess, its power, its unbelievable eyesight, and its defense of mate, nest, and young are all images that mankind universally looks for and reveres.

ABOVE: Two immature bald eagles spar over spawned-out salmon. Fraser River, British Columbia.

OPPOSITE: A bateleur eagle portrait. Rift Valley Region, Kenya.

An American Emblem

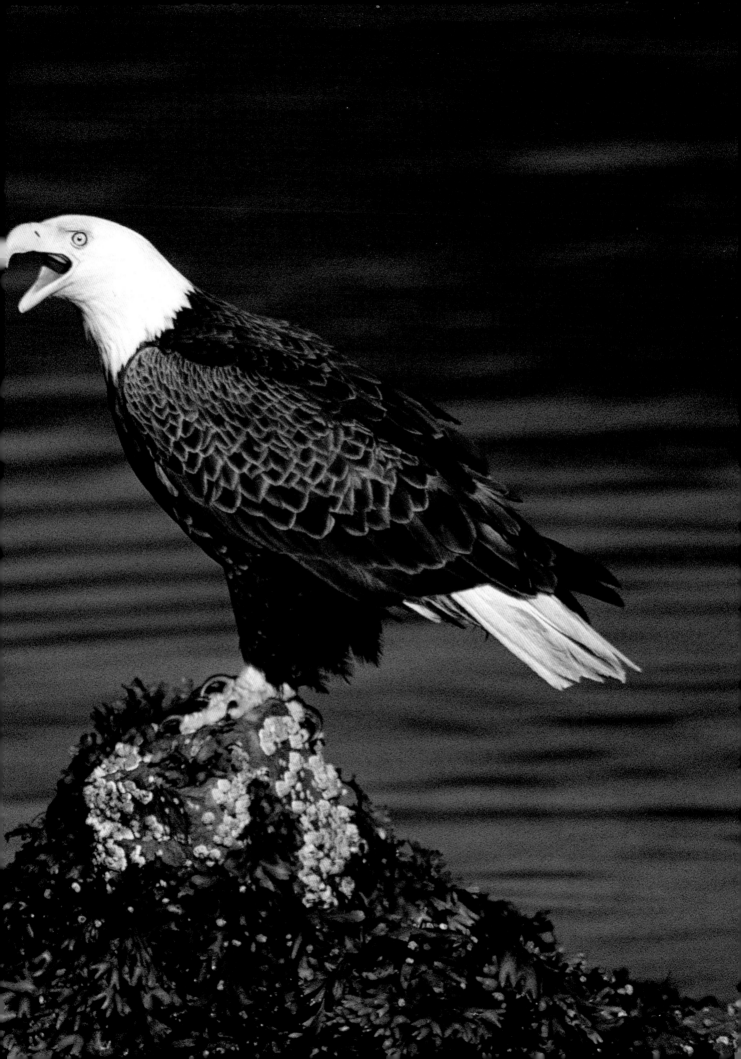

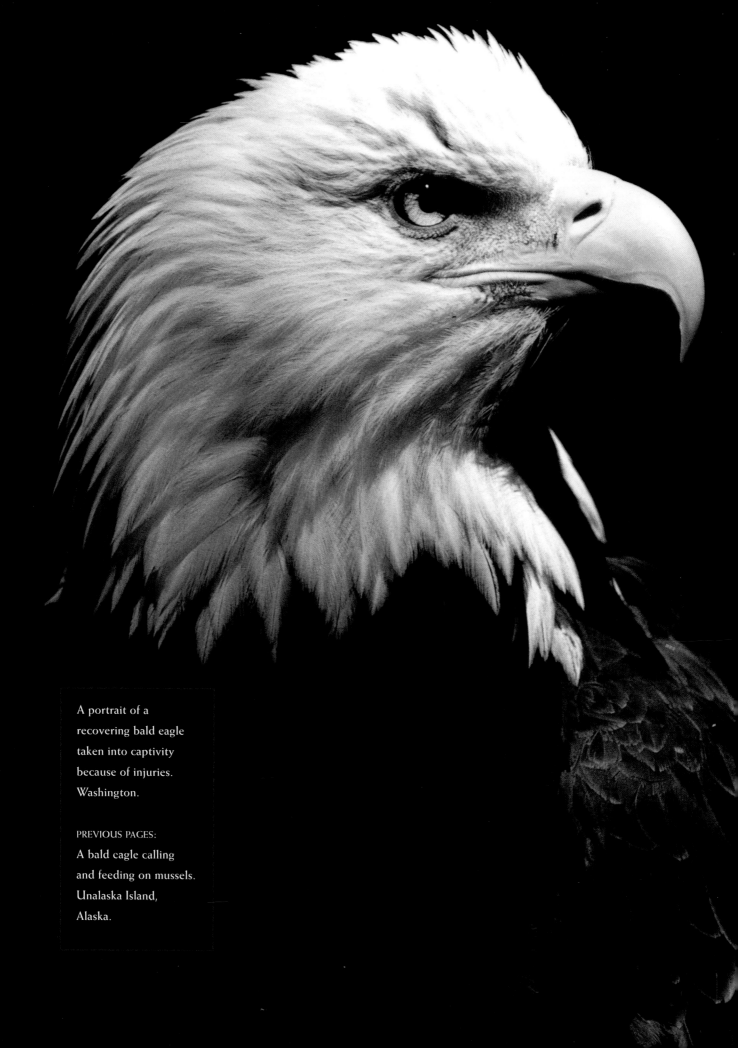

A portrait of a
recovering bald eagle
taken into captivity
because of injuries.
Washington.

PREVIOUS PAGES:
A bald eagle calling
and feeding on mussels.
Unalaska Island,
Alaska.

At the Second Continental Congress, after the thirteen colonies voted to declare independence from Great Britain, the colonies determined they needed an official seal. So Dr. Franklin, Mr. J. Adams, and Mr. Jefferson as a committee prepared a device for a Seal of the United States of America. However, the only portion of the design accepted by the congress was the statement *E pluribus unum*, attributed to Thomas Jefferson. Six years and two committees later, in May of 1782, the brother of a Philadelphia naturalist provided a drawing showing an eagle displayed as the symbol of "supreme power and authority." Congress liked the drawing, so before the end of 1782, an eagle holding a bundle of arrows in one talon and an olive branch in the other was accepted as the seal. The image was completed with a shield of red and white stripes covering the breast of the bird; a crest above the eagle's head, with a cluster of thirteen stars surrounded by bright rays going out to a ring of clouds; and a banner, held by the eagle in its bill, bearing the words *E pluribus unum*. Yet it was not until 1787 that the American bald eagle was officially adopted as

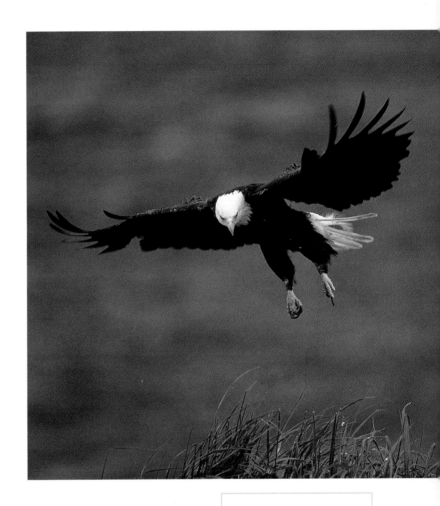

An adult eagle flying along the cliffs near its nest. Unalaska Island, Alaska.

the emblem of the United States. This happened only after many states had already used the eagle in their coat of arms, as New York State did in 1778. Though the official seal has undergone some modifications in the last two hundred years, the basic design is the same.

While the eagle has been officially recognized as America's national bird, there have been dissenters who feel that the bird was the wrong choice. Benjamin Franklin wrote:

> *I wish that the bald eagle had not been chosen as the represen-tative of our country; he is a bird of bad moral character; he does not get his living honestly; you may have seen him perched on some dead tree, where, too lazy to fish for himself, he watches the labor of the fish-ing-hawk, and when that diligent bird has at length taken a fish, and is bearing it to its nest for the support of his mate and young ones, the bald eagle pursues him and takes it from him. . . . Besides he is a rank coward; the little kingbird, not bigger than a sparrow attacks him boldly and drives him out of the district. He is therefore by no means a proper emblem for the brave and honest . . . of America. . . . For a truth, the turkey is in comparison a much more respectable bird, and withal a true original native of America . . . a bird of courage, and would not hesitate to attack a grenadier of the British guards, who should presume to invade his farmyard with a red coat on.*

Franklin was clearly against the eagle and let everyone know it. Likewise, the artist John James Audubon agreed with this opinion of the bald, or white-headed, eagle.

Nevertheless, selected as our national bird, the eagle has appeared on all official seals of the United States, as well as on most coinage and paper money, and on many U.S. stamps. It is curious to note that the minted eagles have been issued in a great variety of shapes and positions. Also, there is great variation in the species depicted. Some of the most famous images have species other than the bald eagle—for example, the famous ten-dollar gold pieces exhibit the "double eagle" instead. Numerous people have complained because many, if not most, of these illustrations show the wide-ranging golden eagle rather than our own

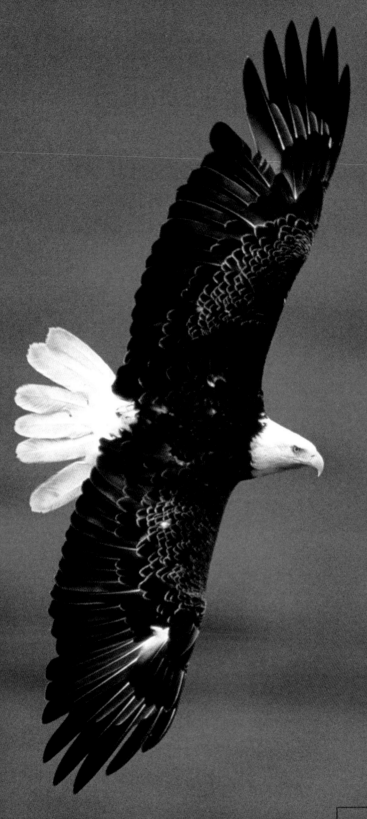

A bald eagle in flight.
Unalaska Island,
Alaska.

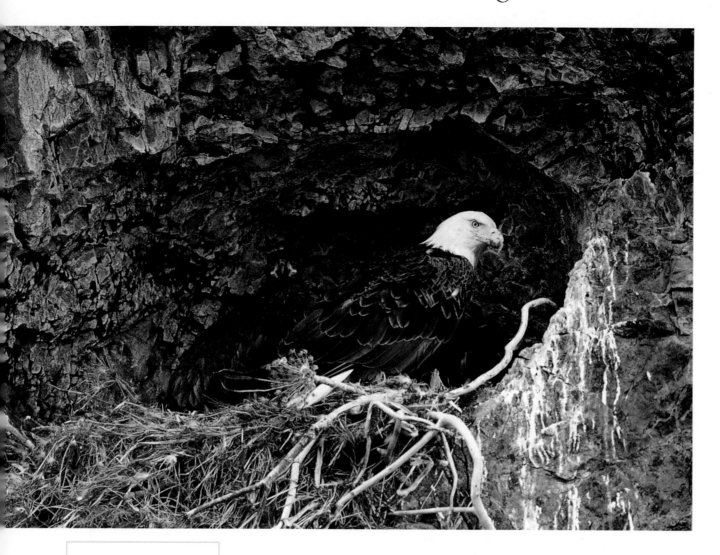

An ideal location for an eagle nest within a natural pocket formed when the volcanic cliff hardened. Unalaska Island, Alaska.

national bird, the bald eagle. They feel these representations mislead the general public into believing that they are looking at a bald eagle. The easiest way to distinguish between the golden and bald eagles is by the feathering on the legs. The golden eagle is feathered down the entire leg, while the bald eagle has no feathers on the lower part of the leg until at least two or three years of age, when bald eagles also start developing the white head and tail.

The American eagle, bald eagle, bald-headed eagle—although the bird has known many names, it is uniformly called the bald eagle today. Its image appears everywhere, as the symbol of the U.S. Postal Service and as an adornment on flagpoles, statuary, and buildings. The eagle is even pictured on buttermolds and blazoned on quilts. Companies take advantage of the power associated with the eagle image and apply it to their prod-

ucts. For instance, the Jeep Eagle is intended to convey a sense of power, strength, and prestige. The bird is even used to designate the highest ranking within the Boy Scouts—that is, the Eagle Scout. For Americans, the eagle has truly come to symbolize the "bird of freedom." Even the naming of the lunar landing craft and the much quoted statement "The *Eagle* has landed" has helped to perpetuate the tradition, power, and symbolism of the eagle.

Adoption of the bald eagle as America's symbol has conferred a mantle of affection and significance on this magnificent bird. The Eagle Protection Act was passed using the following words: "Whereas, by the Act of Congress and by tradition and custom during the life of this nation, the bald eagle is no longer a mere bird of biological interest but a symbol of the American ideals of freedom." And the public's respect for and awe of the bald eagle has continued to increase significantly in the last fifty years. News of declines in eagle populations and then of their slow recovery has kept eagles in the public's mind, adding strong support for our national symbol.

A bald eagle calling. Unalaska Island, Alaska.

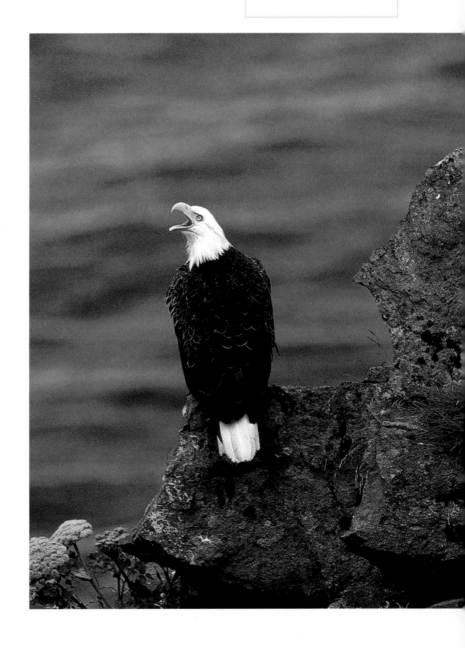

The Bald Eagle

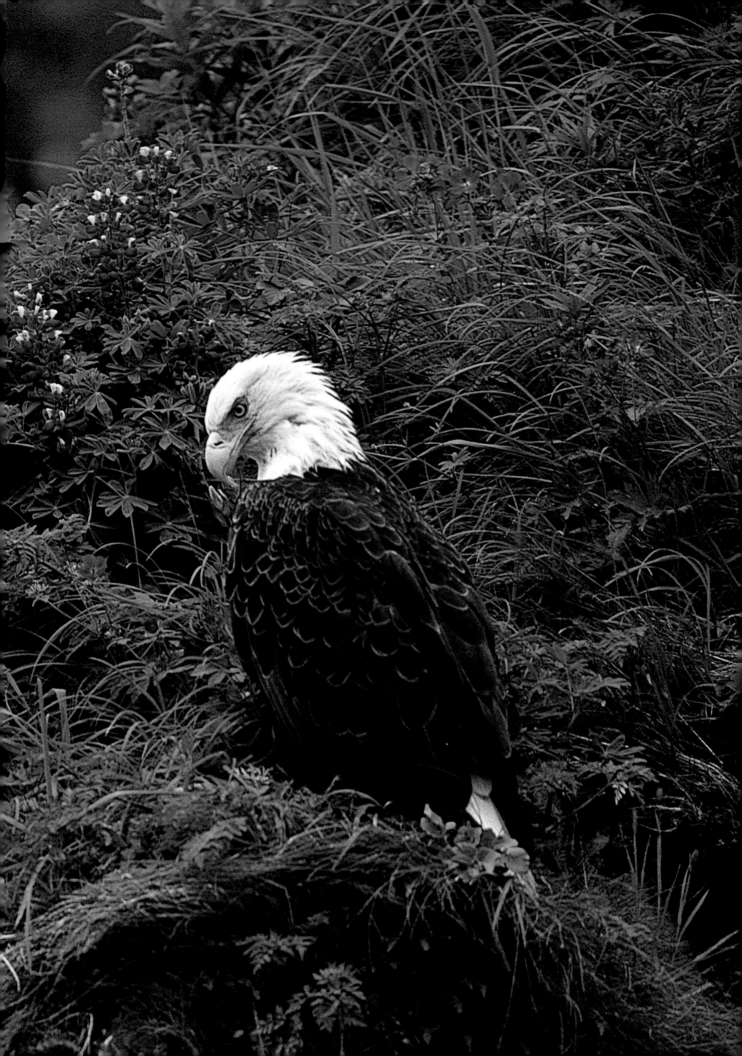

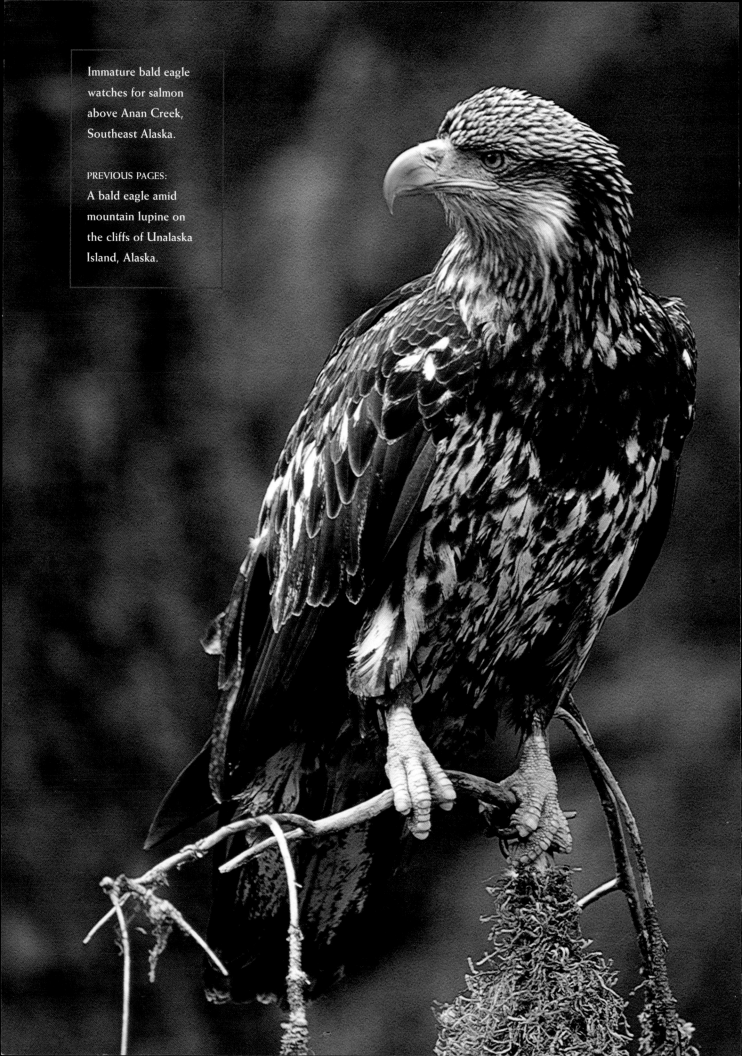

Immature bald eagle
watches for salmon
above Anan Creek,
Southeast Alaska.

PREVIOUS PAGES:
A bald eagle amid
mountain lupine on
the cliffs of Unalaska
Island, Alaska.

The bald eagle, *Haliaeetus leuco-cephalus,* is the only eagle confined to North America. Adult bald eagles have a black back and breast; a white head, neck, and tail; and yellow feet and bill. In North America, there are no other large black birds with white heads and tails. Juvenile bald eagles, however, can be much more difficult to identify. The young birds are a sooty brown color with the adult plumage taking several years to develop. The bill is black in young birds.

Exquisite feather detail of a bald eagle. Washington.

Audubon believed that these sooty brown immature birds with black bills were a third species of eagle, in addition to the bald and golden eagles. He even named this third species the Washington eagle. It is now evident that Audubon was basing his analysis on immature bald eagles he observed in Washington; however, his measurements for these birds seem to have been exaggerated considerably. Audubon was clearly unaware that young bald eagles take several years to mature. The young birds often develop the white color before the sooty brown switches completely to the adult black plumage, and some birds never get as black as others.

As in other eagles and most birds of prey, the female bald eagle is

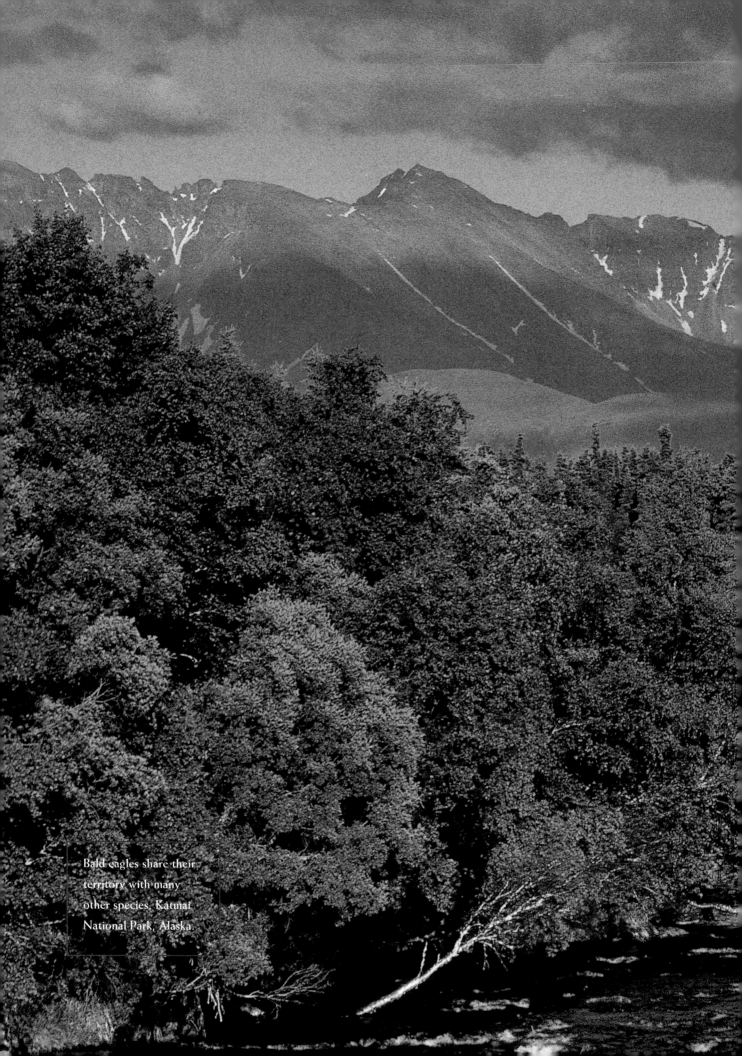

Bald eagles share their
territory with many
other species, Katmai
National Park, Alaska.

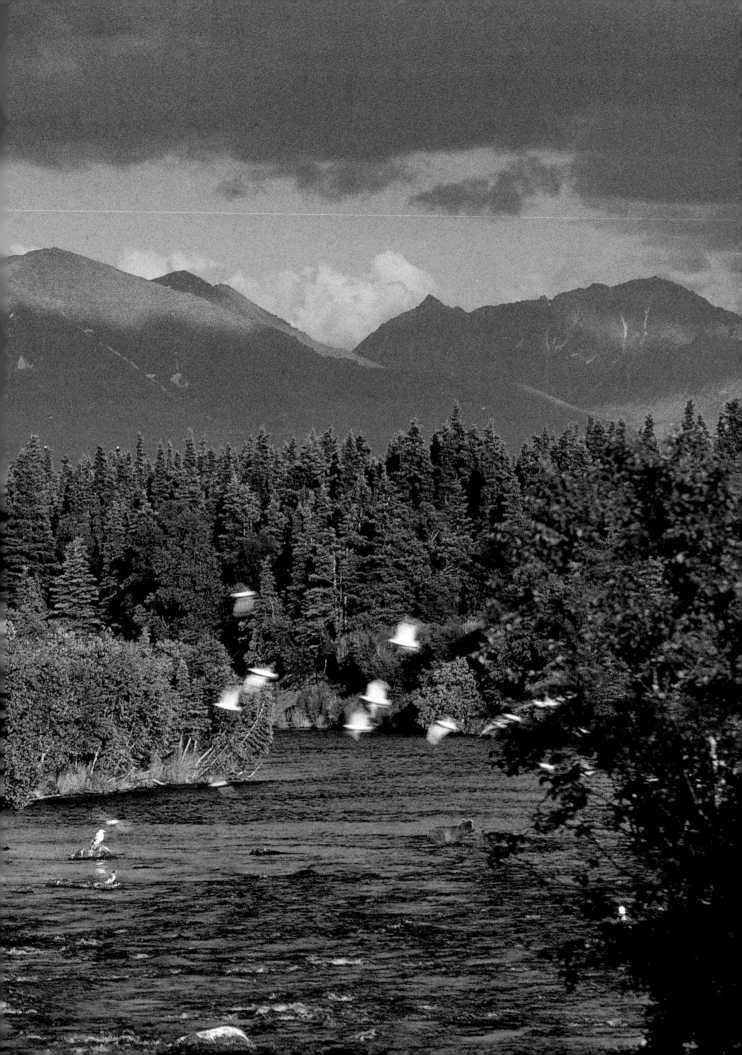

slightly larger than the male. Males range in body length from 30 to 34 inches, while females are 35 to 37 inches. The wingspan of a male ranges from 72 to 85 inches, while that of the female varies from 79 to 90 inches. Also, northern birds are significantly larger than their southern relatives.

The bald eagle has had a number of other names since Europeans arrived in North America. They include bald-headed eagle, American eagle, sea eagle, white-tailed eagle, white-headed eagle, black eagle, Washington eagle, Ole Abe, bird of freedom, and even gray eagle (referring to young birds, as Audubon did).

Two subspecies of the bald eagle are generally recognized. The southern bald eagle, *Haliaeetus leucocephalus leucocephalus*, is apparently confined to the gulf states from Texas and Baja California across to South Carolina and Florida, south of 40 degrees north latitude. The northern bald eagle, *Haliaeetus leucocephalus alascanus*, occurs north of 40 degrees north latitude across the entire continent. The largest numbers of this subspecies occur in the Northwest, especially in Alaska, where aggregations of hundreds can be seen regularly. The northern bald eagle has been seen, although rarely, in eastern Siberia and even once, in the 1860s, as far west as Sweden.

The bald eagle is a member of the fish eagle group of birds of prey. Its closest relatives are the fish eagles of Africa and Asia, many of which are similar in appearance and habit. All members of the genus *Haliaeetus* are generally fish eaters, but as with most birds of prey, they will take what-

When both adults return to the nest, the size difference between the sexes becomes evident. The female is always larger than the male. Orcas Island, Washington.

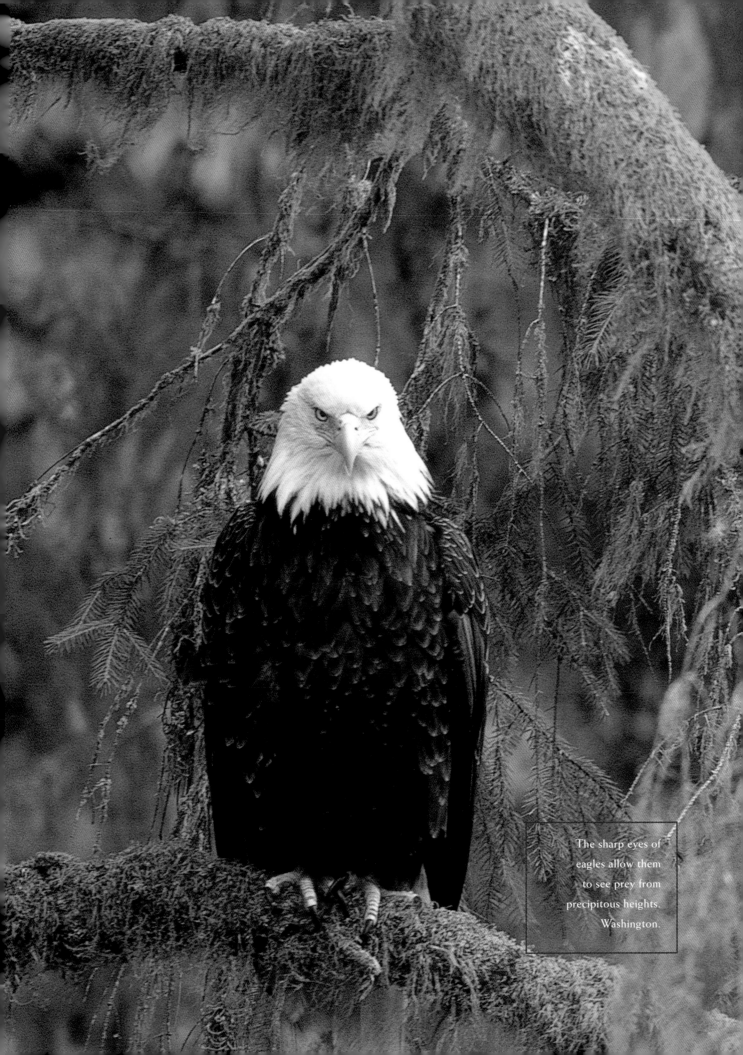

The sharp eyes of eagles allow them to see prey from precipitous heights. Washington.

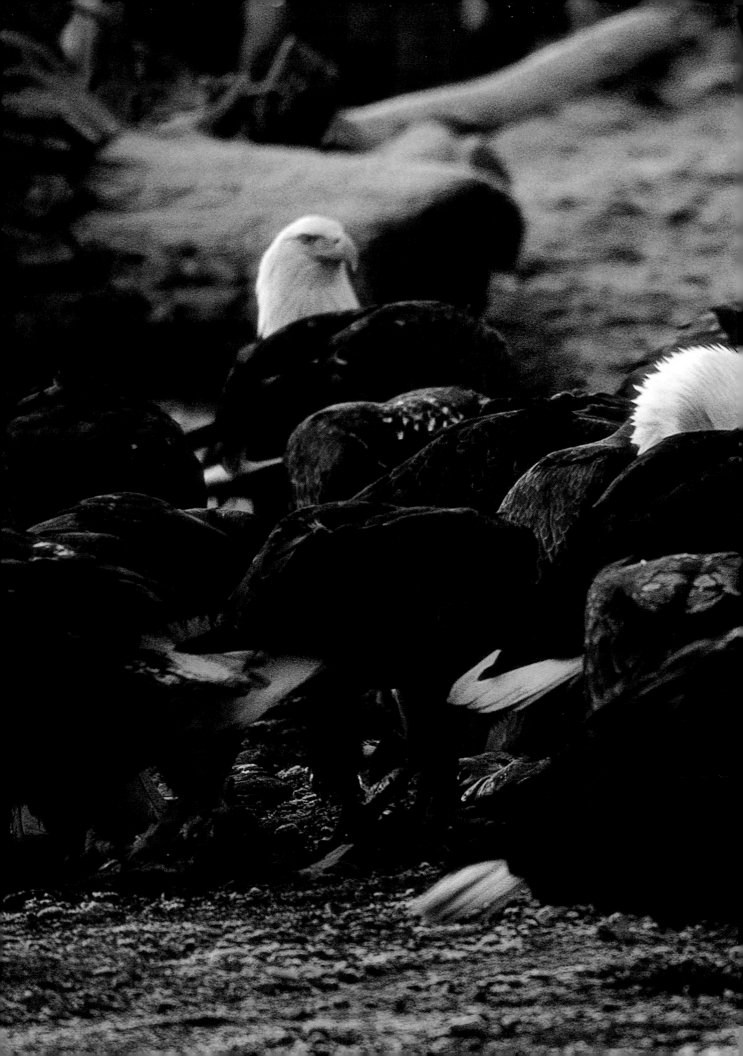

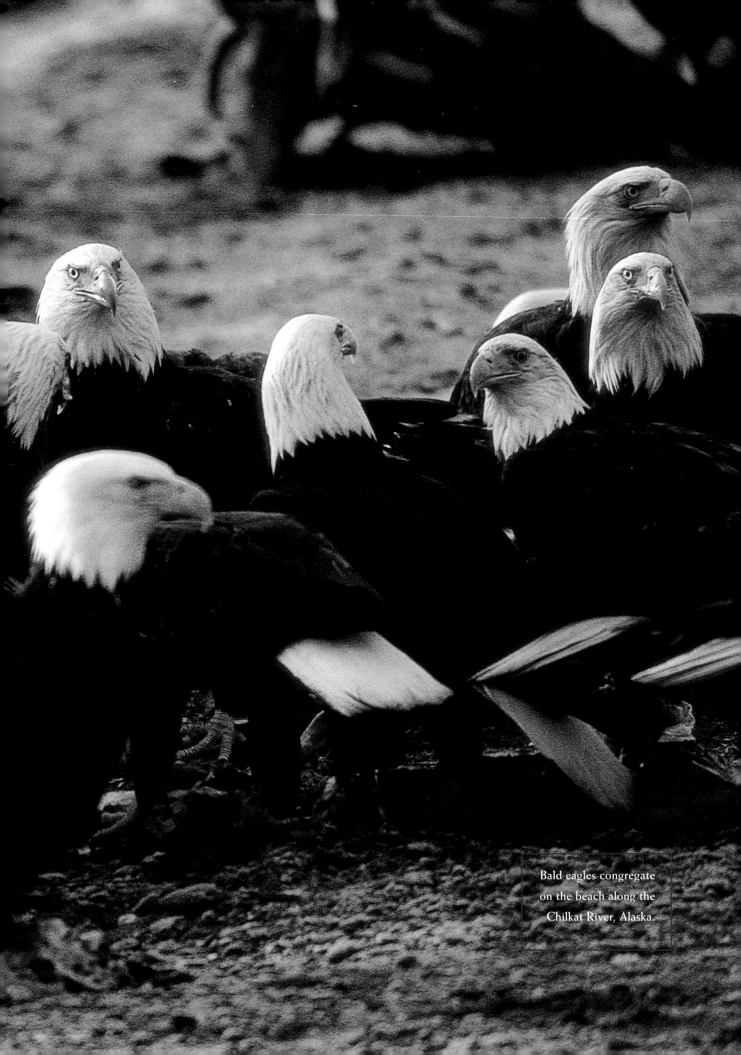

Bald eagles congregate
on the beach along the
Chilkat River, Alaska.

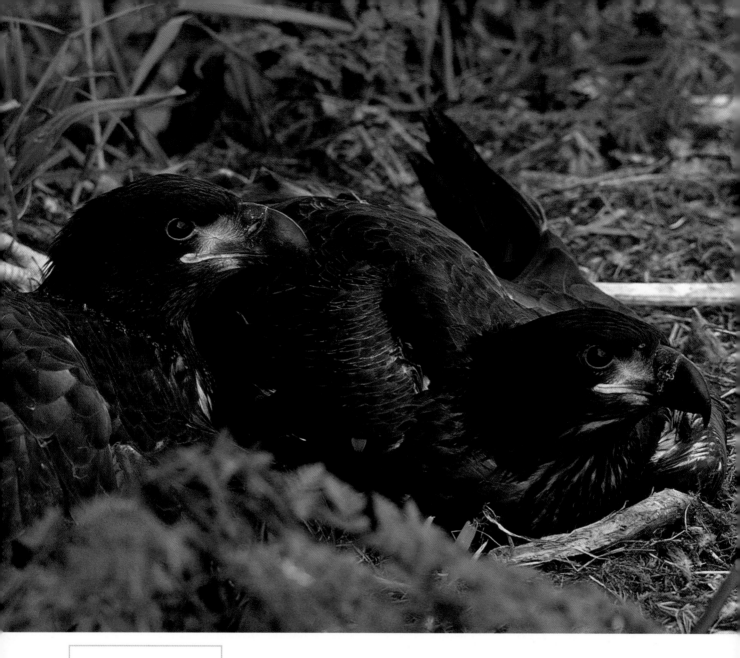

When no trees or vertical cliffs are present, bald eagles will nest on relatively flat ground if no predators are nearby. Unalaska Island, Alaska.

ever prey is available and is easiest to obtain. There is also a tremendous variation between individuals as to the type of prey they prefer and habitat that they live in, and thus the food available to them. While bald eagles living along the coasts and on major lakes and rivers feed largely on fish, birds that live in the intermountain areas of the western United States may depend much more on rabbits and other small mammals and birds, especially waterfowl, as prey.

Bald eagles, like most birds of prey, have suffered badly at the hands of people who do not understand the bird's role in nature or who perceive them to be competition for food. Bald eagles do not generally feed on chickens or other domestic livestock, but they will certainly utilize any food source available, often resulting in conflicts with humans, which

can lead to the unnecessary killing of eagles. Individual eagles do occasionally cause problems when they discover an easy source of food and capitalize on it.

Since most farmers, ranchers, and fishermen cannot distinguish between eagles and other birds of prey, all of these birds are persecuted. The golden eagle is much more likely than other birds of prey to have conflicts with humans, as it is a much more aggressive hunter of small mammals and would be more likely to take a chicken or some other domestic animal. However, studies have shown that these birds seldom take healthy domestic animals. Unfortunately, though, they are blamed for the deaths of a lot of animals, deaths often resulting from other causes or other predators.

Golden eagles will also eat carrion if the opportunity arises, but it is not their major source of food. They tend to be much more aggressive hunters, killing for most of their food. On the other hand, historically and even today, bald eagles will take advantage of carrion far faster than will golden eagles. Pictures of tens, even hundreds, of bald eagles lined up at town dumps in Alaska and British Columbia are clear examples of how bald eagles prefer carrion if it is available. It is probably for this reason—its scavenger image—that some people dislike the bald eagle so intensely. Other people are uncomfortable about any powerful and aggressive bird, and thus dislike the bald eagle even though it is not generally as aggressive or powerful a hunter as the golden eagle. Still other people object merely on the grounds that it is a bird of prey, which takes live food by killing other animals.

Biology

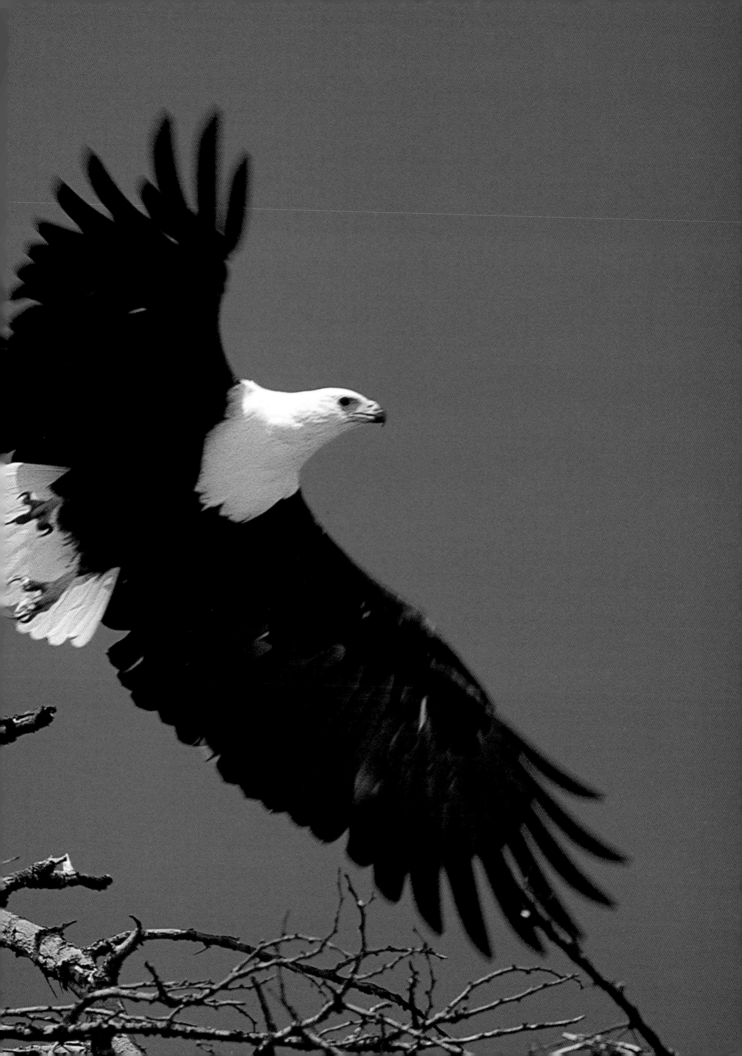

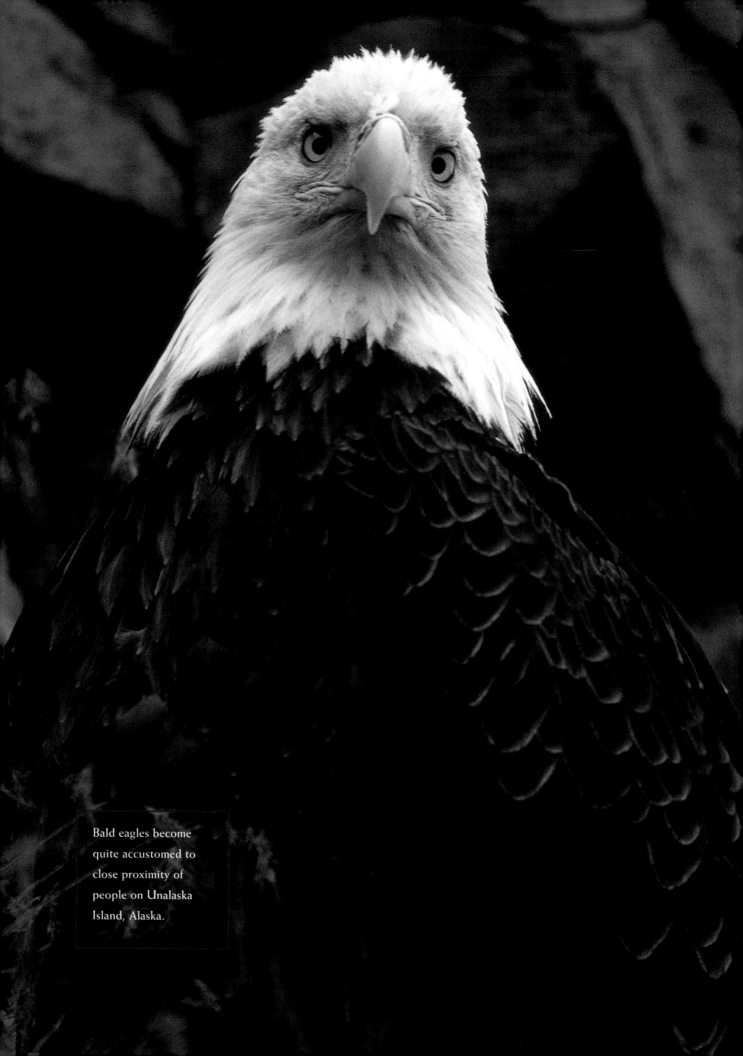

Bald eagles become quite accustomed to close proximity of people on Unalaska Island, Alaska.

Wings and Flight

The bald eagle depends on flight as its primary means of getting around and of warding off enemies. Birds of prey, especially eagles and condors, use a gliding or soaring flight the vast majority of time they are airborne. However, if it were not for air currents and updrafts, these birds would be hard-pressed to get airborne and stay airborne for long enough to locate adequate food.

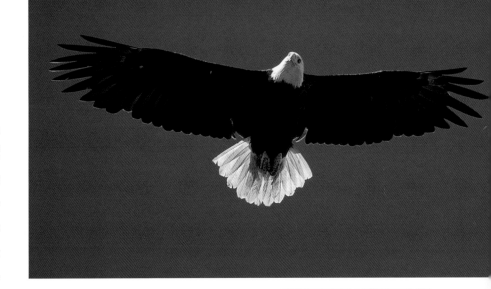

Photographs comparing the bald eagle (ABOVE: Southeast Alaska) with the African fish eagle (PAGES 58 AND 59: Lake Bogoria, Kenya).

It is now known how eagles use updrafts and other air currents to maintain or gain altitude. In perfectly still air, with no thermals and other updrafts, these large birds would have to use a flapping flight to become airborne and gain sufficient altitude for gliding. Flapping flight takes a tremendous amount of energy, and while an individual eagle certainly has the power and strength to do this, the great energy requirement would mean the bird would have to increase its food supply. In addition, migration would be extremely difficult, as the energy required to fly long distances over short periods of time would also demand a greatly increased food supply, which would be especially challenging in unfamiliar territory.

It is the wings and tail of the eagle that make its soaring and glid-

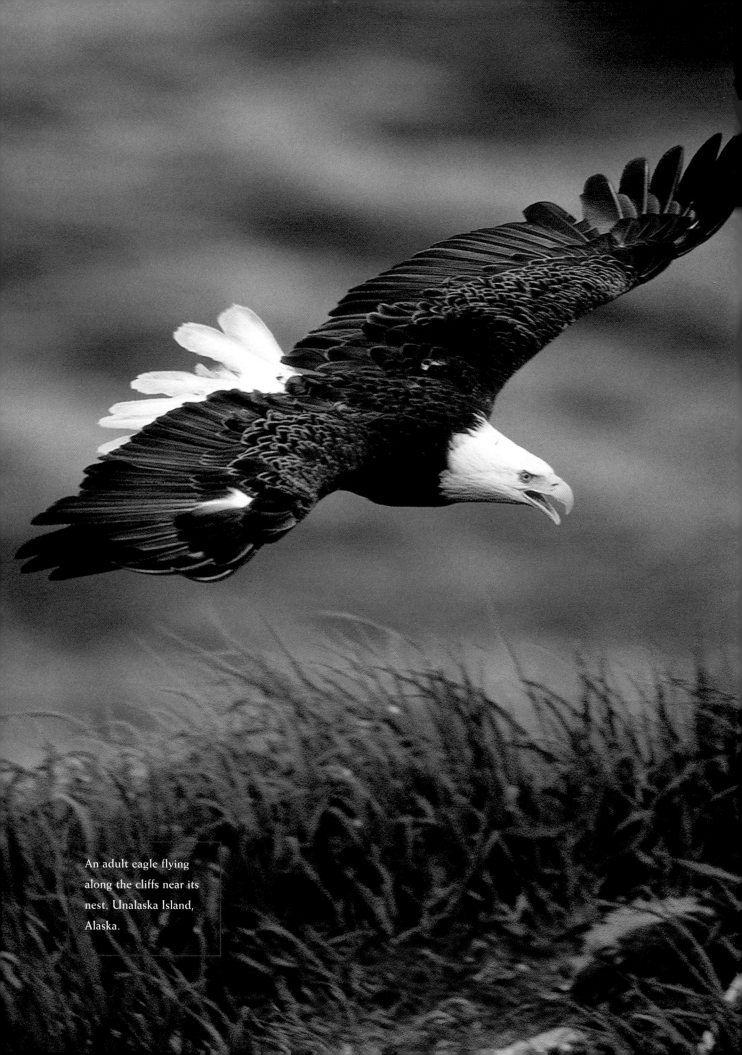

An adult eagle flying
along the cliffs near its
nest. Unalaska Island,
Alaska.

ing flight possible. The wings are relatively long and very broad. The "pri-
maries" are the wing feathers that are the main controls for flight, and they
provide the lift needed as well. In contrast, the twisting and turning of these
feathers help the eagle to brake and maneuver. It is always a magnificent

sight to see a slow-motion film of an
eagle in flight when coming in for a land-
ing or swooping down to snatch a fish
from a lake or stream. It is possible to see
how the eagle tilts and rotates individual
flight feathers to provide braking or to
redirect its flight. Even still pictures of
eagles in flight or landing show the dif-
ferent positions of the flight feathers.
One cannot help but be amazed at the
strength of the feathers, in particular the
follicle holding the feather, which must
sustain most of the air pressure. To real-
ize the extent of air pressure, one need
only take an eagle's primary flight feather
and wave it in the air or hold it out in a
strong wind.

Wing marks left in the
snow after an eagle
took flight. Chilkat
River Valley, Alaska.

The basic shape of the eagle's
wing is just like that of an airplane wing. This shape provides the necessary
lift for flight. The eagle's wing is covered by a layer of lightweight feathers
that, because of their positioning, help streamline the wing as long as the
air flow is coming from the front. As well as being light and strong, the
layer of feathers also traps air, thereby serving as good insulation and help-
ing to prevent excessive heat loss or gain.

The tail is also very important for flight and maneuvering in the
air. During soaring or gliding flight, the tail feathers are spread, thereby
maximizing the total surface area and increasing the effect of thermals and
updrafts. Once again, slow-motion films and close-up still pictures taken
during landings or aerial maneuverings show how the tail feathers and tail
position are used. The tail helps the bird brake when landing and assists in
stabilization when it attempts a controlled dive or swoop toward prey.

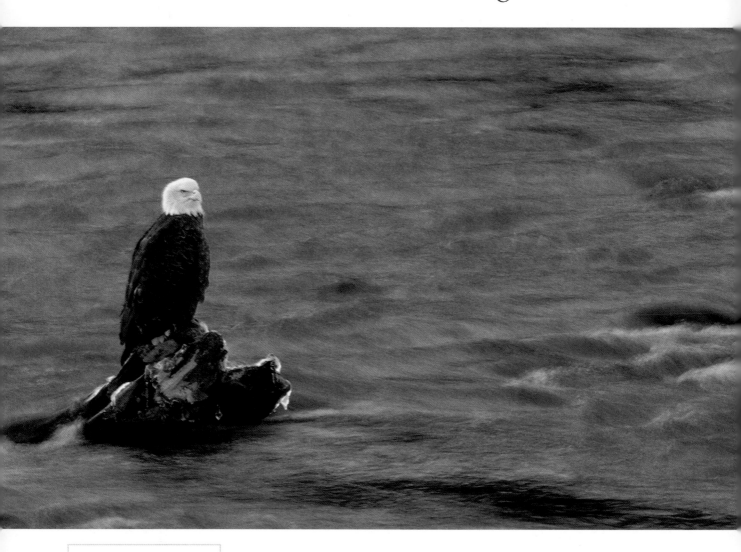

A bald eagle sitting on a log on the Fraser River. British Columbia, Canada.

Watching the tail tilt back and forth and up and down during such maneuvers can be an impressive experience. Again, not only the strength of the feathers but the strength of the follicles holding the feathers is quite striking.

It is not surprising that humans designed the airplane wing based on the structure of birds' wings, such as the eagle's. Even the internal structure of an airplane wing follows the makeup of birds' feathers and bones in order to provide the light weight and strength necessary to make flight possible and efficient. The interior of an airplane's wing has cross struts within a hollow shell, just like the lightweight bones of most birds.

Eagles are not the fastest fliers, even among the birds of prey; in fact, they are among the slowest fliers in the hawk family. However, they make up for their lack of speed with their power and their ability to soar and glide

for hours on end. An eagle can become airborne in the early morning and not land or rest for the entire day. Most faster and more agile fliers must rest periodically, as they are far less efficient in their use of energy.

Feathers

Eagle feathers, like almost all bird feathers, have unique features. They are lightweight yet extremely strong, hollow yet highly resilient. Trapping layers of air, they serve as a great insulator from environmental conditions. Generally we think of feathers as providing insulation from the cold, but they also can offer protection from the heat of the sun. This idea may, on first thought, seem odd when you consider that eagles can often be seen sunning themselves on a cold morning to gain some warmth. Why would

Bald eagles congregate on the beach along Homer Spit, Alaska.

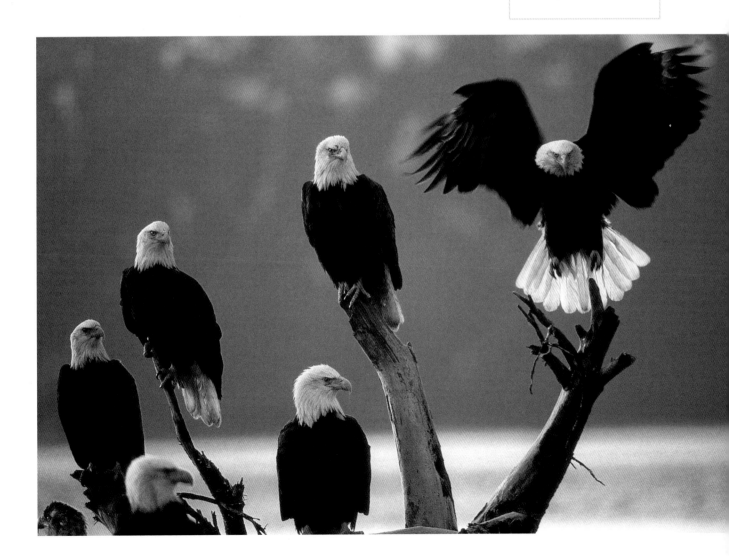

A bald eagle portrait.
Anan Creek, Southeast
Alaska.

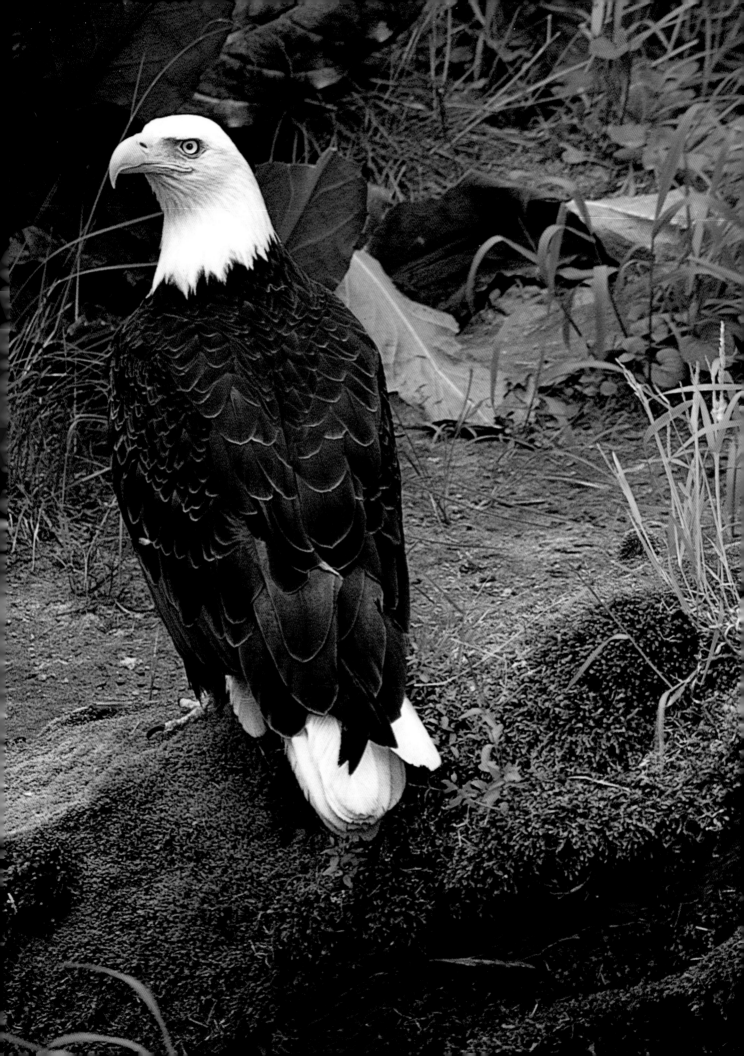

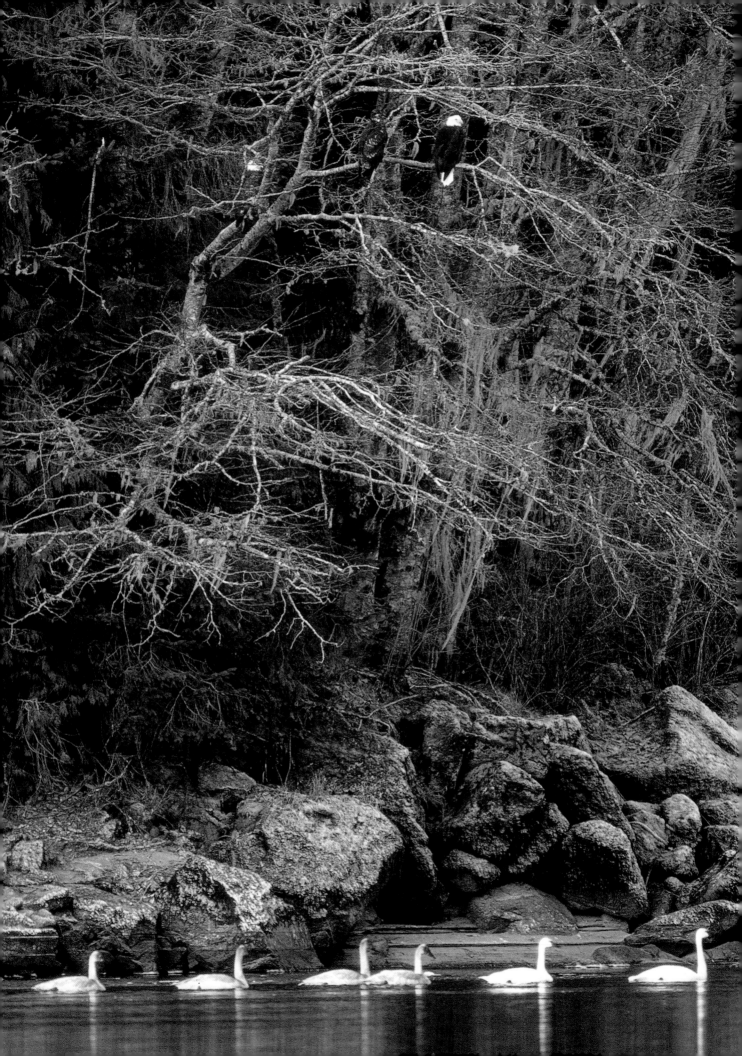

they need to do this if the feathers are such great insulators? The answer is quite simple. When an eagle suns itself on a cold morning, it ruffles and rotates its feathers so that the air pockets are either opened to the air or contracted to reduce the insulating effect. It is possible to see just how this works by putting on a down-filled coat. When the coat is zipped up, your body heats the air inside the coat and the down prevents loss of that heat until the coat is opened. If the coat is a dark color, on a sunny day it will absorb much of the sun's heat. However, the down and its layers of trapped air greatly slow this transmission of heat inward toward the body. If the coat is unzipped, cooler air is allowed to come inside, while the coat's surface absorbs the heat and keeps it away from the body. By allowing an exchange of air inside the coat, the wearer thereby remains cooler than if he or she were not wearing the coat. The eagle uses the same principle to maintain its body temperature simply by changing the position of its feathers.

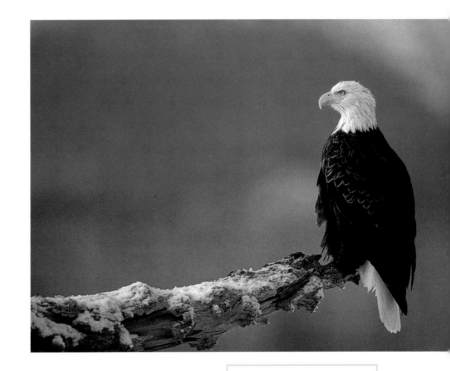

Feather structure is a major factor that makes this flexibility possible. Overlapping feathers can form as solid a covering as any manufactured material, which the birds can open or close at any time they want. Additionally, the eagle has several layers of feathers, each of which serves a different function. Under the outer layer or covering of feathers is a layer of down or other smaller feathers. The interlocking design of birds' feathers is an engineering marvel that even human beings cannot duplicate.

It is the feathers that make it possible for eagles to live in extremely cold environments. This means they do not have to migrate to the tropics each year to fulfill temperature requirements. Thus, eagle migration is related far more to available food supply and far less to extremes in temperature.

ABOVE: A bald eagle perched on a log. Chilkat River, Alaska.

OPPOSITE: Trumpeter swans float under the watchful gaze of three bald eagles. Squamish River, British Columbia.

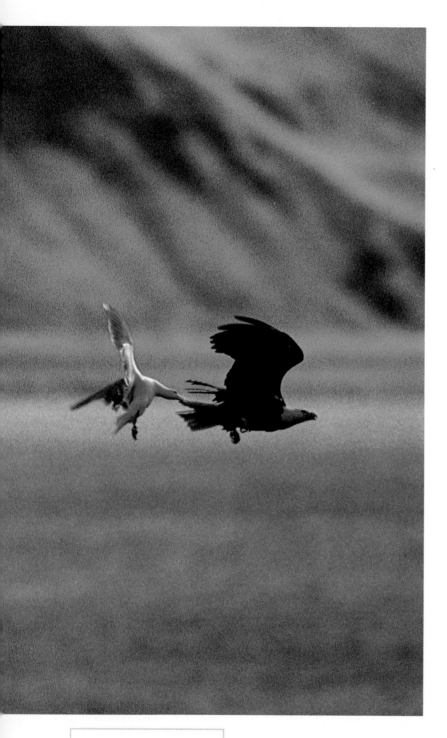

An eagle harassed by a gull. Unalaska Island, Alaska.

Bald eagles, like all birds, depend on their feathers for a variety of purposes. In addition to providing insulation from either heat or cold (even though eagles do not have the quantity of down feathers that ducks, geese, and swans have), the wonderful covering of feathers provides waterproofing and protection. At the same time, the feathers are crucial for flight.

It is not hard to understand why North American Indians incorporated the eagle's primaries and tail feathers into their ceremonies and legends. A lone feather was believed to convey great power.

Respiratory System

Eagles, like most other birds, have an efficient respiratory system that starts with the external nares opening on either side of the bill. But the oval nares opening of the eagle is not as adapted as that of falcons like the peregrine, with its special rod structure that allows sufficient breathing even in power dives of over 150 miles per hour. The eagle does not need such special adaptations, as it never reaches speeds that would interfere with normal breathing. The eagle's lungs and air sac system is efficient for its size. Air moves in through the lungs and on into the air sacs before moving back through the lungs and out again. This means the air passes through the lungs twice with each breathing cycle—double that of mammals.

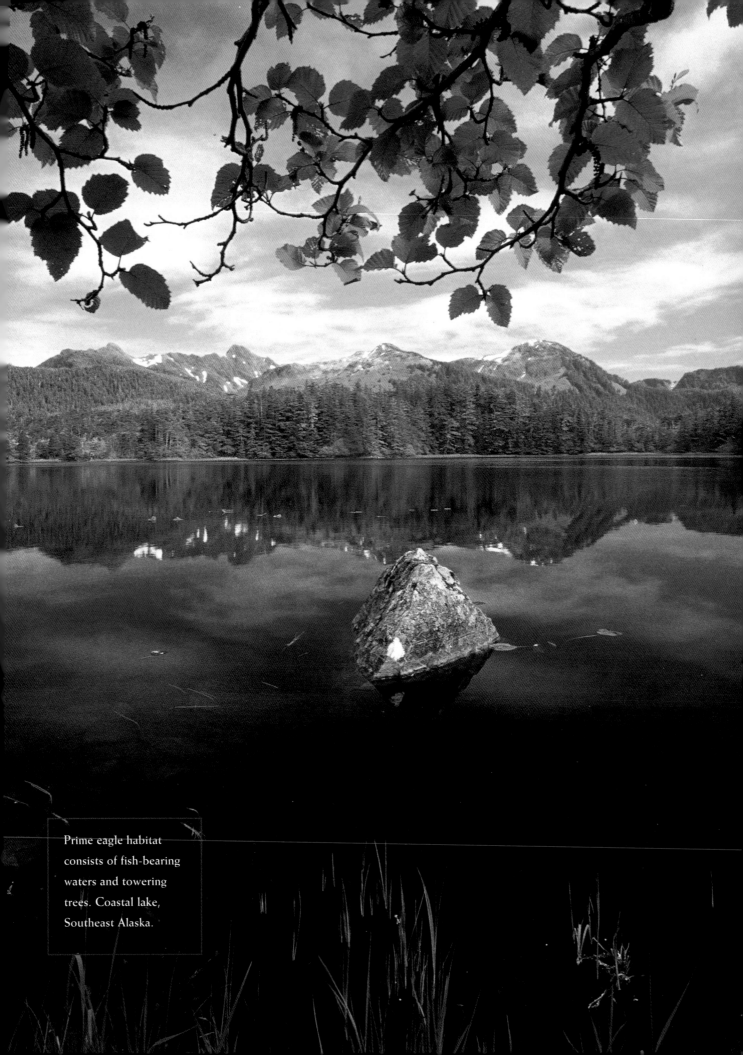

Prime eagle habitat consists of fish-bearing waters and towering trees. Coastal lake, Southeast Alaska.

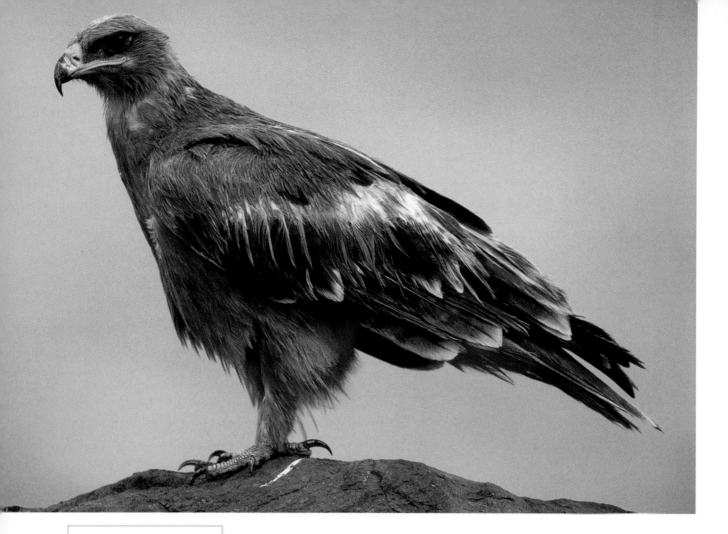

An African tawny eagle portrait. Rift Valley Region, Kenya.

Skeleton

Eagles need a very strong skeletal system to allow them to attack and tear apart their prey, as well as to be able to fly and carry off prey. At the same time, the skeleton must be as light as possible to make efficient flight possible. Hollow bones make it possible to have both strength and light weight. Everyone is aware of how light feathers are, but few people realize that the total weight of an eagle's skeleton is less than the weight of its feathers. In fact, the total weight of an eagle would greatly surprise most people. Here is a bird that appears to be at least five to ten times the size of a chicken, but it weighs only about twice what a chicken weighs.

Eagles have a basic skeleton similar to most other birds of prey. The most obvious feature is a strong keel, where the heavy breast muscles needed for flight are attached. The hollow, long bones of the wings provide strong but light support for the wings. The short, stout bones of the legs are attached to and support the bird's large and powerful talons. The talons are heavy, slightly curved toenails used to capture prey.

Before you can understand the anatomy of a bird's leg and foot, it is important to realize that birds have similar bone structures to mammals, including humans, with an upper thigh section and a lower calf section. However, most people mistake the next section of leg for the calf; in birds, the foot is elongated and divided into two sections, the upper portion looking like another section of the leg and the lower section looking like (and is) the foot, or at least half of it. The extra section of leg is really the portion of the foot from the heel to just before the toes. The talons of an eagle are, therefore, equivalent to the toes and associated joints on our feet. Once a bird's leg is considered with these facts in mind, the knee does not appear to bend the wrong way, since it is really the heel and not the knee.

One of the most obvious and striking features of an eagle is its large and powerful bill. The heavy yellow bill of the adult bald eagle distinguishes it from most other birds of prey, and it is this heavy bill that enables the eagle to tear apart its prey.

Yet another interesting feature of the eagle is the bones around the bird's very large eyes. These bones, present in many other bird species as well, are important for supporting the eagle's large eyes and their movement in the skull.

Eagle tracks in snow.
Chilkat River Valley,
Alaska.

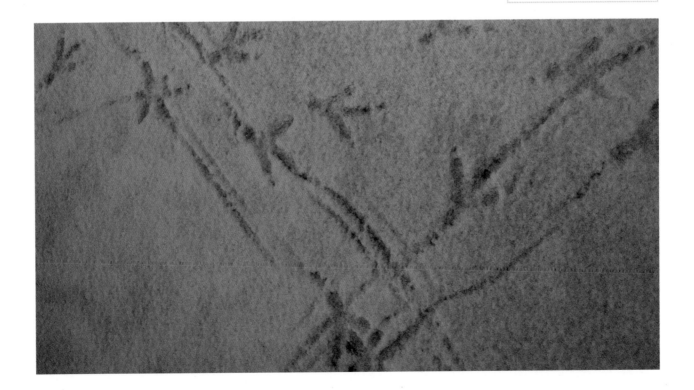

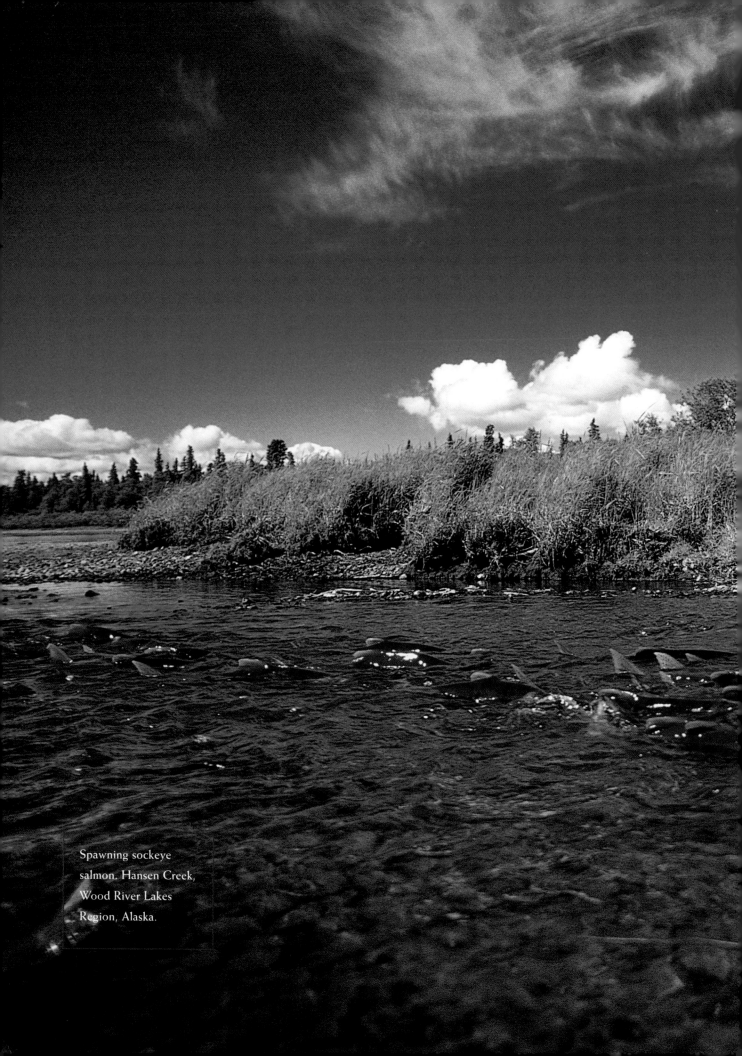

Spawning sockeye
salmon. Hansen Creek,
Wood River Lakes
Region, Alaska.

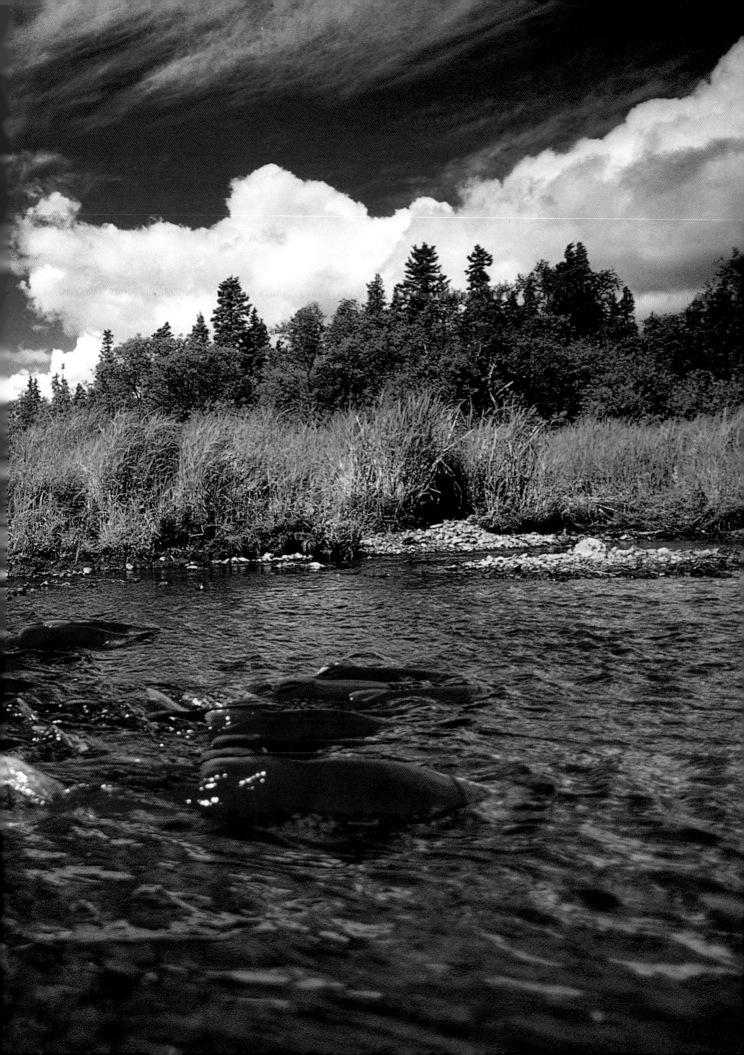

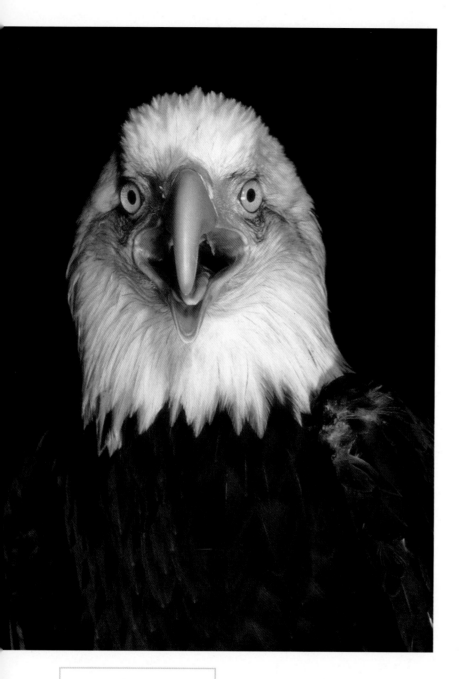

Eyes

All eagles are noted for their great eyesight, and the bald eagle is no exception. They have two foveae, or centers of focus, that allow the birds to see both forward and to the side at the same time. Bald eagles are capable of seeing and recognizing prey, such as fish, from several hundred feet above the water, while the eagle is soaring, gliding, or in flapping flight. Imagine just how difficult this must be, since most fish are counter-shaded, meaning they are darker on top and thus harder to see from above. Fishermen can attest to how difficult it is to see a fish just beneath the surface of the water from even only twenty or thirty feet away. Seeing a fish below the surface from a shoreline perch of fifty or one hundred feet above the water, or while flying hundreds of feet in the air, is a feat certainly the envy of any fisherman.

ABOVE AND OPPOSITE: A portrait comparison showing the eye membrane, a protective feature utilized, for example, when clutching prey. Washington.

Bald eagles, especially young ones, have been known to make mistakes with this, though, attacking objects like plastic bottles floating on or just below the surface of the water. Studies have shown that bald eagles will locate and catch dead fish much more rapidly and efficiently than live fish. This is presumably because dead fish float with their light underside up, making them more visible. This also helps explain why the birds often eat carrion; they probably do not prefer it per se, but find it far easier to locate and catch.

Bald eagles take other kinds of prey, too, especially in inland areas. Coots, ducks, and other waterbirds are commonly taken during the winter, when fish are harder to locate. These birds are generally much easier to find than are fish, but they are usually much harder to catch. Similarly, rabbits and other small mammals are difficult to see unless they are moving. While an eagle can see from a great distance, bald eagles, like most birds of prey, locate mammalian prey by spotting movement. Once the bird detects movement, it is then able to concentrate on the object in order to determine if it is suitable prey. Hence the reason that many prey species freeze in place when they detect a predator. Eagles do not generally catch mice or other small rodents, as do many of the smaller hawks. Since they do not need to concentrate on preying on these small rodents, the bald eagle tends to fly much higher than other smaller birds.

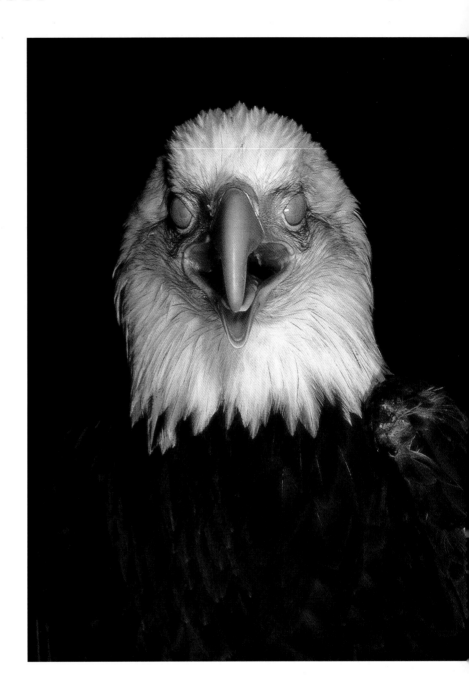

Hearing

While eagles are not noted for their hearing, this does not mean that they have poor hearing. Diurnal birds of prey like hawks and eagles have good hearing and use it to locate prey or other birds, but the acuity is not as crucial as in some owls, which can locate prey in the dark by only their sound.

Longevity

How long do eagles live?

This is a commonly asked question, but there is no simple and correct answer. Eagles in captivity have lived for forty to fifty years. Yet in the wild it is unlikely that they will live much beyond twenty years, if they even make it that long. Few studies provide much information on the longevity of the eagles in their natural environments, so this variance cannot be fully explained.

Young eagles in their first year have the highest mortality rate, and with each passing year the mortality rate declines until somewhere around ten to fifteen years of age, when the mortality rate starts to increase again. No long-term studies have concentrated on the life span of bald eagles. However, long-term studies have been done on crowned eagles, which live in South America, and results indicate there is generally a change of mates at nests every six or seven years, which would indicate a normal life span of twelve to fifteen years for this species. Presumably the life span of other large eagles may be similar.

Mate Fidelity

Eagles are frequently claimed to be among the birds that maintain fidelity to a single mate for life. While it is generally true that eagles probably maintain mate fidelity for as long as both mates are alive, they do not languish over the loss of a mate. Nests are usually occupied again within a year after the loss of one member of a pair. Clearly the surviving mate almost immediately begins looking for a new partner.

The fact that the surviving member of a pair is able to locate a new mate so soon indicates that there must be a number of unpaired birds waiting for a mate at any one point in time. There are indications that occasionally, if a newly formed bald eagle pair is not successful, they may change mates before the next nesting season. But once a pair is successful nesting, it is unlikely that the pair will split up until one member of the pair dies.

OPPOSITE: Bald eagles guard their nest during winter months. Chilkat River Valley, Alaska.

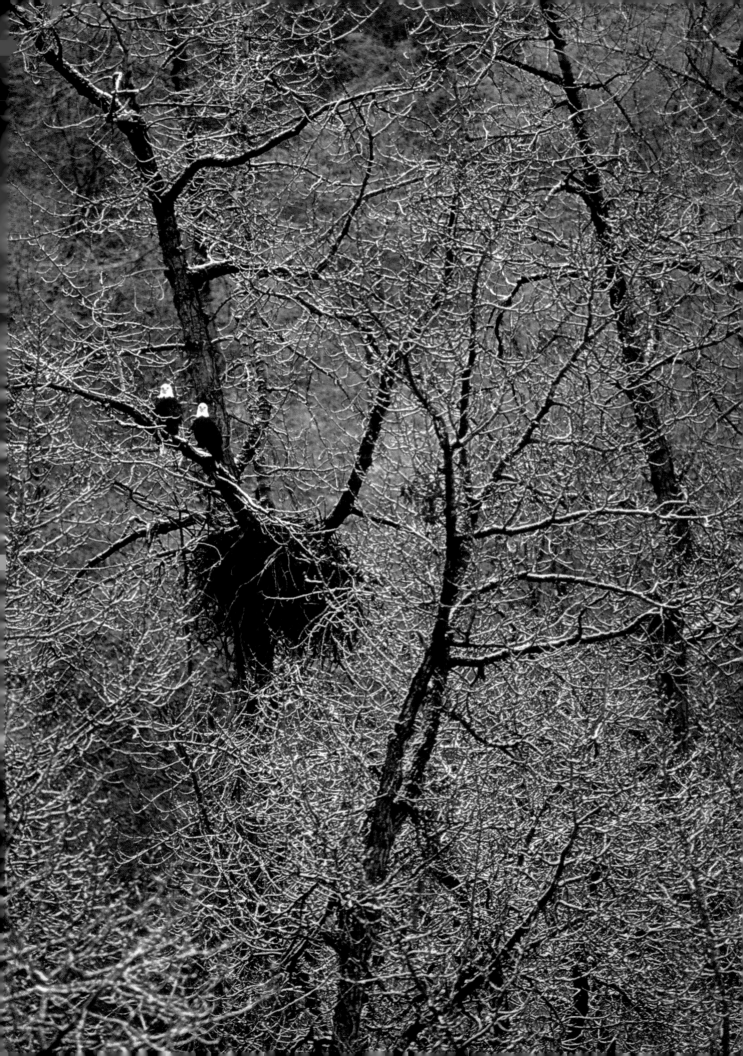

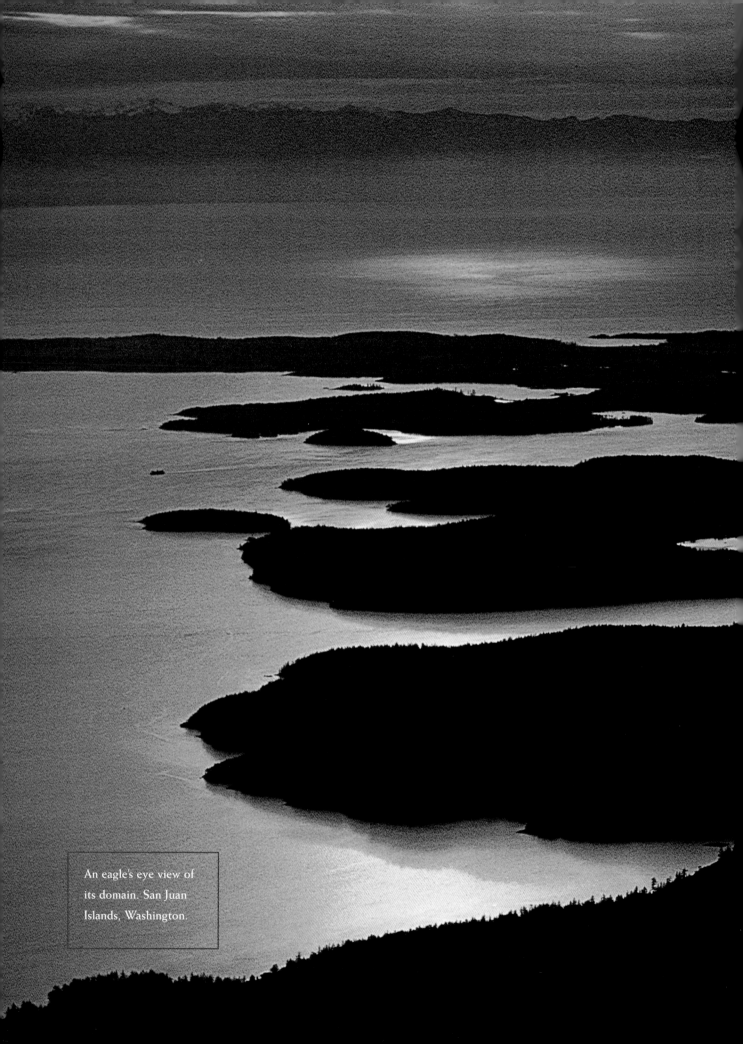

An eagle's eye view of
its domain. San Juan
Islands, Washington.

6

Behavior

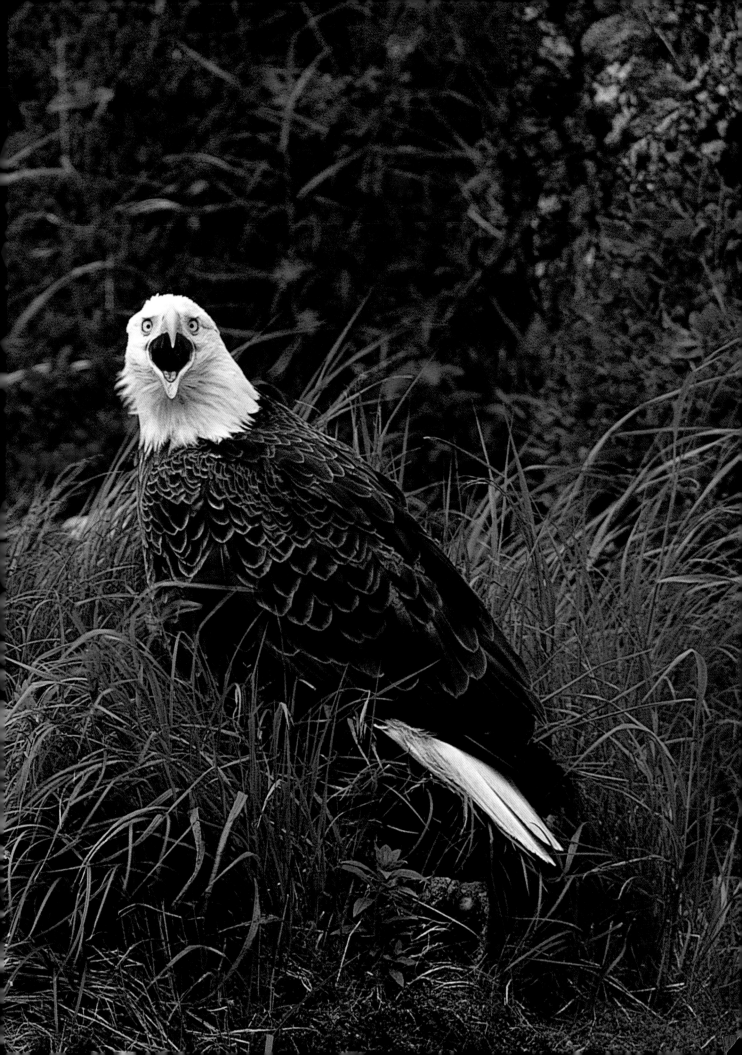

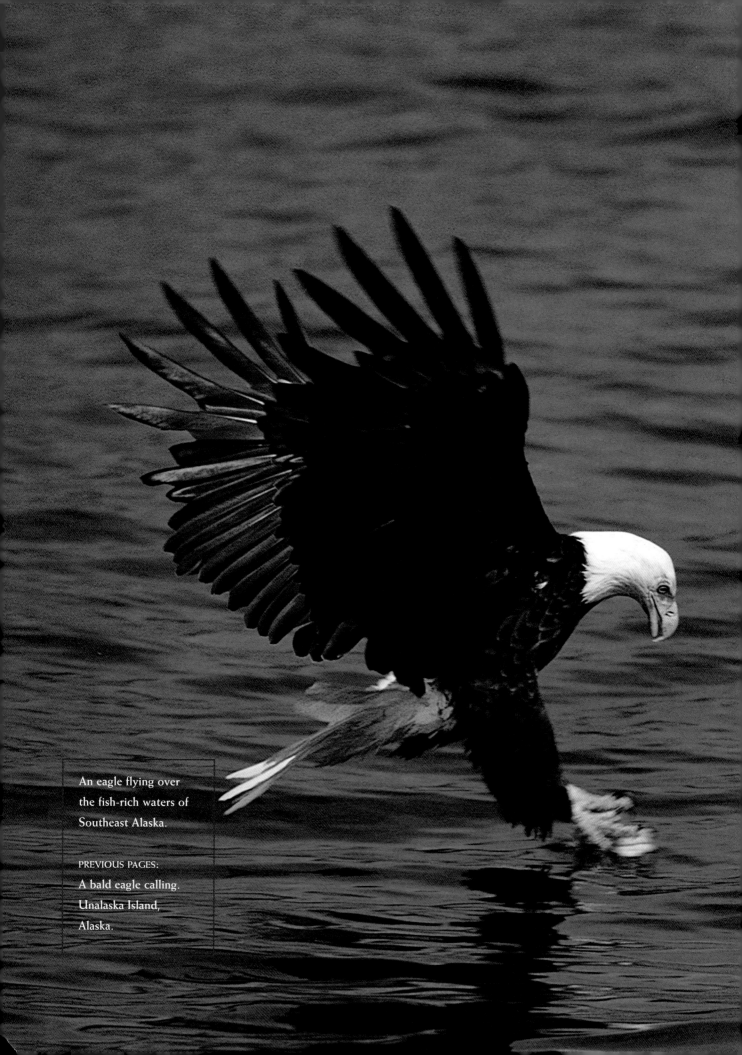

An eagle flying over
the fish-rich waters of
Southeast Alaska.

PREVIOUS PAGES:
A bald eagle calling.
Unalaska Island,
Alaska.

Hunting

Eagles have long been noted for their hunting skills and power. The most common image is that of an eagle like the golden, which swoops from the sky to capture a rabbit or other small animal in its talons. But the most spectacular hunter among

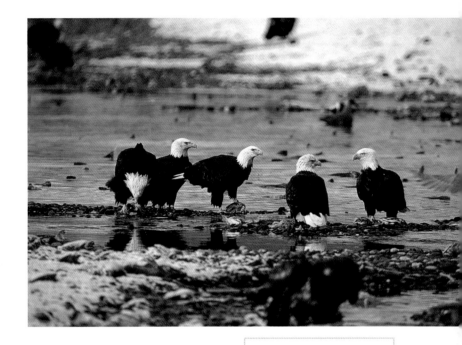

Bald eagles feeding on salmon. Chilkat River, Alaska.

the birds of prey might be that of the monkey-eating eagle in the Philippines or a harpy eagle in Central and South America. Both of these large eagles regularly feed on primates. The sight of these birds swooping from the sky to seize a monkey from high in a tree has probably helped give rise to the stories of eagles attacking children.

While there are many stories of eagles carrying off young lambs, calves, and pigs, it seems unlikely if not impossible for the bald eagle. Even if a bald eagle was successful in killing one of these animals, it is unlikely it would be able to carry off the carcass. (Golden eagles would be much more likely candidates, but generally the young domestic animals would also be too large for even the golden eagle to carry away.) Bald eagles simply do not have the power or hunting skills to capture and carry off anything weighing more than three pounds. Field observations have shown that the bald eagle has serious problems trying to carry prey as heavy as

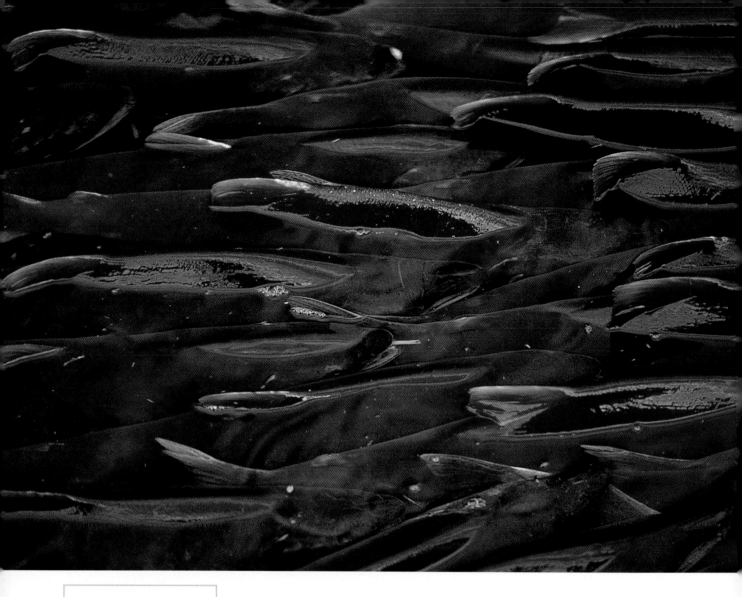

Spawning sockeye
salmon. Hansen Creek,
Wood River Lakes
Region, Alaska.

four pounds. For example, an adult southern bald eagle could not lift off from the water once it had captured a double-crested cormorant in Florida. An adult northern bald eagle in Alaska was seen struggling to carry a cormorant to some low rocks protruding from a lake because it apparently could not gain sufficient altitude to reach its feeding perch.

The bald eagle as a breeding adult in most of its range feeds mainly on fish. During the winter, when fish are much harder to come by, many adult eagles capture ducks and coots. Coots under attack by an eagle cluster together to confuse the eagle. Frequently the eagle must attack many times until one coot breaks away from the group and then becomes easier prey. The same tactic of multiple attacks has been seen with ducks ranging in size from teals to mallards. Rabbits and other small mammals are also taken in the western mountain states, where the fish supply is much more limited in the winter. Eagles that manage to kill larger prey like

rabbits often feed on the ground, since rabbits frequently are near the weight limit of what an eagle can carry off.

Studies have shown that young eagles spend much more time soaring in search of food than do adult eagles and tend to eat a higher portion of carrion. This is probably because young birds develop their hunting abilities only over several years, yet must have food while they perfect their skills. In Alaska, fully three-fourths of the eagles seen feeding on whale and sea lion carcasses were juveniles, while they make up less than one-third of the local eagle population. Additionally, well over half of the eagles observed soaring were juveniles.

After a long absence, bald eagles can once again be seen feeding on deer and other animal carcasses in New York's Adirondack Mountains. While this has not been uncommon in the mountain valleys of the Rockies and Cascades, it had been unusual until relatively recently to even see a bald eagle in the Northeast.

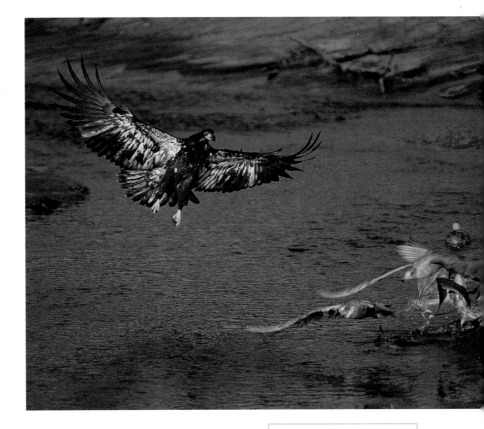

During the fall and winter, there are spectacular sightings of bald eagles throughout the Northwest, from Oregon and Washington north through British Columbia to southeast Alaska. Bald eagles congregate along streams during salmon runs. Indeed, there are few scenes in nature that can compare to the hundreds of eagles lined up along a stream, feeding, fishing, and simply sitting among large numbers of Kodiak bears. Roger Tory Peterson tells of counting more than 190 bald eagles leaving a roost one winter morning near Klamath Falls, Oregon, in an area where more than six hundred eagles spend the winter. Even these numbers are small, though, compared to how

An immature bald eagle landing at Fraser River, British Columbia, Canada.

many eagles can be found near the Chilkat River in Southeast Alaska, where several thousand gather seasonally. Where there is not such an abundant supply of food seasonally, concentrations of eagles are rare.

A fishing eagle can be quite a sight to see. The eagle sits on top of a dead tree overlooking a body of water. The bird watches carefully, then suddenly launches itself into the air with several strong wing beats and begins a swooping glide down toward the water as it builds up speed. When the bird nears the water, it extends its legs and opens its talons wide. Then soaring just over the surface of the water, the eagle suddenly drops slightly, plunging its legs into the water. If the attack is successful, the open talons strike a fish and close instantly, the back talon driving into the side of the fish and the others encircling it. Now the eagle must beat its wings strongly to pull the fish from the water and to maintain sufficient speed to remain airborne. The wings often hit the water's surface on one or two of these strong beats.

Using this technique, the bald eagle can carry off a fish weighing a couple of pounds. However, if the fish is too big or the bird has misjudged its speed and power, the eagle can end up in the water. If the prey is too large and powerful, the eagle can be dragged underwater and drowned. It seems that all the eagle need do is release its prey and fly away, but the structure and nature of the talons can prevent this.

Eagles, like many other birds of prey, have a special locking mechanism for their talons. The bird physically opens up its talons when it prepares to attack prey. The bird attacks by extending its legs and talons as it approaches prey from the air. Within fractions of a second after the talons hit the prey, the foot and thus the talons close, driving the talons deep into the flesh of the prey. Once this occurs, the talons cannot be opened again until the bird pushes down on the feet against some solid object, such as the ground. This locking mechanism helps prevent birds of prey from losing their grip on the prey. It's a great advantage for any bird of prey, especially when the bird is having difficulty capturing enough food for itself or its offspring, by reducing the chance that any one prey will escape. Prey generally can't escape unless they pull free from the talons, which generally means being badly torn.

Osprey can also have this release problem if they capture too large a fish. But osprey use a different hunting style and generally dive into the

OPPOSITE: Black bears share habitat and food resources with bald eagles, which sometimes scavenge the remains of bear catches. Anan Creek, Southeast Alaska.

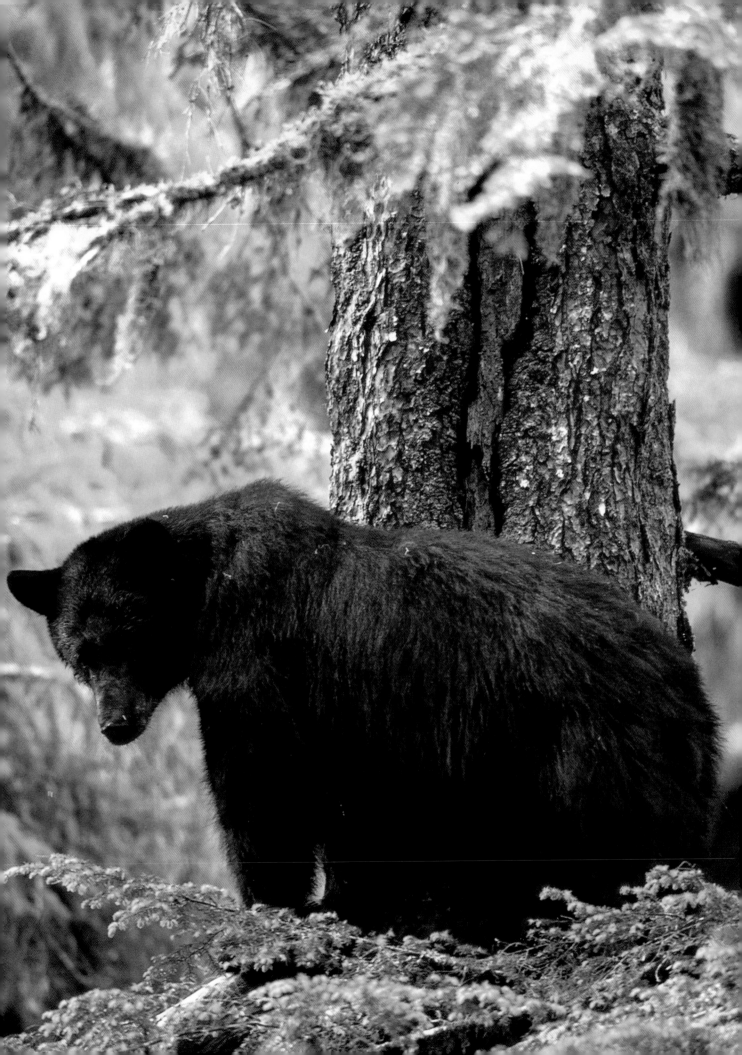

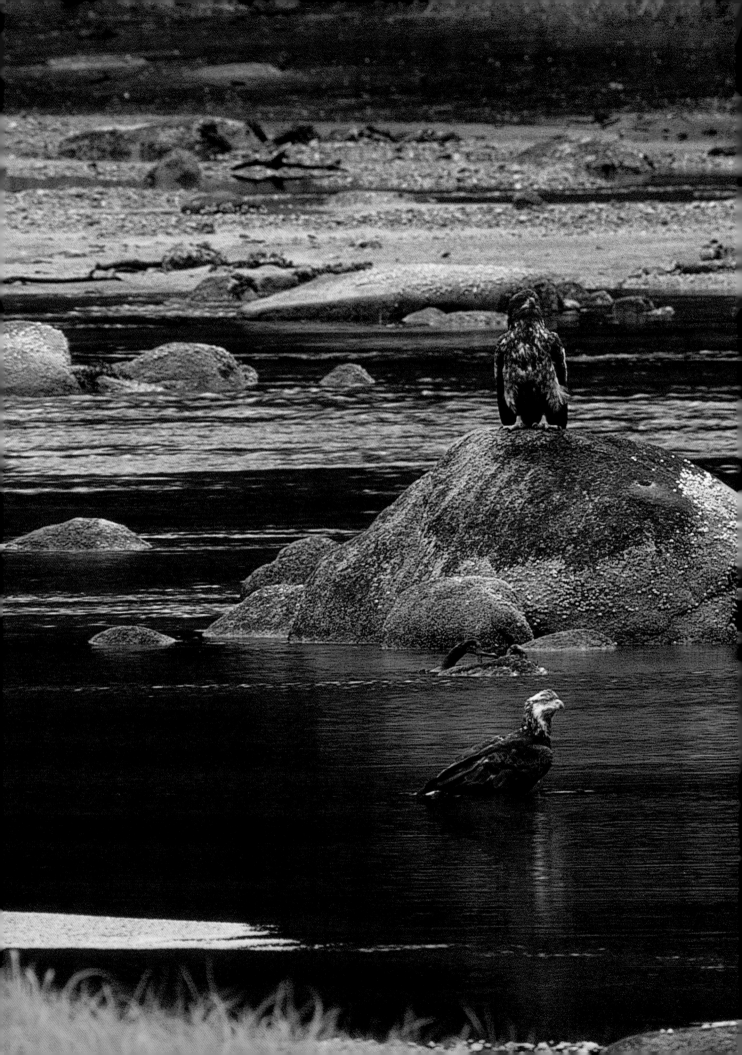

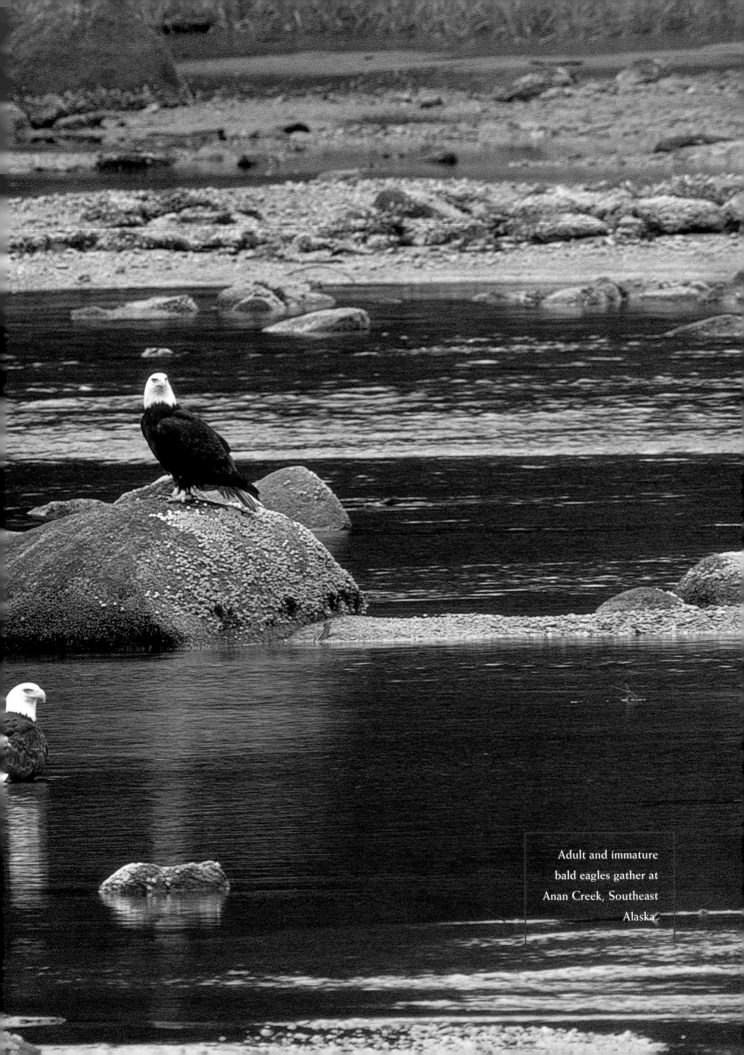

Adult and immature
bald eagles gather at
Anan Creek, Southeast
Alaska.

water much more frequently than bald eagles do. Actually, the osprey sometimes is the victim of the bald eagle's "stealing habits." Stories of bald eagles' taking fish from osprey date back to Benjamin Franklin's time and explain why he didn't want the bald eagle as the country's national emblem. Bald eagles often take fish from osprey in midflight. One of the most impressive stories describes an eagle's attack on an osprey from above. The eagle dove onto the osprey, hitting it with its body and slowing its flight. The osprey refused to release its prey and continued flying off. The eagle flapped mightily to regain height and once again entered a power dive at the osprey. This time as it swooped past the

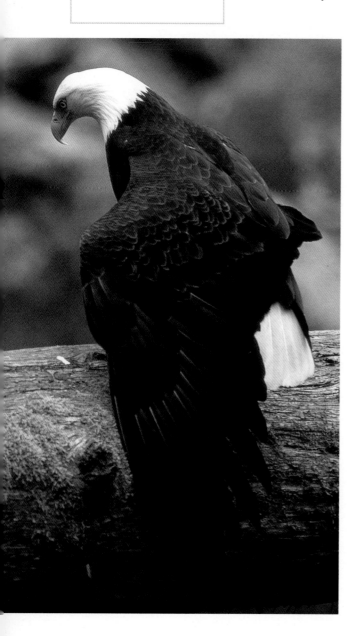

A bald eagle stretches its wing. Anan Creek, Southeast Alaska.

osprey, the eagle twisted around upside down, and as it passed directly under the osprey, it extended its talons to grab the fish held by the osprey. Then, owing to its larger size and greater momentum, the eagle literally ripped the fish right out of the osprey's talons. While one could call the eagle a thief, this description explains why bald eagles generally drive osprey out of their territory.

How much time do eagles spend hunting each day? This may seem like an easy question, but few studies have been able to follow the birds throughout the day and therefore most information comes from combining separate observations of different birds at different times of the day and year. All of these factors, along with whether the bird is very hungry, help determine the time and method of hunting. Observations show that most hungry eagles begin hunting early in the morning. If the air is dry, an eagle may start hunting as soon as the sun comes up. For bald eagles, hunting can consist of sitting on a favorite perch, carefully scanning the water below. However, if the bird is very hungry, it may catch thermals to soar high over the water in search of prey. An eagle may soar over a body of water many times in search of prey. Bald eagles generally hunt

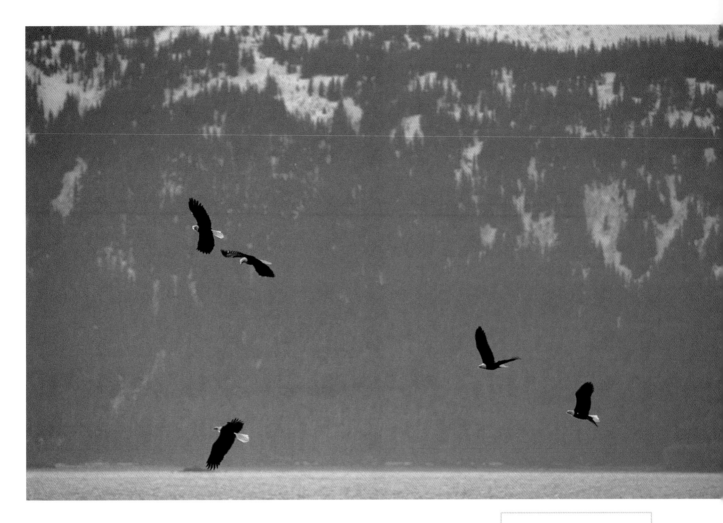

Bald eagles flying over
inlet. Homer Spit,
Alaska.

along the side of a lake opposite the wind, where they can spot any dead
or dying fish. They generally don't use a great amount of flapping flight
during hunting, but use it only to get airborne or after capturing prey.
Also, bald eagles do not travel far when hunting if they are along a river or
lake with an abundant fish supply. This hunting behavior makes good
sense when one realizes that the birds are looking for the maximum
amount of food with the minimal amount of effort, and anything dead or
dying will float to the surface and be blown across the lake to be found
floating near the shore. It is for this reason that bald eagles do most of
their hunting where they expect to find most of the easy prey or carrion.

Generally, prey taken by bald eagles weighs less than half the
weight of the eagle. An adult eagle needs between one-half and three-
quarters of a pound of food each day, unless it is nesting and rearing young,
when it needs additional food in order to feed its young. This means that if

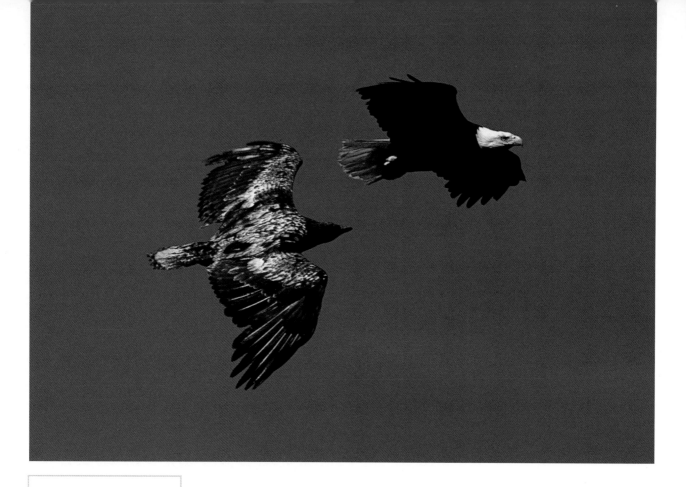

Immature and adult
eagles in aerial display.
Washington.

an eagle kills prey weighing three pounds, the pair will have sufficient food for a couple of days.

A bald eagle can consume a one-pound fish in as little as four minutes. The eagle will usually hold down the carcass with one talon, hold on to its perch with the other talon, and then tear off one large bit after another with its powerful bill. The bill and neck muscles of the bald eagle are specially adapted to allow the bird to quickly gorge itself. Eagles can easily gorge themselves on one or two pounds of food when it is available, and then they don't need to eat again for a couple of days. While this type of feeding by gorging and fasting is probably more common in the golden eagle, it does apply to bald eagles as well. Bald eagles in Alaska gorge themselves for days on salmon when the fish are spawning, then the birds may have to wait out bad weather or wait until the next salmon run before there's another bountiful supply of food.

Gorging also means that the eagle does not have to spend as much time at a carcass as do most other scavengers, which is fortunate for the eagle, because it is while the eagle is on the ground that it is most vulnerable to predators. Because the eagle cannot get airborne nearly as quickly as most other birds, it is most vulnerable any time it is on the ground.

Courtship and Mating

Courtship by eagles can be seen at the nest and in spectacular aerial displays. Sometimes the pair will appear to attack each other in flight, high above the ground. Walt Whitman, in his "The Dalliance of the Eagles," describes one of these aerial displays:

Skirting the river road, (my forenoon wall, my rest,)
Skyward in air a sudden muffled sound, the dalliance of the eagles,
The rushing amorous contact high in space together,
The clinching interlocking claws, a living, fierce, gyrating wheel,
Four beating wings, two beaks, a swirling mass tight grappling,
In tumbling turning clustering loops, straight downward falling,
Till o'er the river pois'd, the twain yet one, a moment's lull,
A motionless still balance in the air, then parting,
* talons loosing,*
Upward again on slow-firm pinions slanting, their
* separate diverse flight,*
She hers, he his, pursuing.

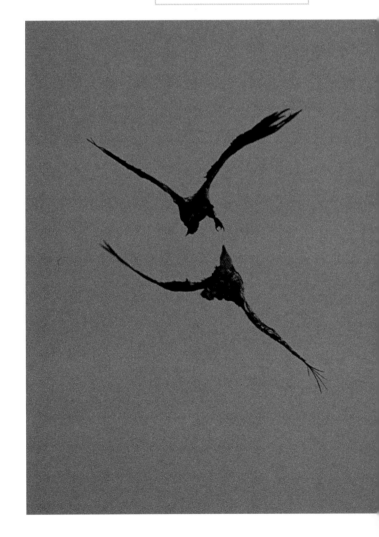

Two eagles perform an aerial display of courtship or aggression. Unalaska Island, Alaska.

But is what Walt Whitman described truly a courtship display or is it a territorial defense? Based on studies in Africa, researchers have suggested that these cartwheeling flights are more frequently associated with territorial defense. From more than 107 detailed observations of 39 species of birds of prey, researchers claim that over 80 percent of all cases appear to be those of aggressive behavior between a territorial bird and an intruder. According to the study, "Some of these observations even involved the snatching of food during the process. Other observations were between a parent and offspring, but even these appear to be aggressive in nature." Researchers Rob Simmons and John Mendelsohn go on to explain:

Cartwheeling also occurs in different contexts as part of play behavior in peregrine falcons and booted eagles. It has been reported on a few occasions that cartwheeling occurs during courtship activities. Courtship flights do occur regularly, which may involve diving at each other and turning and touching talons in midair; however, this rarely leads into full cartwheeling flight as it does often in aggressive encounters.

These observations are interesting but not surprising, since many courtship components in bird behavior have evolved from aggressive behavior. In fact, many aggressive displays directed at nonmates can become courtship displays when directed at a mate. Frequently the display change is very subtle when switching from aggression to courtship. As a result, it makes sense that these aggressive encounters have occasionally been modified as part of a pair courtship display, even though the majority of such encounters are purely aggressive in nature.

Most courtship occurs early in the season. For northern birds, this means when the lakes are still frozen and when even the staunchest eagle observer will have a difficult time in the field. As a result, details of mating behavior were not well documented until researchers at Patuxent Wildlife Research Center in Maryland were able to observe a series of breeding pairs of eagles. Their results confirm the few observations that had been made from blinds in the wild over the last thirty to fifty years.

Since the female eagle is larger than the male, there have been cases among captive birds of females having killed males. Males, therefore, must be very careful in approaching their mates, which quite possibly explains the observation that females often initiate courtship and mating. The birds approach each other usually at nest sites. The female bows her head slightly, spreads her legs wide apart, and lowers her body and tail. The male carefully advances toward the female, raising his tail. As the female utters a single-note call, the male clenches his talons, thus avoiding accidental injury to the female. He then tries to step up onto the female's back. Once on the female's back, the male lowers his tail and cloaca (the common opening of both the reproductive and digestive systems) to meet

OPPOSITE: A typical nest site along the inland waterways of Frederick Sound, Southeast Alaska. The giant Sitka spruce offers strong limbs to hold the enormous eagle nests.

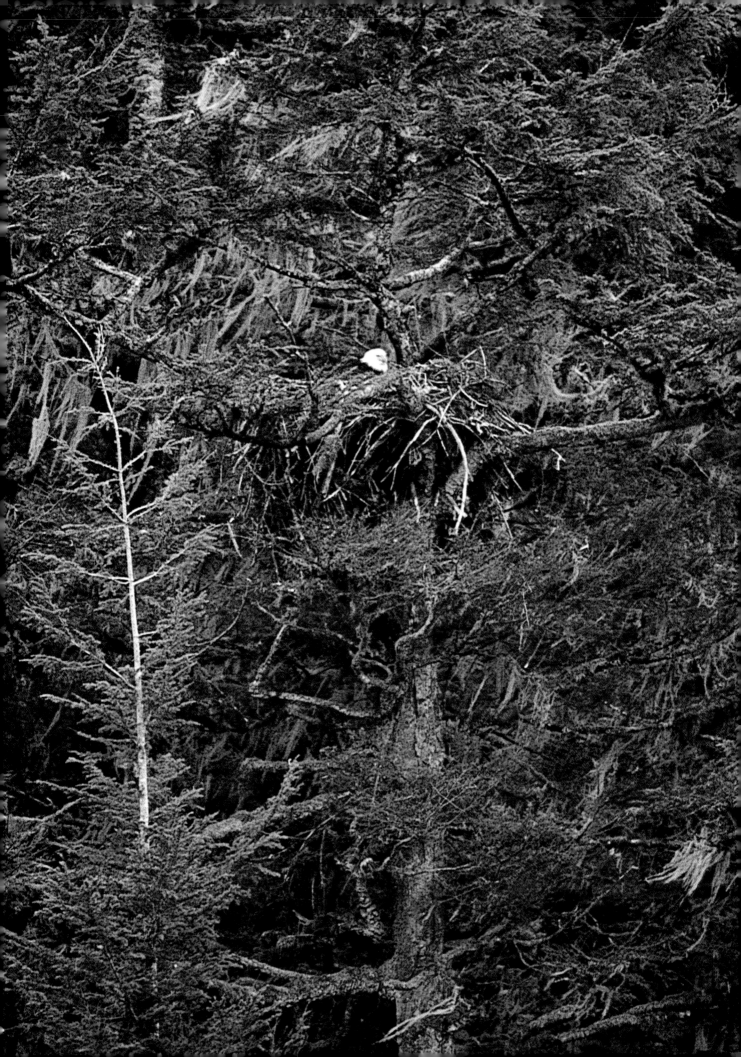

the female's as she raises her tail and cloaca. Semen is passed from the male's cloaca to the female's. The male steps off and both birds stand up, ruffle their feathers, and usually do a simultaneous call.

During the winter there are seldom any signs of courtship mating, but beginning in late winter the frequency increases, until reaching a peak in early spring. Copulations occur frequently during the short breeding season just before eggs are laid, but once eggs are laid, matings are much less common and stop completely once the chicks are being reared.

Nesting

Across North America, the bald eagle is considered to be adaptable in the selection of nest sites. That is, it is capable of living in a wide variety of environments. Individual pairs have been known to nest on top of a large cactus in Baja California, on a large rock in the middle of a Saskatchewan river rapids, on a grassy knoll on an island in the Bering Sea, in a hayloft of a barn along the Niagara River, and on a shelf of rock in the middle of cliffs in Arizona. While these kinds of nesting sites do commonly occur, bald eagles prefer to nest high in a dominent emergent tree or in any prominent tree along the edge of a lake or river. The preferred species of tree varies with the location. For instance, pines and cypress are chosen in Florida, spruce and fir in the West, cottonwoods in the Midwest, and large aspen in northern Canada. However, any large tree or prominent structure can be a suitable site.

The bald eagle generally does not build its nest in the very top of trees, as does the osprey. Rather, it occupies the crotch of the last set of branches a third or a quarter of the way down from the crown. The most important factor in nest selection seems to be accessibility, so the adults can swoop in to the nest without having to fly through the canopy of surrounding trees.

Another way the bald eagle differs from the osprey is that the eagles are not as readily attracted to man-made structures on which to build their nests. This may well be due to their preference for nesting below the canopy; most man-made nesting platforms lack shelves or platforms at lower levels.

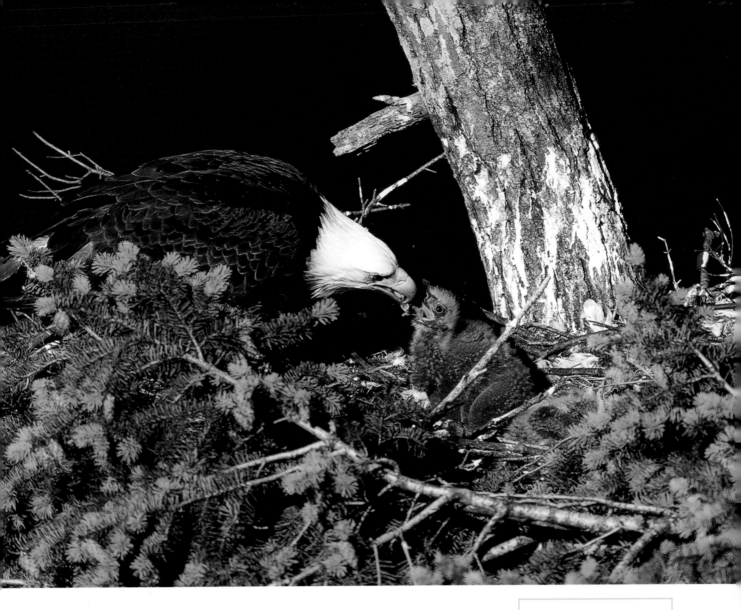

Bald eagles build stick nests that are usually used year after year by the same pair. The nests also contain remains of food, including bones, old feathers, and other debris, brought to feed the chicks. This material is simply covered over by new branches, twigs, and other vegetation each year. The twigs and sticks are placed on the edge of the nest, with other vegetation (grass and leaves) placed in the center. Nesting pairs often continue to bring green twigs with leaves to the nest until the chicks are nearly full grown, at which point the chicks require full-time attention. In Florida, there can be a foot or more of Spanish moss in the center of the nests. Eagle pairs continue to add material throughout the season—to the point of sometimes even burying the chicks and eggs. Nest-building activity seems to help maintain the pair bonds. Also, chicks have been seen chewing on and eating leaves from branches brought to the nest by parents well after the chicks have hatched.

A bald eagle gently feeds small bits of fish to its chick. Orcas Island, Washington.

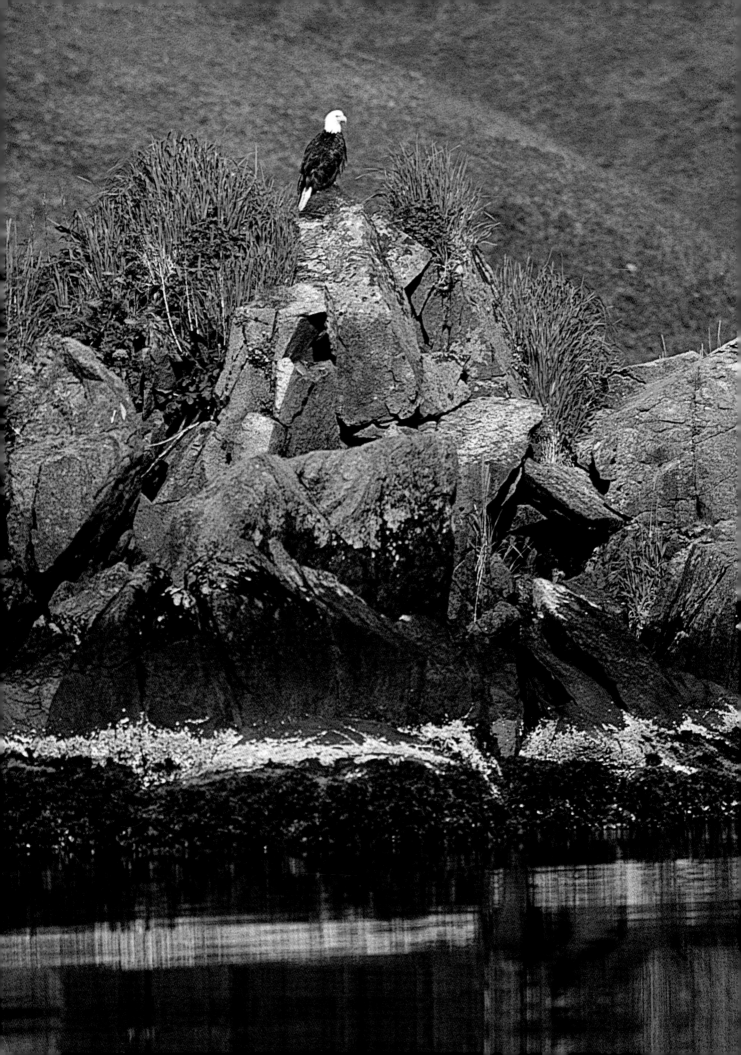

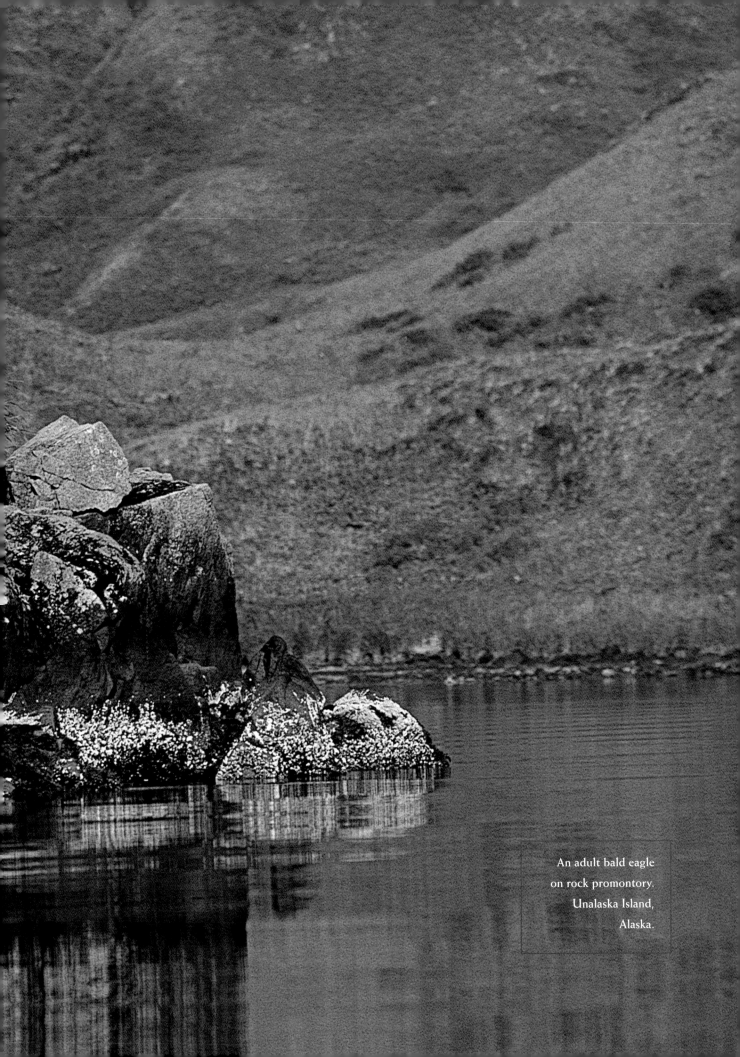

An adult bald eagle
on rock promontory.
Unalaska Island,
Alaska.

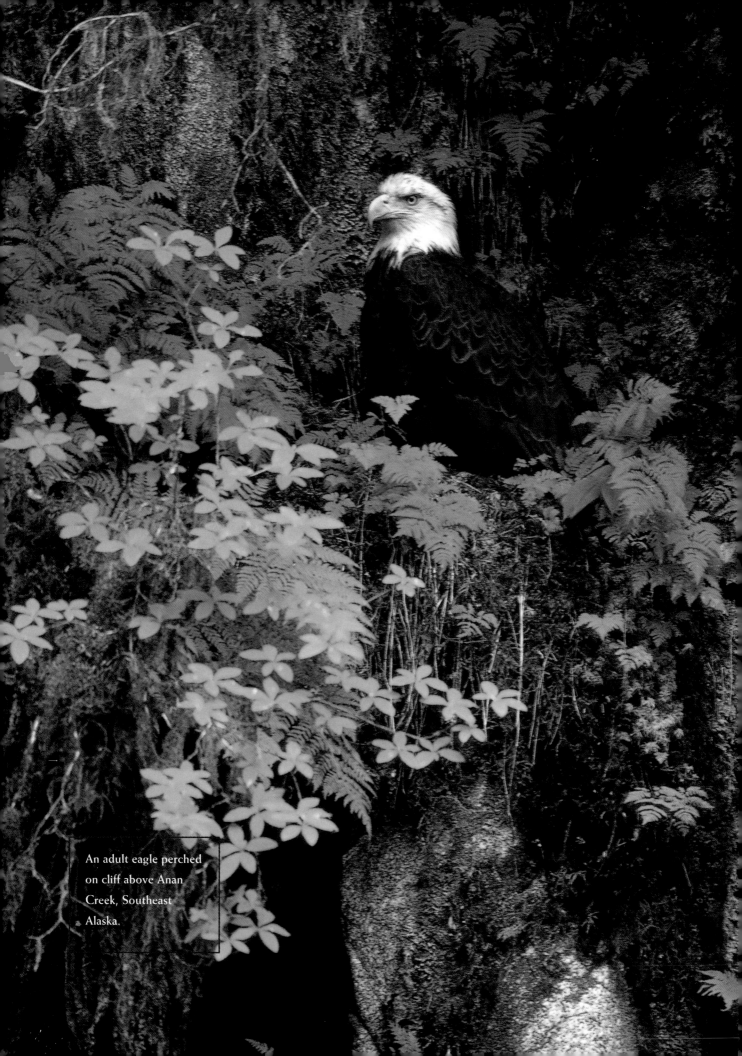

An adult eagle perched
on cliff above Anan
Creek, Southeast
Alaska.

Eagle nests can become huge, fre-
quently weighing up to two tons and mea-
suring up to twenty feet thick and nine
feet across. New nests, of course, are not
nearly as large as old nests that have been
used for generations. There are records of
a nest being used continuously for more
than thirty-six years; however, the famous
Ohio nest that was so carefully observed
for thirty-six years housed several different
pairs during that time. A well-established
nest will probably be used by a pair of
birds until the birds die or the tree holding
the nest collapses, is cut down, or is blown
down in a storm. However, some pairs will
abandon a well-established nest if they fail
to produce chicks one year or if they are
disturbed too regularly. Some eagle pairs
even build a second nest while still using
the first nest.

Fidelity to a nest site and a mate
are well noted in bald eagles, with some
nest sites having been observed for more
than fifty years. While many of the early
observations were not as detailed and sci-

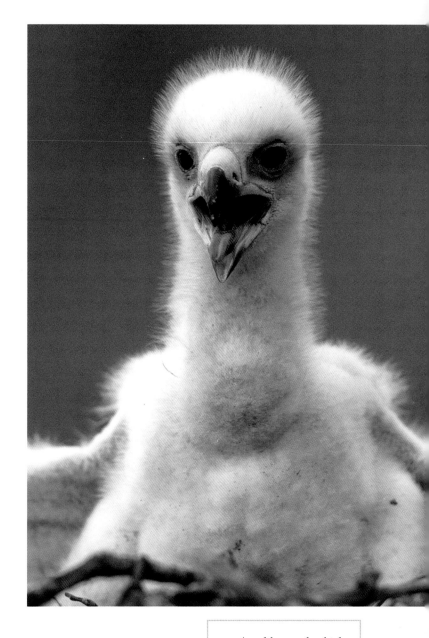

A golden eagle chick
in nest. Brooks Range,
Arctic National Wildlife
Refuge, Alaska.

entific as we might strive for today, they still clearly give an indication of
fidelity over long periods of time. Even when a nest tree falls or a strong
wind blows a nest down, the established pair usually rebuilds at or near the
site within a few weeks if it is near the breeding season.

Eggs

In the northern parts of the eagle's range, eggs are laid during a very short
period of time. In central and northern Canada, for instance, nearly all
eggs are laid within a two-week period in late March and early April. Near

Vancouver, eggs are laid in late March and early April, while in northern Canada and Alaska they are not generally laid until well into May. Meanwhile, in Florida, the egg-laying period begins as early as November and extends until January.

The fact that all birds, including the bald eagle, lay eggs is a significant feature that allows them to produce young without having to carry them around during development. This permits the female to be as competitive and efficient in hunting as other birds while the young are developing.

Bald eagles lay between one and three off-white eggs, from one to three days apart. Just as body size in adults decreases from north to south, so does egg size. Eggs laid in Florida range from 79 by 56 millimeters to 58 by 47 millimeters, while eggs laid in Alaska and northern Canada range from 84 by 60 millimeters to 70 by 53 millimeters. The eggs laid by each female are quite consistent in size from year to year, although there is usually a slight decrease in size from the first egg to the last laid each year.

Since the eagle pair starts incubating almost immediately, the eggs hatch asynchronously over a two- to nine-day period. Unlike many other birds of prey in which the male provides food for the incubating female, bald eagle parents share in incubation duties and each hunts for its own food during this time. The incubating adult usually stands up to shift its position and turn the eggs about once an hour. The pair usually trade positions several times a day. Incubation of eagle eggs lasts thirty-four to thirty-six days.

Chicks can take from twelve to forty-eight hours to hatch after pipping (making that first break in the shell). The chick uses its egg tooth—a small, hard, and pointed bump on top of the bill—to initially break the shell. The chick then rests for a few hours before starting to use the egg tooth to chisel a crack around the large end of the egg. Once the break is made around the entire end, the chick pushes the resulting flap off and struggles out of the shell. Generally the chick starts breathing and inflating the lungs once it has broken into the air cell. Full breathing occurs once pipping has occurred and the chick has access to outside air.

The hatching process for eagles is, as for all birds, a time of major transition. The chick must literally switch its source of oxygen. Before hatching, it absorbs oxygen through the shell and the membranes into the

OPPOSITE: For weeks immediately before fledging, an adolescent eagle will test its wings by flapping and often lifting off from the nest platform. China Poot Bay, Alaska.

bloodstream via the mat of blood vessels within the membranes surrounding the chick just under the shell of the egg. The chick must also cut off its blood supply to these membranes by trapping the blood back within its body so that it does not bleed to death by breaking the blood vessels in the membranes. At the same time, the chick must pull the remaining yolk

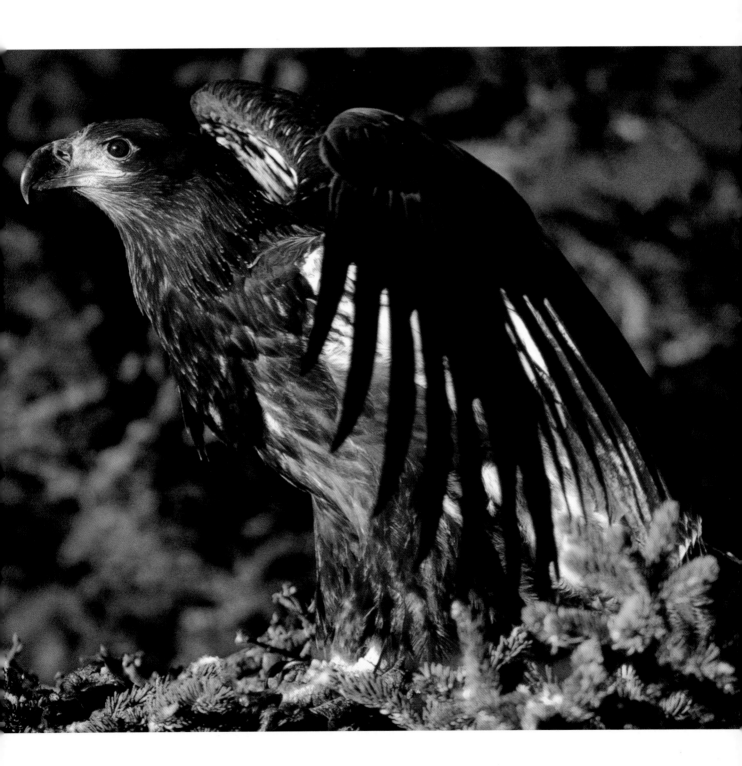

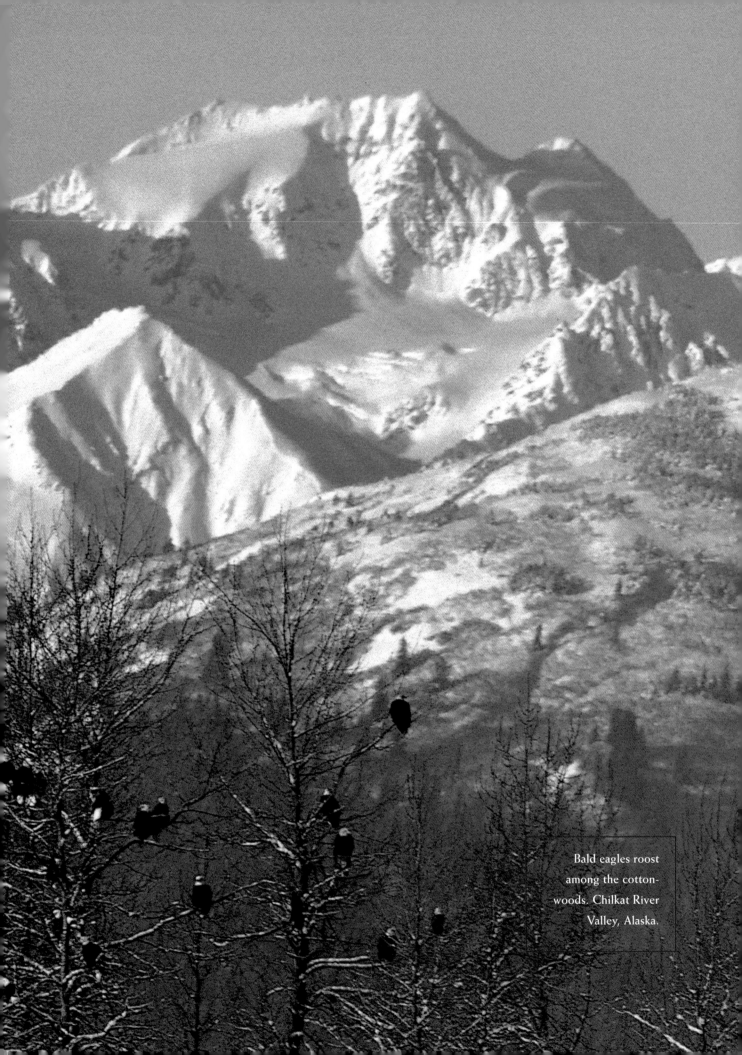

Bald eagles roost
among the cotton-
woods. Chilkat River
Valley, Alaska.

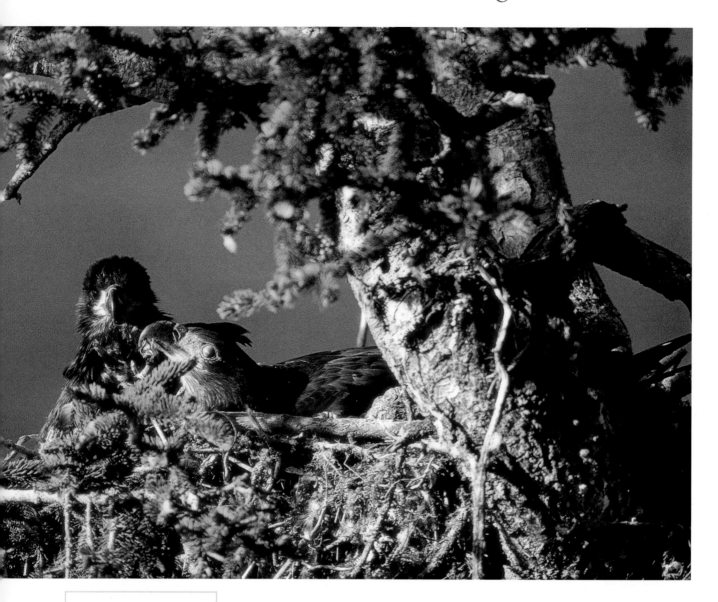

Two eaglets rest in the late-afternoon sun. Often only the strongest of the two survives. When both eaglets have reached fledgling stage, it is frequently a sign of abundant food sources. China Poot Bay, Alaska.

sack, which has been nourishing it during development, into its body and seal off the umbilicus. All of these processes must occur simultaneously while the chick is struggling to break the shell, beginning to breathe through its lungs, and struggling to turn itself around within the egg to break a ring in the shell.

This is certainly a tiring process and the fuzzy-wet chick then needs time to rest and dry off. After hatching, the egg tooth—having served its purpose—simply falls off sometime during the first four to six weeks as the chick's bill grows rapidly with the rest of its body.

The survival rate of chicks correlates directly with the order of hatching and the available food supply. In Canada, eggs are timed to hatch

at the same time as the ice breaks on the lakes, thus allowing the maximum time for the adults to provide fish to the young. The young are then of optimal age and size by the first cold of winter.

Young

Hatchling eagles are covered with a full coat of pale gray down, with much whiter down on the head and underside. Their eyes and bills are black, while their legs, their proportionally large feet, and their talons are yellow. After about three weeks the chicks molt into a second, much thicker and darker down covering that they keep until their first set of feathers gradually grows in. During this period at least one of the parents is generally at the nest to shelter the chicks from the sun, wind, rain, or anything else that can harm them. As the chicks grow, the parents spend more and more time hunting for food, which means more and more time away from the nest.

The parent birds can be quite aggressive to any intruder during the nesting period, but this aggression becomes most intense once there are young in the nest. Scientists studying eagles must be extremely careful during this period. Some researchers have been injured by defending parents; the talons of an eagle can be quite a formidable weapon.

Furthermore, the chicks in the nest can injure anyone who climbs up onto the nest, as they are already well equipped with talons and a powerful bill and are willing to use both to defend themselves. Most people studying eagles in this manner have had some injuries as a result. And as the young eagles near the fledging state, they can be very aggressive and hard to handle.

The young grow rapidly, depending on the amount of food brought by the adults. Curiously, studies have shown that adult birds provide about the same amount of food daily for the newly hatched chicks as they do for young who are almost ready to fledge. When chicks are small and food is plentiful, a lot is wasted. However, as chicks get older and competition increases, food becomes a limiting factor. In good years, there is sufficient food for all chicks, but in bad years, the smallest and youngest chick or chicks may not survive. When a chick dies, it may simply be buried or covered over with new nesting material in the nest.

Frequently the older chicks will develop faster, which led early re-searchers to believe that eggs were laid weeks apart, which is not the case. But the first hatched chicks usually do fare better than their younger sib-lings and grow faster or take a greater portion of the food if food is in short supply.

Young eagles are usually at the nest for about ten to eleven weeks. During the last week or two, the young can be seen exercising their wings with increasing frequency, especially if there is a breeze or wind. At first the chicks hold on to the nest with their talons, flapping and beating their wings. Eventually they actually lift off the nest during some of these exer-cise periods.

The chicks begin exercising more with each passing day once

OPPOSITE: **An adult bald eagle portrait. Chilkat River, Alaska.**

BELOW: **Within a few weeks of leaving the nest, the eaglets appear quite anxious. China Poot Bay, Alaska.**

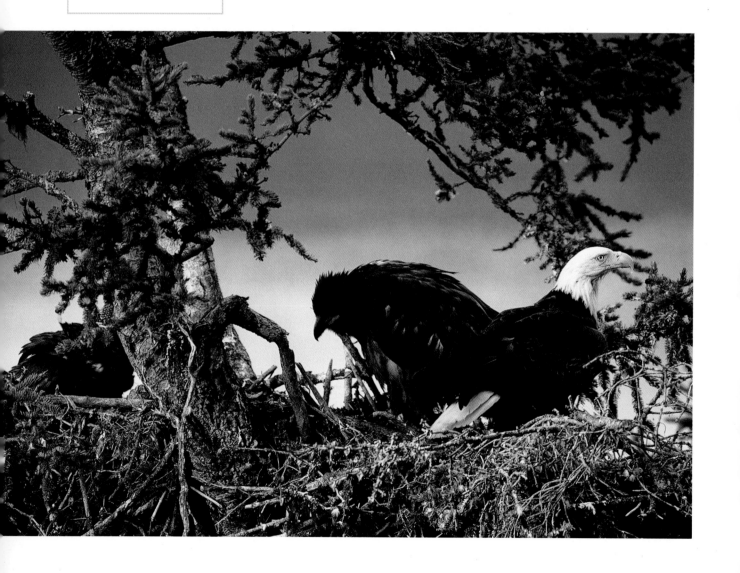

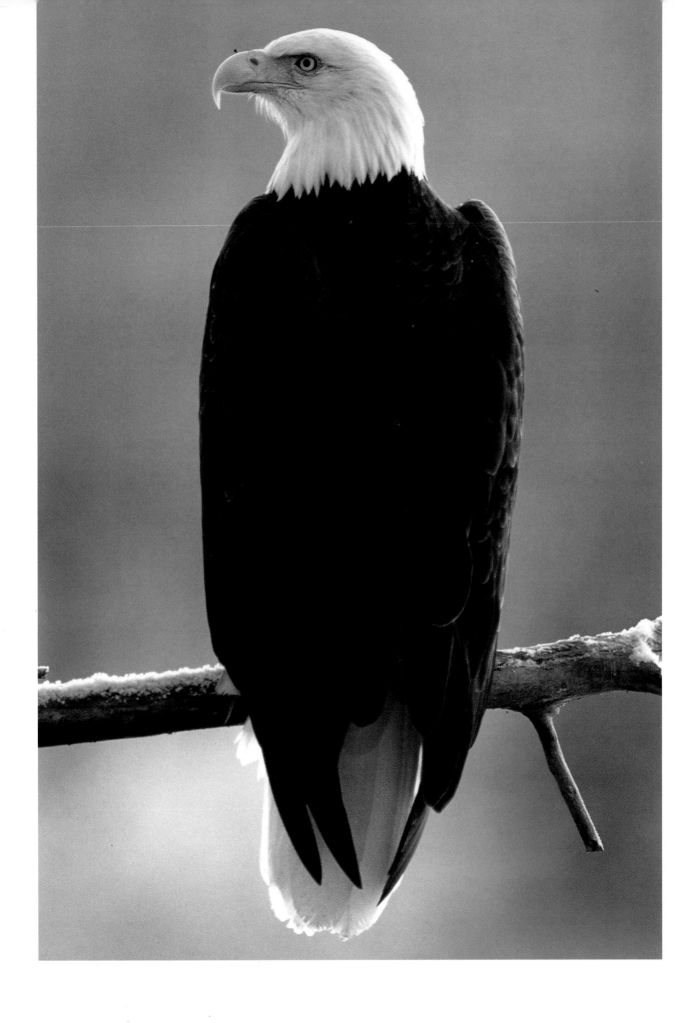

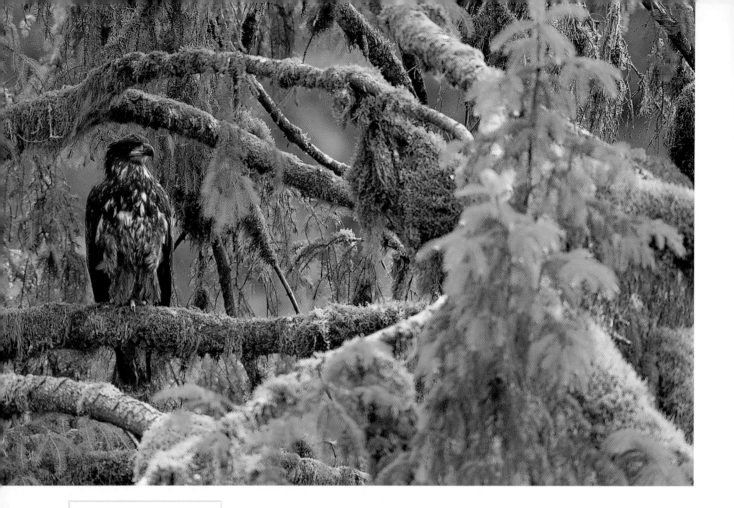

An immature bald eagle
in old-growth forest.
Anan Creek, Southeast
Alaska.

their feathers are fully developed. This is another dangerous period for the chicks because, while exercising, it is not uncommon for one to fall or be blown off the nest. If the chick is near fledging when it falls, it may be able to fly into another tree. However, if it falls too early in development, it may not be able to get to another tree or branch. It is not uncommon to find the skeletons or other remains of young birds beneath the nest or hanging from lower branches of the nest tree.

Fledging

Once the young have strengthened their wings and muscles, they are ready to leave the nest. There is speculation as to what prompts their first flight. Sometimes it is accidental, as when the chicks are exercising in a strong wind and get blown off. Other times it may simply be that they get carried away with their exercising. There is also some indication that the parents lure the chicks away from the nest with food. Certainly at some point the parents reduce the amount of food being provided or it is insufficient to satisfy the young birds' increasing appetites. Males fledge by mak-

ing their first flight at an age of from sixty-eight to eighty-four days, while females are seventy-five to eighty-eight days old. Probably at least 10 percent of the young leave the nest prior to when they are truly ready. Many of these birds fall to the ground or into the water, and must then struggle to get back up into the nest for their first successful flight a few days later.

Eagle parents do provide food to the young during this transition period. However, the young have been fattened up to give them additional time to learn to find their own food. Often, chicks can be as heavy as even their parents when they leave the nest. In any case, the young have a difficult transition to make and they must quickly learn how to find their own food.

The first flight can be very clumsy, but once airborne, the birds take to flying quickly. The landings require a bit more practice and the first few are often awkward. Juvenile birds normally have longer wings and tails than their parents; this aids them in learning to fly.

Young birds spend far more time flying than they will later as

Bald eagles congregate
on the beach along
Homer Spit, Alaska.

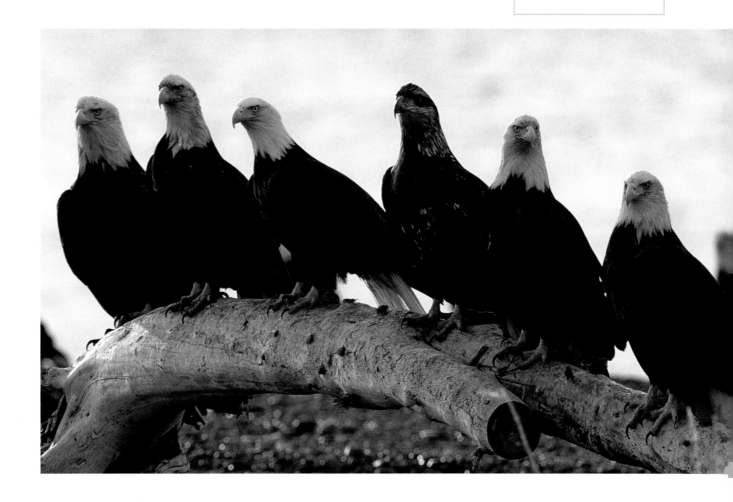

adults. This is largely due to their inexperience in hunting, but it is also because of their apparent need to migrate and seek out new territories.

Flight

Eagles expend a great deal of energy to get airborne, and their heavy flapping flight often seems labored and inefficient. Yet at the same time their soaring flight is remarkably graceful and uses very little energy, allowing the birds to remain in the air for many hours at a time, especially during migration. Eagles usually take flight in the morning, after the sun has started warming the ground. The thermals created by the sun are used by the birds to spiral higher and higher with little expenditure of energy.

Watching eagles and other birds of prey ride the thermals into the morning sky can be a fantastic experience. This is one of the reasons that thousands of birdwatchers congregate each fall at places like Hawk Mountain Sanctuary near Kempton, Pennsylvania. At Hawk Mountain, visitors can walk a series of trails with views along the main mountain ridges. These ridges serve as "highways" for hawks and eagles in their fall migrations.

There are numerous observation sites, but the most popular is at the top of the mountain ridge overlooking the valleys to both the east and west. Migrating hawks and eagles use the thermals generated in both valleys to spiral high into the sky and then soar for miles along the ridge. The majority of eagles pass Hawk Mountain during September, but some are as late as October and November. (It is the eagles and peregrine falcons that generate the most enthusiasm from the people who travel to Hawk Mountain each fall to see this spectacle.) The best days to see the maximum number of birds are the first sunny days after a series of rainy days. It is at these times that the birds are concentrated in migration. The excitement generated when someone shouts "Eagle!" really must be experienced. From this mountain ridge at Hawk Mountain it is possible to see an eagle several miles away and watch it soar closer and closer until it finally crosses right over your head or sometimes within forty or fifty feet in front of you. The bald eagle is a spectacular sight at these times.

Efficient flight, which is always important to an eagle, is even

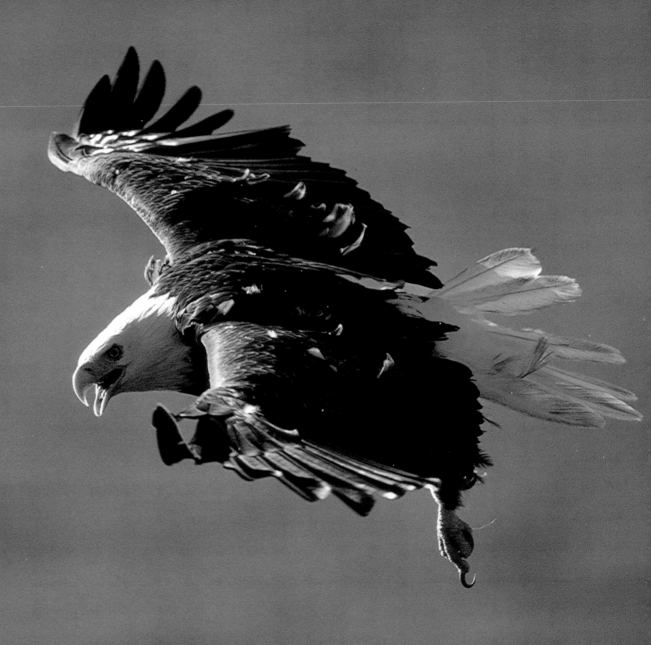

A bald eagle in flight.
Unalaska Island,
Alaska.

more important during migration, when the eagle spends the maximum amount of time in the air. If weather, sun, and wind conditions are just right, an eagle can cover tens of miles in a single soar. By riding the thermals as high as possible, the bird can travel for miles before needing to catch another set of thermals that will provide sufficient altitude for the next glide. If the wind direction is also assisting, an eagle can cover a large portion of its migration in just a few good days. However, often the birds will have one good day in which they cover many miles, and then they must wait several days or even a week before another good day comes. It is for this reason that there are spectacular days when one can see thousands of hawks and dozens of eagles if conditions are right.

Migration

Most bald eagles migrate each spring and fall. Eagles choose their fall migration routes to take advantage of thermals, updrafts, and food supply, while the spring migration is often a more direct route across land without regard to food supply or thermals. Adult eagles generally migrate north in spring and south in the fall. Some migrate long distances while others migrate relatively short distances.

Although eagles can be seen migrating all along the east and west coasts of North America, individual birds do not necessarily migrate all the way from northern Canada to Florida or California. As banding studies have shown, northern Canada birds migrate only as far south as southern Canada and New England, while the mid-Atlantic birds migrate down to northern Florida and Georgia on the east coast. Florida birds may migrate within Florida and some may not really migrate at all. Similarly, birds on the west coast don't all migrate long distances. The birds from central and northern Canada do migrate longer distances much more directly south.

Bald eagles migrate to find locations where there is sufficient food for the winter. This means that some Alaskan birds that have found good winter food supplies at the garbage dumps of Juneau don't need to go farther south, while others that have traditionally gone farther south continue to do so.

Territory and tradition are strong influences on eagles, as with

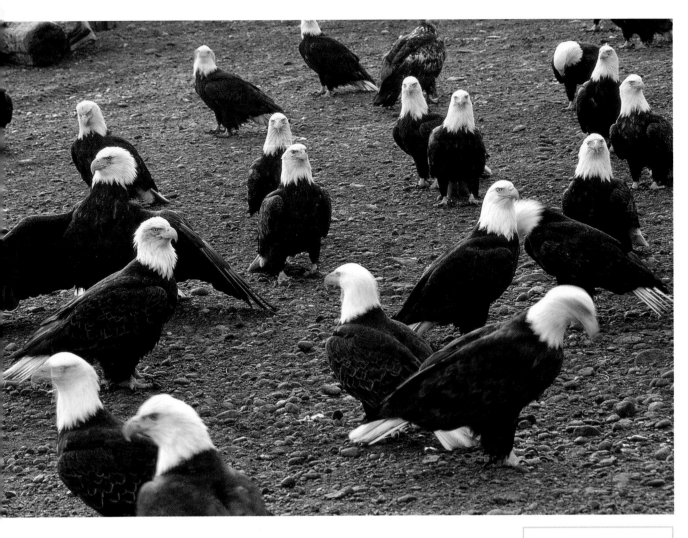

Bald eagles by the
Chilkat River, Alaska.

most other birds. Eagle migration routes vary greatly depending on factors such as what part of the country the birds are in, the age of the birds, the weather, and the food supply. During the last fifty years, banding and tagging studies along with the use of radio transmitters have made it possible to track migrating birds. However, even with this technology, none of these studies would have been possible without the many dedicated researchers and their helpers who spent countless hours in the field locating nests, banding and marking birds, and observing birds over the months and years. All of this effort has given us a great deal of information on the routes and distances that birds cover during migration.

The routes followed by eagles during migration are very complex. This can be best conveyed through a series of examples.

The adult eagles that nest in and around Yellowstone National

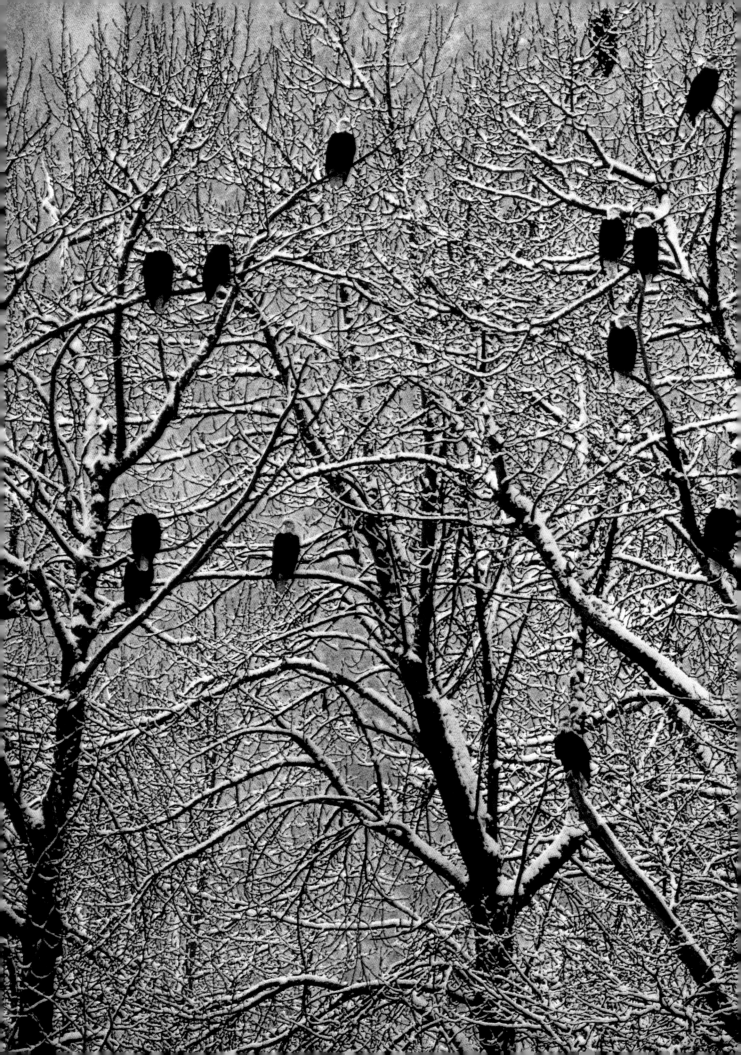

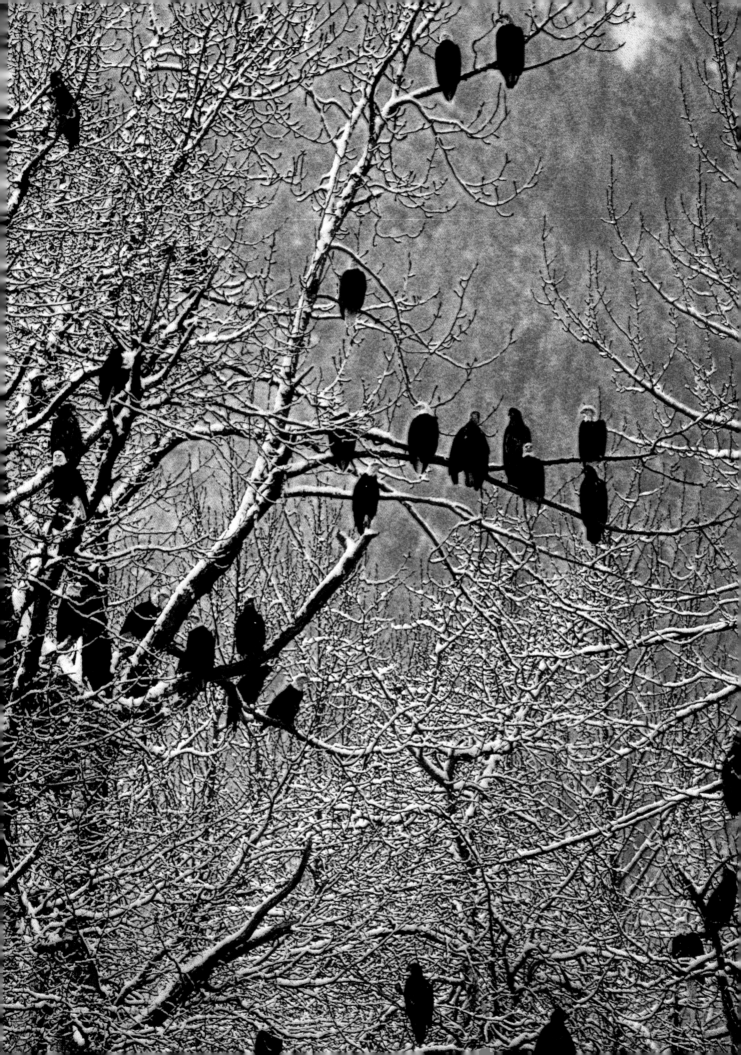

Park generally do not leave the area in the winter. However, most of the young eagles reared in the area migrate to the west coast and spread up and down the coast, while a smaller number stay in the Yellowstone area or move into the surrounding area to the north, south, and west. Likewise, many British Columbia eagles migrate down the coast to Washington and Oregon, while others remain along the coast in British Columbia. Inland Alaska eagles also generally migrate to the coast, while many of the coastal and island birds do not migrate at all.

Eagles from central Canada generally migrate south, with some spreading to the southeast, south, and southwest. Yet many of the birds from northern Saskatchewan winter in the San Luis Valley in Colorado. Nova Scotia eagles tend to remain within the province in Canada; however, a few migrate south as far as Maine. Maine eagles generally migrate down along the Atlantic seaboard, some as far as the Carolinas; however, some Maine birds, especially young birds, have been found from Arkansas to Colorado to Illinois. Florida eagles generally remain in Florida or neighboring states. Eagle migration clearly does not have one set pattern.

During nearly the entire first half of the century, only the migration of adult bald eagles was studied, and it was assumed that eagles would generally migrate south during the winter and north in the spring. Little consideration was given to whether or how fledging birds migrated until 1939. At this time, Charles Broley retired from managing a bank in Winnipeg, Canada, and decided to spend the winter in Tampa Bay, in Florida. En route, when he stopped at the American Ornithologists Union meeting in Washington, Broley was given four bands for eagles by Richard Pough of the National Audubon Society. Once Broley arrived in Florida, he set to work banding young eagles. One of the first four birds that Broley banded in late January near Tampa Bay was shot near Columbiaville, New York, on May 8. This clearly showed, for the first time, that young birds after fledging may migrate significant distances north. It has since been established that most young eagles migrate after fledging. This discovery led Broley to band more than a hundred young eagles each year. This work clearly showed, for the first time, the migration patterns of young eagles. Broley's efforts also showed the first indications of a rapid decrease in the eagle population that would begin to occur just ten years later.

PREVIOUS PAGES:
Bald eagles roost among the cotton-woods. Chilkat River Valley, Alaska.

Besides direction, spring and fall migrations have other differences as well. The spring migration of adults is usually quite rapid. Radio-tracking of adults captured on their wintering grounds in the San Luis Valley of Colorado has shown that birds travel about thirty miles per hour and can cover from ninety to two hundred and seventy miles in a single day en route to northern Saskatchewan.

On the other hand, fall migration is slow. Even on good days, birds may cover fewer than twenty miles but occasionally will cover up to sixty or seventy miles. During the fall, birds stay in one area for several days or a week or more before moving on once again.

Ever since the decline of the bald eagle in the Northeast, a sighting of one of these birds in this part of North America causes tremendous excitement. In recent years the number of eagles in the Northeast has increased to such an extent that frequently during the winter, eagles can be seen on ice floes along the Hudson River. A single bird spent several winters roosting in Woodlawn Cemetery in New York during the 1980s. Sightings of eagles during migration have become quite common all along the east coast as eagle populations increase once again.

On October 13, 1993, on a bright and sunny morning following three days of clouds and rain, at about ten A.M., while I was driving on

An eagle harassed by a gull. Unalaska Island, Alaska.

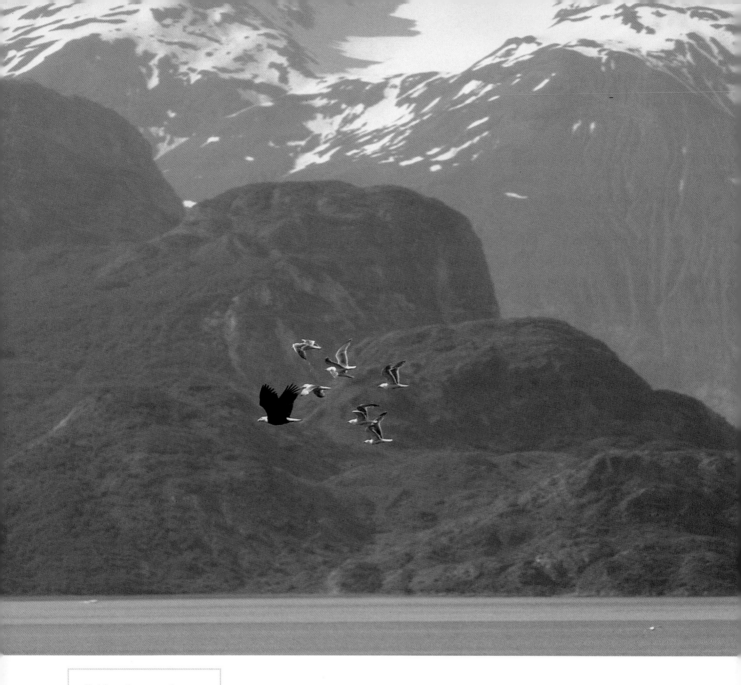

New York State Route 17 near Deposit, New York, a large bird of prey soared into view. The size alone told me that it was probably an eagle. The sun had just burned through the early-morning fog and the trees on the hillsides were ablaze with fall colors. The dark bird wheeled in its upward spiral, riding on a thermal. The brilliant white of the head and tail immediately confirmed its identity. I almost drove off the road trying to continue watching the eagle spiral higher into the morning sky. (Seeing an eagle like this in all its splendor makes one appreciate why eagles have been held in such high esteem by mankind throughout history.) Ten years ago, such a sight would have been rare, but with each passing year more and more eagles are reported. Still, one can only wonder what it must have

been like to witness large numbers of eagles filling the sky, as they did when the first settlers arrived in North America.

The timing of migration for adults in the interior of North America generally coincides with the freeze-up. This may allow the birds to take advantage of the waterfowl that are crippled or get caught in the forming ice. Immature eagles generally migrate before the adults, thus demonstrating that the adults do not "show the way to the young." In spite of years of research, we still do not know for sure how the immatures know where to go or when to leave. Wind certainly has an impact on where birds migrate and often moves them well off their normal course. Regardless of all that we do know of bald eagle migration and movement, we still do not know why most of these patterns occur or if they have been consistent for years or are constantly changing.

Interactions with Other Birds

Because of their large size and power, eagles generally do not have to be concerned about threats from other birds. However, like most birds of prey, eagles often are annoyed and chased by smaller birds, who try to protect their nests or young. Generally these efforts are unnecessary. Bald eagles are unlikely to bother smaller birds or their young. "Mobbing" actions by smaller birds certainly can annoy eagles; however, the eagles often ignore such behavior. In fact, it was his observations of a bald eagle either ignoring or retreating from such mobbing behavior of kingbirds that probably led Benjamin Franklin to claim the cowardice of bald eagles.

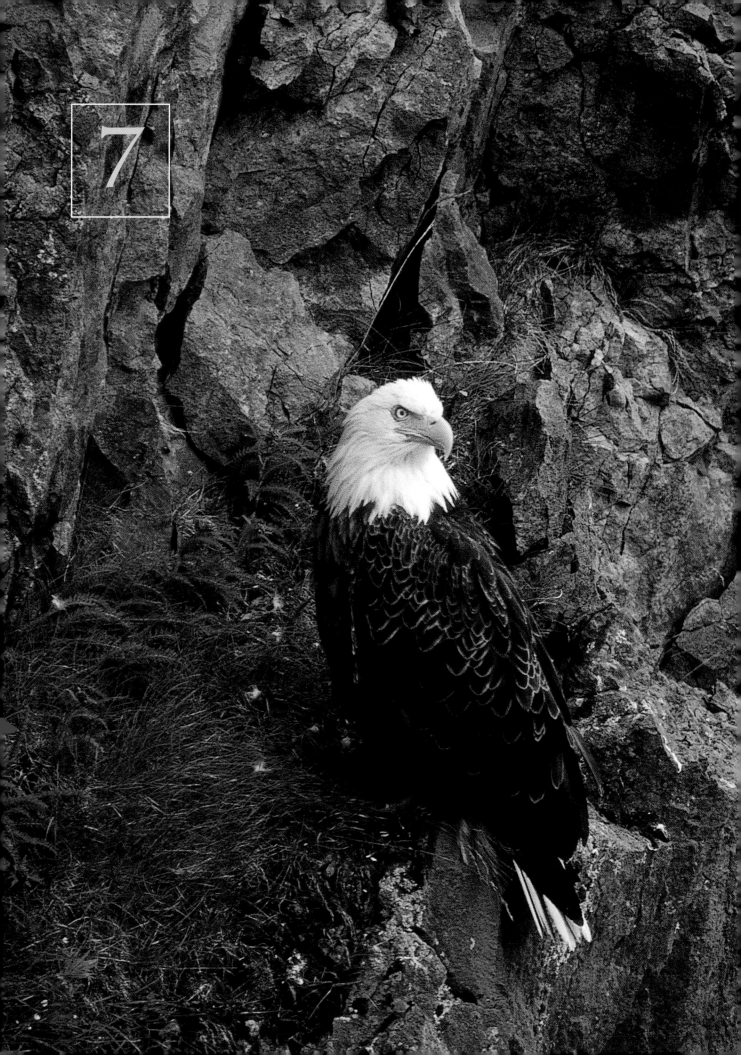

Conservation
of the
Bald Eagle

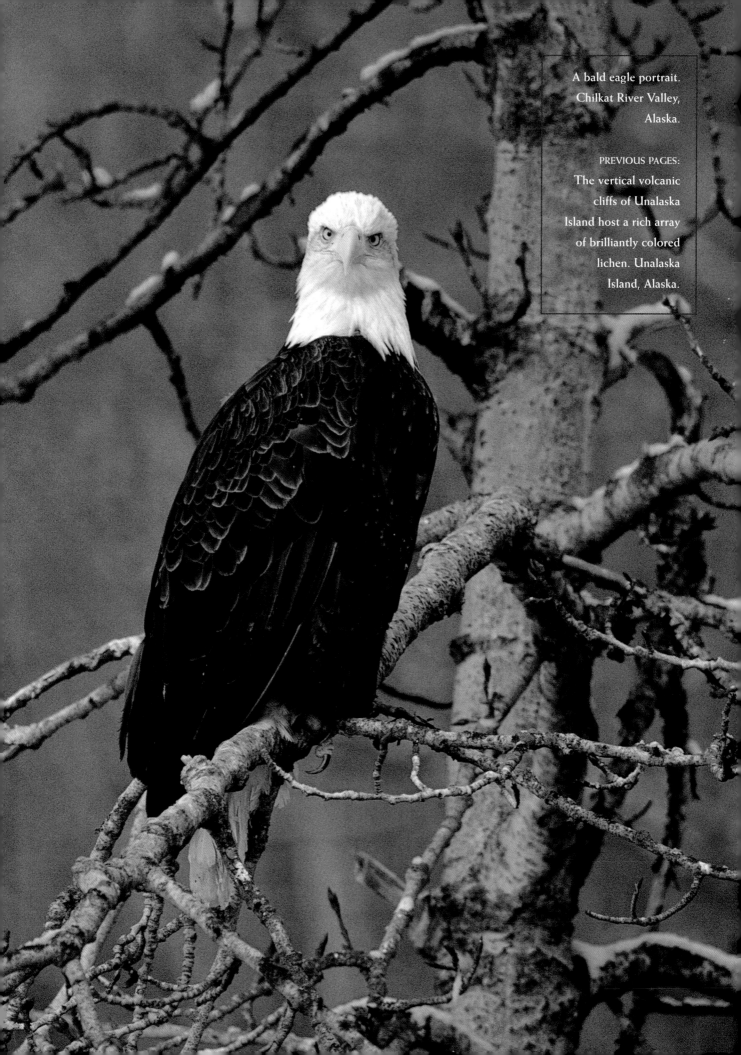

A bald eagle portrait. Chilkat River Valley, Alaska.

PREVIOUS PAGES: The vertical volcanic cliffs of Unalaska Island host a rich array of brilliantly colored lichen. Unalaska Island, Alaska.

Historical Decline and Recovery

When Europeans first set foot in North America, the bald eagle was a relatively common bird. Eagles nested on both coasts and on most major lakes, as well as along most large rivers across the country. This species was widespread across the continent; however, bald eagle populations were probably concentrated in certain areas as they are today, such as in Florida and

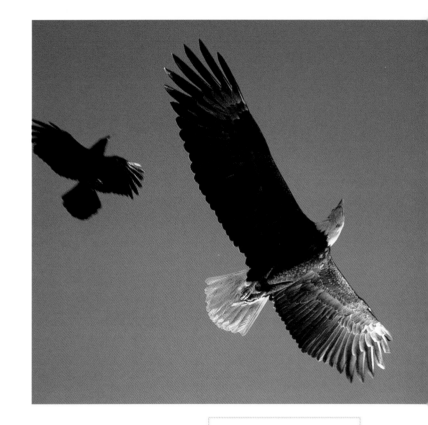

A bald eagle harassed by a crow. Southeast Alaska.

Alaska. At first the bald eagle was perceived as symbolic of the untouched majesty of the continent, yet soon the settlers saw these birds as competing with them for fish and other wildlife resources. At this point, the number of eagles started to drop. It is true that eagles probably were a much greater problem for early settlers than they are for ranchers or farmers today because wildlife numbers were so high then. As is typical, when fishermen and hunters started finding it more difficult to obtain fish and game, they blamed it on the eagles. Like other birds of prey, eagles got the blame whenever game populations declined: They were seen feeding on such game, there was no documentation to the contrary, and there was no one to fight back.

Historical observations support the concept that bald eagles were very common throughout most of North America as late as 1890. Their nests, and thus bald eagle populations, were commonly seen along the Chesapeake Bay. There was at least one nest for every mile of shoreline in the late 1800s. Likewise, in Minnesota, almost every lake had at least one pair of eagles nesting along its shoreline. Eagles were common along the shores of the Great Lakes, along every major river, in Colorado's mountain parks, and along the coasts and major rivers on both sides of the country, as well as along all the major rivers across the great plains.

On Manhattan Island, New York, in the mid-1800s, there were hundreds of bald eagles reported fishing from floating ice in midwinter, with eagles bringing captured fish into Central Park, where they would sit and eat. At the same time, there were reports of the air being "simply alive" with the birds near slaughterhouses along the Mississippi and other large rivers of the Midwest. Gerrard and Bortolotti, in their recent book, *The Bald Eagle: Haunts and Habits of a Wilderness Monarch*, estimate that there was somewhere between a quarter and a half million bald eagles on the continent when Europeans arrived in the mid-1700s. But by the late 1950s and early 1960s, there were only a few thousand bald eagles outside Alaska, with most in the Northwest and Florida. What happened to all the eagles in a little over two hundred years?

The first major decline in eagle numbers seems to have occurred in the mid- to late 1800s, starting in the East and moving westward with the expansion of human populations. There were probably many factors involved, but the decline of many other species, like the bison and the passenger pigeon, gives a good indication of a major cause for eagle decline. Hunting of large numbers of ducks, geese, and other shorebirds reduced the numbers of those birds, thus reducing the eagle's seasonal food supply. Likewise, fishing to supply food for growing numbers of people began to reduce the fish populations in some locations. People became more health and disease conscious, and as a result buried the carcasses of dead animals. Bald eagles, which depend on a lot of carrion, especially in the winter, simply had less to eat. Then, the shear increase in human populations, as well as the popularity of hunting, which meant more hunters with guns in the field, also had a significant impact. Eagles were directly impacted, if for no

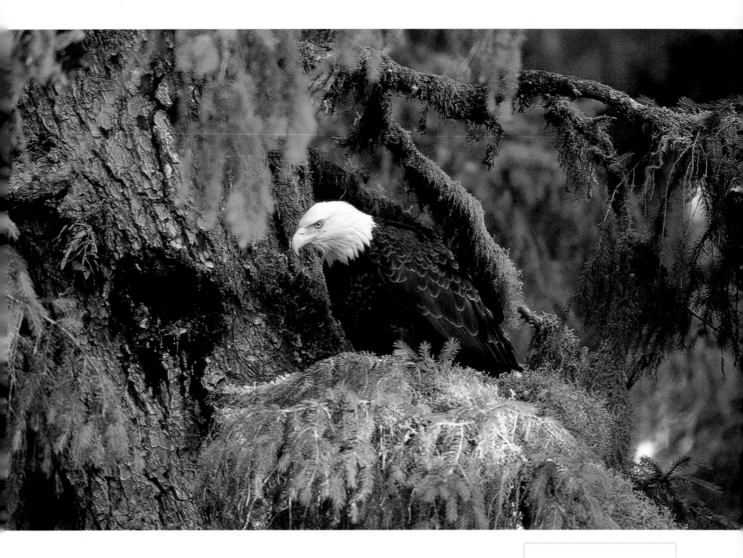

A bald eagle in a spruce tree. Anan Creek, Southeast Alaska.

other reason than they made good target practice. Moreover, traps for wolves and strychnine poisoning of bait took the lives of many eagles. From one end of Montana to the other, the bounty on wolves resulted in the poisoning of hundreds, if not thousands, of eagles.

As humans took over the land, natural habitats were destroyed, resulting in the loss of nesting sites and hunting grounds for eagles. Eagle numbers and suitable habitats decreased with each passing year. Unfortunately, even native peoples helped to deplete eagle populations in their quest for feathers, prized for ceremonial bonnets, and as social circumstances dictated major changes for these people. Early in the 1900s, the bald eagle was "almost extinct" in the Wichita Mountains of Oklahoma, where only forty or fifty years before the birds had been quite common. Here, Indians even killed and ate eagles when other game was

largely gone and the Indians could not move on to other hunting grounds. During this same period, the bald eagle was becoming rare from the Cascade Mountains of Washington east to the Ohio River, and from the Chesapeake south to Florida. Direct slaughter, removal of food supplies, and changes in habitat probably kept eagle populations quite low until the 1940s.

A shift in public awareness and attitudes caused a decline in the direct persecution of the species, and with passage of the Bald Eagle Act of 1940, the bird started to make a recovery in some areas. In addition, the establishment of wildlife refuges, national parks, and other protected areas and habitats, along with the development of limited hunting seasons and other controls on hunting, resulted in more winter habitat and food for eagles and less direct victimization. Increases in eagle populations across North America started to show up from the mid-1930s to the mid-1940s, but in most areas the changes were slow.

A black bear sow and her two cubs fish for salmon, competing with the bald eagle. Anan Creek, Southeast Alaska.

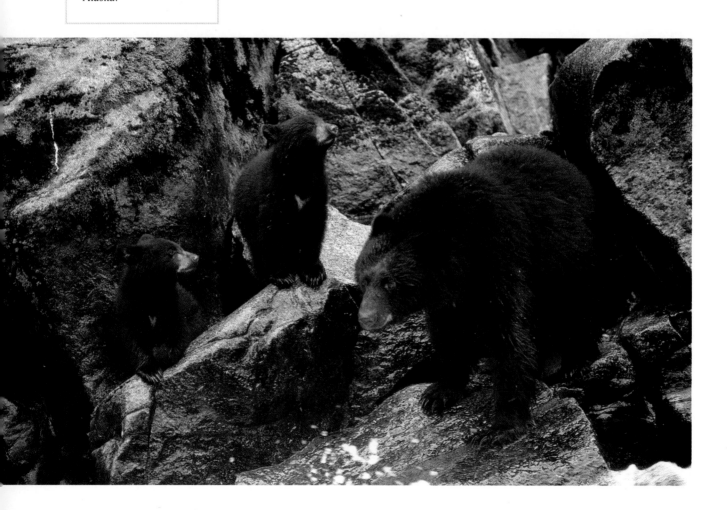

Pesticides

Suddenly, around 1947, there was a dramatic reduction in bald eagles in certain areas—for example, along the east coast from Florida to the Chesapeake and on up to Maine. Charles Broley's banding studies along the gulf coast of Florida gave some of the first indications of the swift decline that was occurring. Broley's data showed that in 1940, from 105 out of 140 nests he was observing, he banded 150 eaglets. By 1952, only 11 nests were active in the same area and only 15 eaglets were banded.

Broley began to suspect pesticides were the culprit because he found that most eagles were still producing eggs, but the eggs were breaking during incubation. Rachel Carson, in her series of books starting with *Silent Spring,* and other naturalists took up the cause and pursued the battle against DDT and other pesticides. Industry and government were slow to respond, until the public outcry became so loud and the scientific proof so strong that the situation could no longer be ignored. However, it was 1970 before the use of DDT was curtailed in Canada and 1972 before its use was banned in the United States. For many birds, like the eastern peregrine falcon, it was too late. But for others, like the pelican and the bald eagle, it was the eleventh hour.

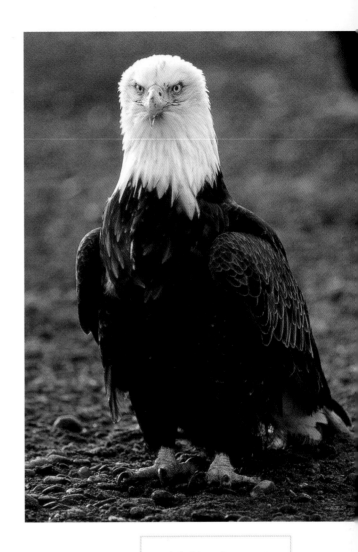

A bald eagle portrait.
Chilkat River, Alaska.

DDT, which was developed during the Second World War and sprayed extensively to control salt marsh mosquitoes, was used after the war throughout North America to control all types of insect pests. DDT was relatively cheap to produce and it killed almost any insect without harming the plants. It seemed like the ideal solution to the problem of insect control until the side effects were clearly demonstrated.

Unfortunately, it took many years to prove that DDT sprayed on plants entered the food chain, broke down very slowly, and accumulated in the animals highest in the food chain. The accumulation of DDT and its

Landscape. Southeast
Alaska.

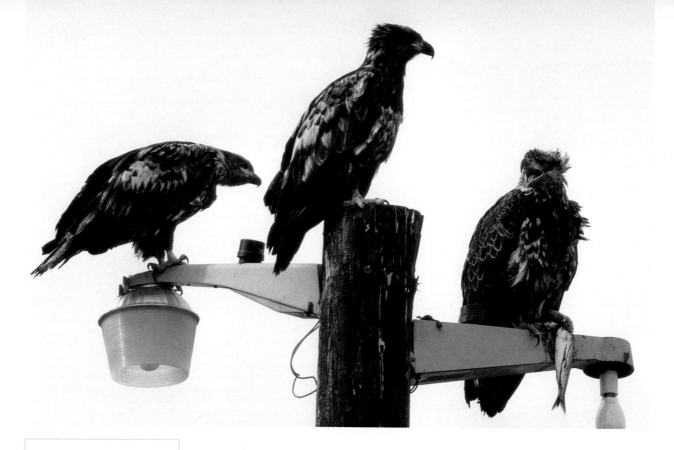

Bald eagles often become habituated to human presence. Here they alight atop utility poles in the heart of Ketchikan, Alaska.

breakdown products in eagles and their eggs resulted in serious nesting failure. DDT and its derivatives interfered with some birds' ability to produce egg shell material. This meant that eagles, falcons, and pelicans produced very thin-shelled eggs that would break before the eggs could be incubated and hatched. Additionally, DDT in high enough concentrations killed almost anything, including eagles. Adult birds tend to concentrate DDT in their eggs well before the concentrations are high enough to kill them. However, the high concentrations in egg yolks, and subsequently in embryos and chicks, killed the chicks or reduced their viability within the egg during incubation. The result was a rapid increase in broken eggs, eggs that did not hatch, and chicks that did not survive. Fortunately for the eagles, falcons, and pelicans, the effect on egg shell thickness had a profound and visible impact well before lethal levels for chicks or adults were reached. Therefore, in effect, the reproductive failure provided an early warning for what lay ahead if people and governments did not heed the pesticide warnings.

DDT, in a period of less than twenty years, nearly did what two centuries of persecution had been unable to do—wipe out entire populations of bald eagles. Only a few scattered populations in the eastern half of North America survived long enough to see the results of bans on the use

of DDT. Over the last twenty years, with careful management, these few viable populations have been able to make significant recoveries, resulting in birds once again spreading back into areas where eagles had once lived. For instance, eagle populations in the Chesapeake Bay region have increased from a low of 7 young produced in 1962 to 188 young in 1986, and are still continuing to increase as we approach the new millennium.

Other Conservation Problems

During the 1950s and early 1960s, DDT was not the eagles' only problem. Out west, in areas where the use of DDT had not been as extensive and

An adult eagle in old-growth forest. Anan Creek, Southeast Alaska.

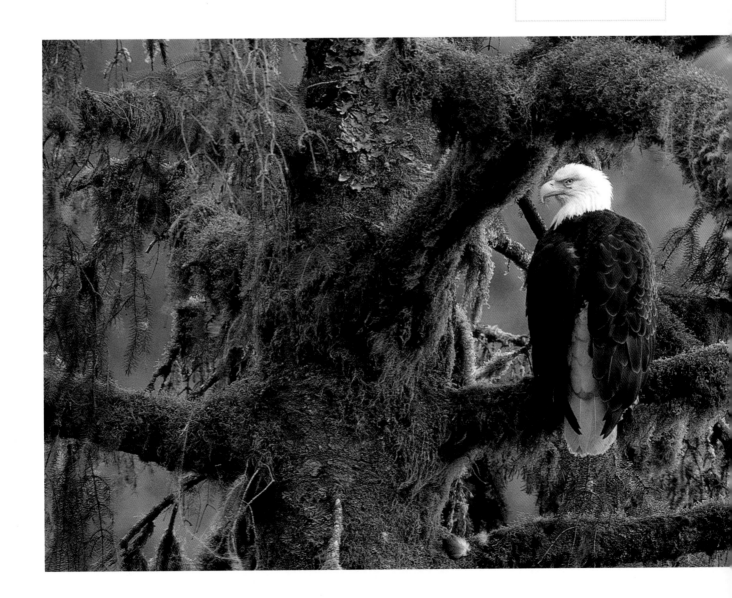

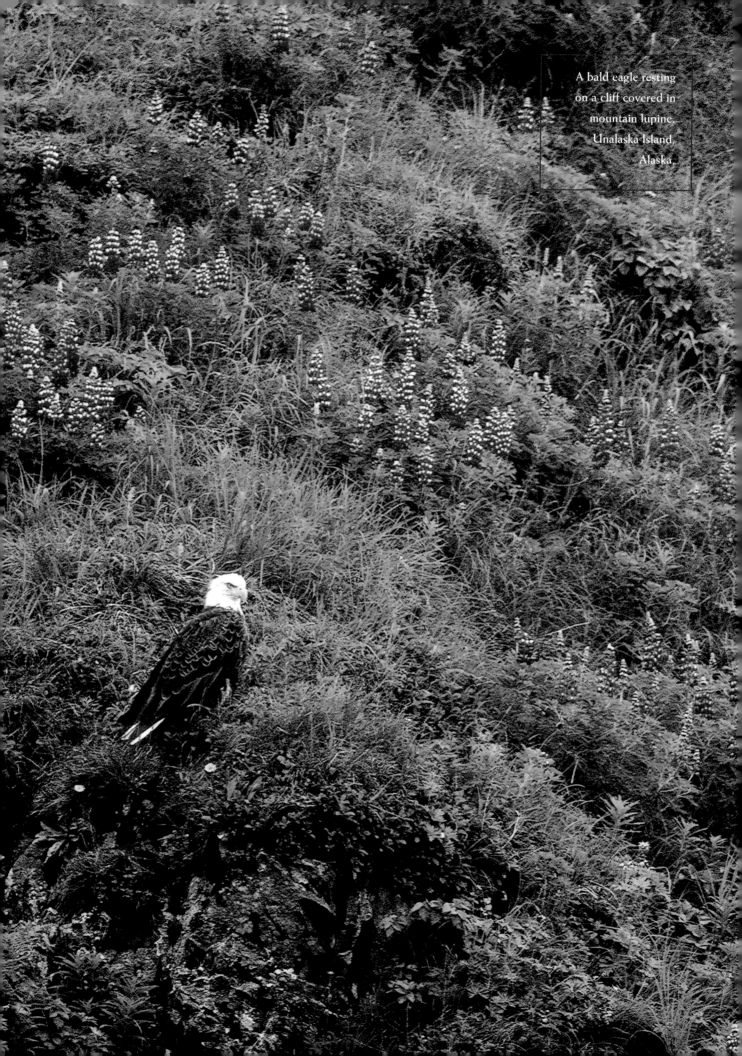

A bald eagle resting
on a cliff covered in
mountain lupine.
Unalaska Island,
Alaska.

had not yet been as destructive, other forces were at work. Some farmers and ranchers, fearing for their livelihood, ignored the law and hired hunters to kill eagles in large numbers. While the majority of eagles (more than 20,000) known to have been killed from Texas to Wyoming were golden eagles, a significant number of bald eagles, especially juveniles, were killed during this period as well. Finally, as a result of a growing public out-cry, the government became serious about enforcing the Bald Eagle Act. In other areas of the West, where there were no serious persecution problems, the bald eagle slowly increased in numbers during this time.

Alaska has a unique and interesting history with regard to the bald eagle. Initially, Alaska was exempt from the Bald Eagle Act because fishermen there convinced the government that the eagles were taking huge numbers of salmon, and thereby were in direct competition with them. The state paid bounties for eagles killed, in the hope that this would result in more fish for the fishermen. It has been calculated that bounties in Alaska were paid on 128,000 pairs of eagle legs turned in prior to 1952.

After research showed that the eagles were not having an adverse effect on the salmon population, and public opinion shifted in favor of the eagle, enforcement of the Bald Eagle Act finally reached Alaska. Bald eagle populations in Alaska grew steadily from 1952 to 1980, at which point they reached what has been considered full carrying capacity (the maximum number of birds that the habitat and food supply will support). Eagle populations in Alaska have remained relatively stable since that time.

The Exxon *Valdez* oil spill in the late 1980s killed an unknown number of eagles. However, the real effects of such an oil spill on the eagle population probably will take years to assess. It will be necessary to consider the loss of food and habitat that resulted from the oil spill, as well as all the clean-up activities that brought in far more human activity to an area that was nearly pristine before the spill. Today most populations

An adult eagle perched atop the spire of an old Russian Church. Pribilof Islands, Alaska.

that have not been affected by the spill or other human activities are doing quite well.

Alaska and British Columbia may have a population of 50,000 or more bald eagles. The boreal forests and lakes of Saskatchewan may have as many as 12,000. Even some areas of Alaska where populations were greatly reduced by the bounties have made remarkable recoveries. Wild populations are slowly recovering in almost all other areas where habitat remains. There will probably never again be the number of bald eagles that once flew the skies of North America, but in Alaska today you can get an idea of how abundant these magnificent birds once were.

Once the plight of bald eagle populations was known and understood, efforts were begun to restore the species throughout most of its former range. In 1973, when the Endangered Species Act was passed by Congress, the bald eagle was listed as an endangered species. The U.S. Fish and Wildlife Service was required to develop a recovery plan for the species, and to consider the declaration of critical habitat for the species.

As part of the recovery plan, a captive breeding program was begun at Patuxent Wildlife Research Center in Maryland to learn enough about the breeding biology and requirements of the birds so that efforts could be made to assist in the reestablishment of birds in areas where they had disappeared. While much has been accomplished, in most cases translocation has turned out to be a better and cheaper method of reestablishing birds. Eggs or chicks have been taken from wild populations with lower DDT levels to be placed in the nests of adults that, still heavily contaminated with DDT, were not able to produce thick-shelled eggs or viable chicks.

Likewise, hacking (a falconry technique) has proved to be a good method for reestablishing eagles in areas where they were depleted. This technique consists of taking young birds hatched in captivity or in a wild nest and placing them in either an abandoned nest or some other suitable nest site. The young are fed at the release site without exposing them to people, so that they will not become imprinted on people and thereby be friendly to or dependent on people after they are living in the wild. Food is provided until the young can learn to feed, fledge into the wild, and hunt for themselves. The rate of success for hacking is quite high, since

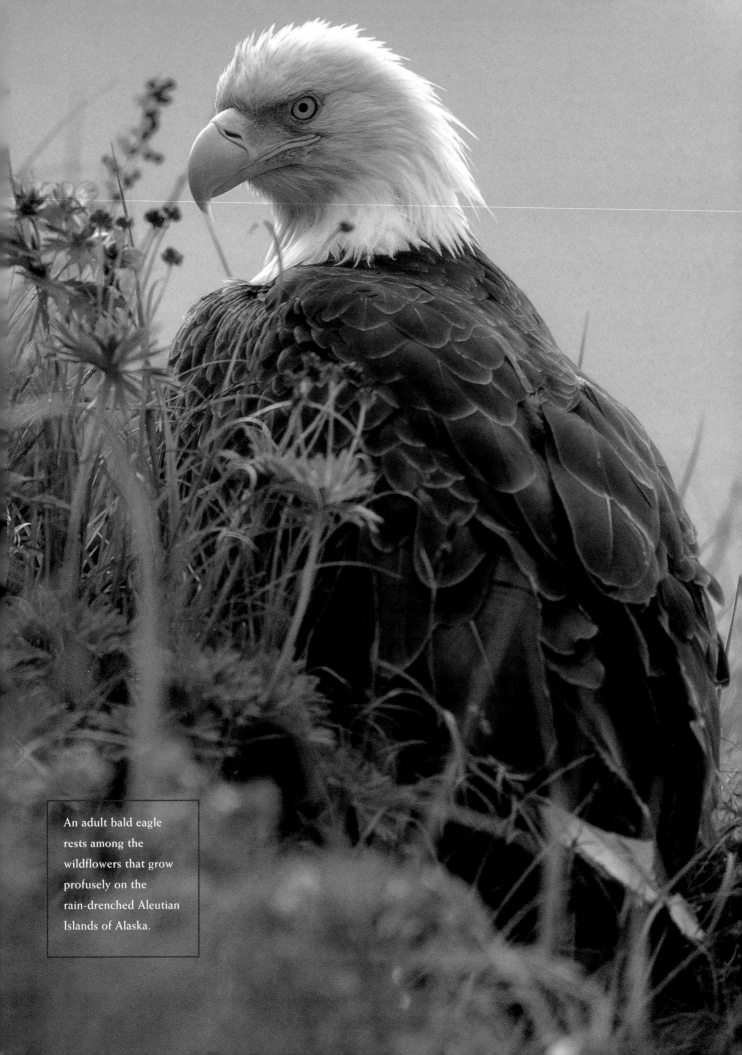

An adult bald eagle
rests among the
wildflowers that grow
profusely on the
rain-drenched Aleutian
Islands of Alaska.

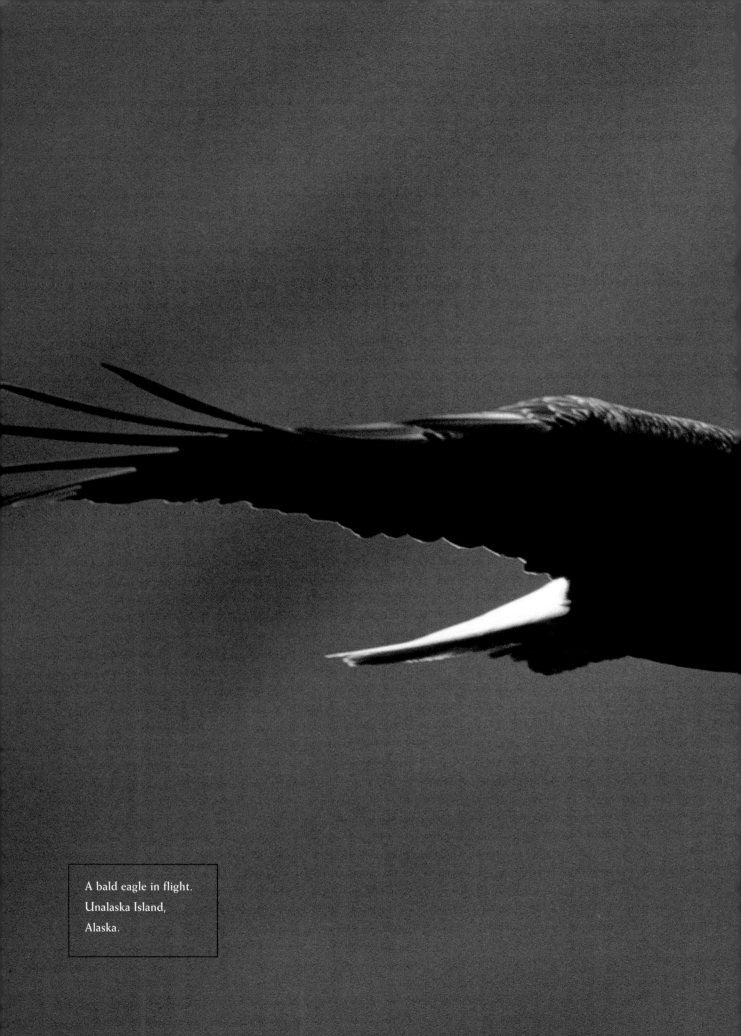

A bald eagle in flight.
Unalaska Island,
Alaska.

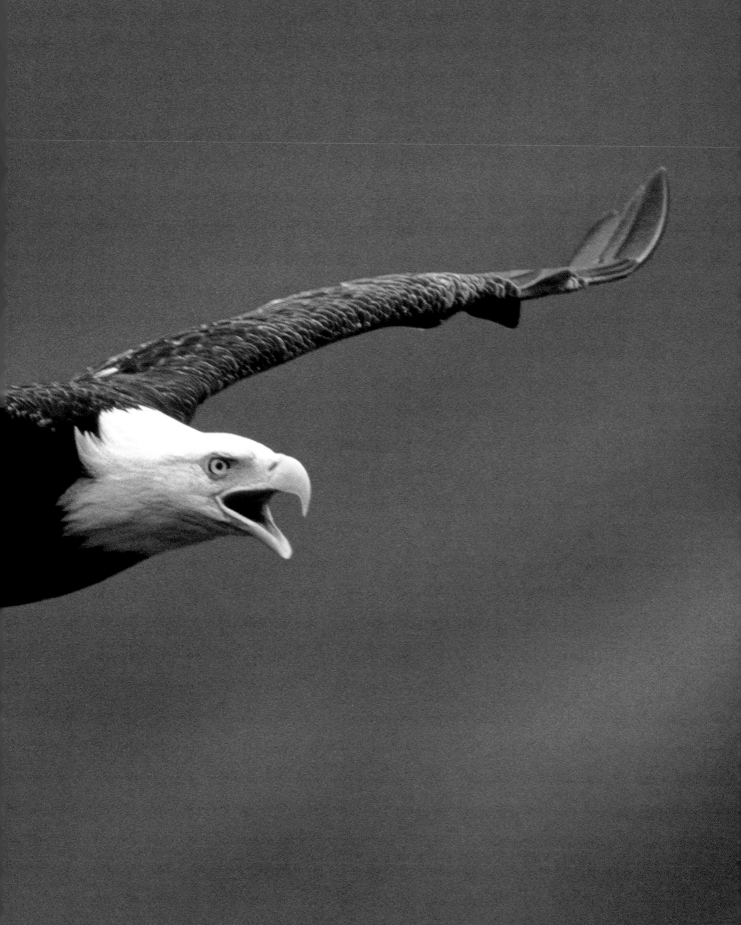

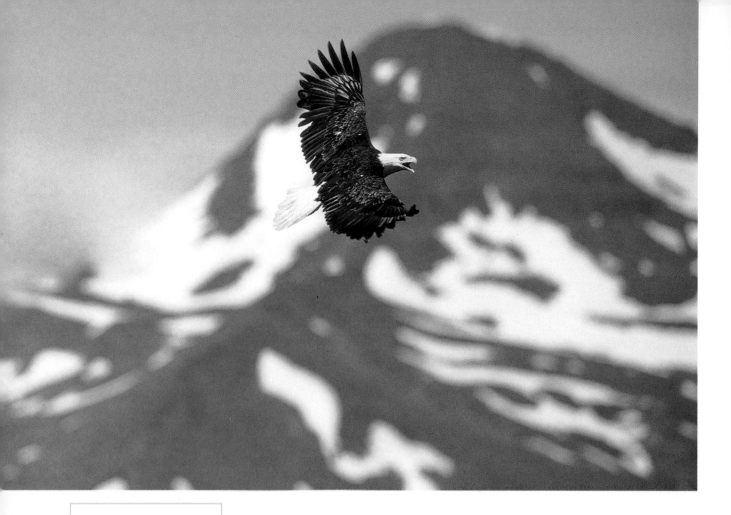

A bald eagle in flight. Glacier Bay National Park and Preserve, Alaska.

the birds are fed continually until they have learned to hunt on their own. This makes the transition even more gradual than in nature, as the parents often leave the chicks before they are able to hunt efficiently. The first bald eagle hacking program was started in New York in 1976, when two birds were successfully fledged. By 1985, a total of 390 birds had been released into the wild in New York State alone. Success came early for the first released birds, as they bred in New York in 1980, less than ninety miles from their 1976 release site. Seven released birds were breeding by 1985, and the number has continued to increase each year since.

Other Threats

Bald eagles still have natural threats with which they must contend. For example, they must be in top condition at all times to survive. Whether adult or young, an eagle must have sufficient food to maintain its condition and ability to hunt. Winter can be a difficult time, especially for inexperienced birds. If rivers or lakes freeze over, or there is too much competition for a limited food supply, or a minor injury prevents a bird

from being able to hunt, it is in deep trouble. Even a few days of fasting or recovery from injury may weaken a bird to the extent that it can no longer compete or obtain sufficient food to get back into top form.

Unfortunately, even if the eagle survives the natural hazards, it must still contend with the hazards created by mankind. For example, eagles eat contaminated fish, fly into powerlines, get tangled up in fishing lines, lose their legs and die in steel-jawed leg-hold traps, feed on wounded waterfowl filled with poisonous lead buckshot, and are shot from the sky because they are predators or by someone who wants their feathers.

Stricter law enforcement and public education, especially in rural areas, have greatly reduced the deliberate hunting and trapping of eagles. Current efforts to switch buckshot from poisonous lead to steel shot will help. Modification of power and telephone lines, as well as other tall

A bald eagle feeding. Chilkat River, Alaska.

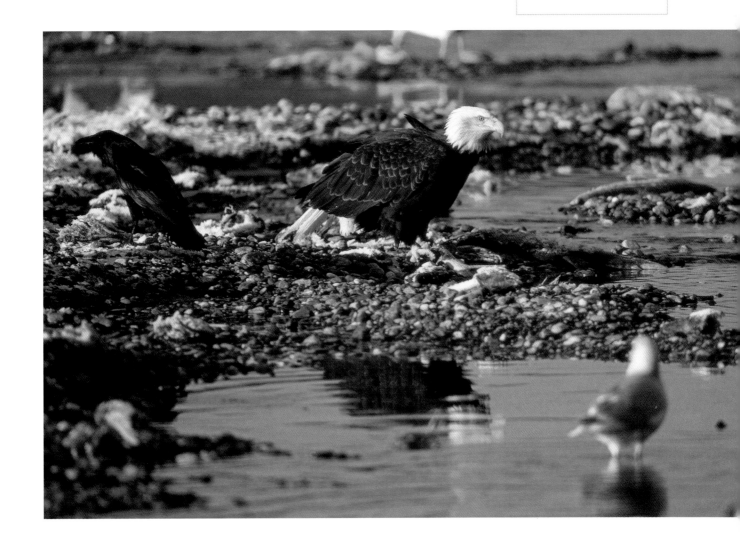

man-made structures, have had an impact on eagle numbers. Since eagles are long-lived birds, any reduction in adult mortality will help ensure the birds' future. But rehabilitation centers and zoos still need to assist individual birds that accidentally are shot or that get injured when they come into contact with man-made structures. And there are still other threats that need to be addressed.

Contaminants need to be monitored and controlled, or at least reduced. The effect of DDT was so dramatic that it could not be ignored. Other contaminants, however, such as lead, selenium, PCBs, herbicides, insecticides, and industrial wastes, also have negative impacts, either directly on the birds or indirectly on their prey species. Unfortunately, these more subtle associations are more difficult to prove and therefore more difficult to stop.

Acid rain may well become one of the next major threats to eagles in many parts of North American. Acid rain changes the ecology of rivers and lakes, and thus results in a reduction of fish. According to a report in the 1993 fall issue of *American Birds* magazine, the bald eagle populations that have rebounded along the Wisconsin shore of Lake Superior now have higher blood levels of toxic DDT and PCBs than do their inland relatives. Studies are currently under way to determine the cause of these high levels of toxic chemicals and whether they are related to recent increases in nesting failure in the area. In Michigan in 1993, four deformed eagles were found on nests near Lakes Erie, Huron, and Michigan. It is presumed that contaminated fish are the immediate source of toxic materials found in eagles, yet tracing them back to the source of contamination has not been possible. What these reports and others like them tell us is that the dangers to eagles and other birds have not by any means been entirely eliminated, and we must constantly be on the lookout for them.

In addition to chemical contamination, logging and mining may have negative impacts on eagles in particular locations by reducing their food supply or other habitat needs. Habitat loss is still occurring at a rapid pace. Local overfishing and destruction of potential nesting trees can have negative impacts. And if any of these developments happens to take place on a major migratory route, they can affect the entire migratory population, as well as the local population.

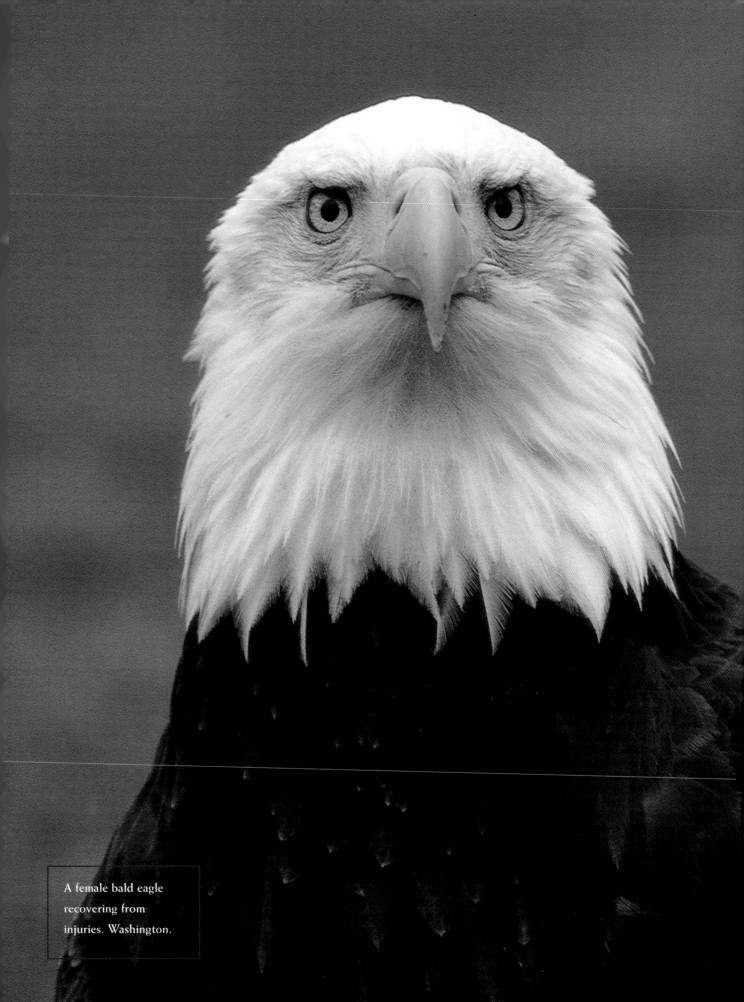

A female bald eagle
recovering from
injuries. Washington.

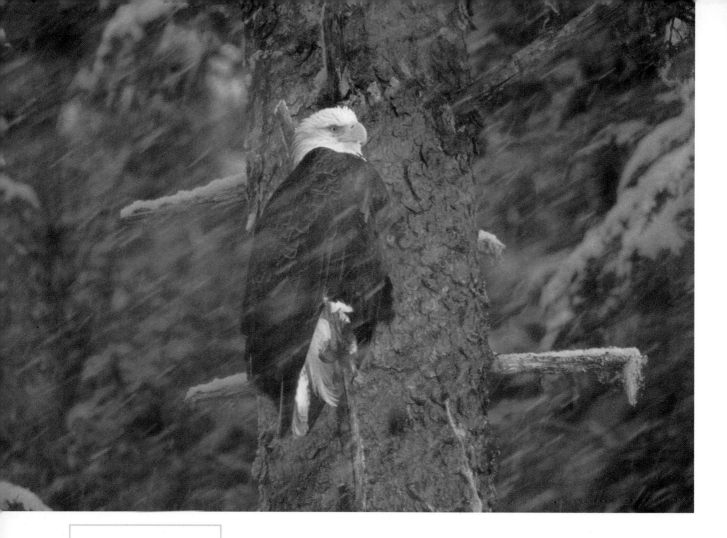

An adult bald eagle in
blowing snow. Juneau,
Alaska.

Human disturbance can also have an impact, as most eagles need
some privacy and quiet to breed successfully. People just wanting to
observe or photograph the eagles can disturb the birds sufficiently so that
they abandon a nest site. Construction of highways or buildings near nest
sites or roosts can also result in abandonment.

Recent articles have reported on yet another threat to eagles, this
time in California, where numbers of wind-powered generators are taking
their toll on eagles. These large windmill-like structures, placed on high
windblown ridges to generate power, are apparently attracting eagles liv-
ing in or passing through the area. The eagles, which generally fly along
or over these mountain ridges, are not able to detect the high-speed spin-
ning of the blades until too late and they have flown into them. The tow-
ers seem to attract many birds of prey, but smaller ones either have an
easier time maneuvering, are faster to respond, or are better able to see the
spinning blades, and thus proportionally fewer get killed. Questions are
now being asked about the impact these generators have on smaller
passerine birds as well. While currently this problem affects golden eagles

more than bald eagles, it will certainly extend to more bald eagles when the generators are placed in areas with larger bald eagle populations.

The Eagle in the Modern World

One day in 1970, when I was working at the New York Zoological Park (the Bronx Zoo), we received a call from the U.S. Fish and Wildlife Service asking if we could treat an immature bald eagle that had been shot on nearby Long Island. We agreed to accept the eagle and arranged for our veterinary staff to treat the bird.

When the bird arrived, we took it immediately into the zoo hospital to X-ray it and determine how much damage had been done. The X-ray showed that the eagle had been shot with a shotgun and that buckshot was still embedded in one wing and breast muscle. The buckshot had shattered both bones in the right wing. After several hours of surgery and several months of recovery, it became clear that the bird would never be able to fly again. Therefore, the bird could not be released back into the wild and would have to spend the rest of its life in captivity.

The U.S. Fish and Wildlife's Patuxent Wildlife Research Center was contacted, but they were unable to take the bird because they already had more birds than they could maintain and more than they needed for their breeding program. Thus the eagle has remained at the Bronx Zoo, with a label on its exhibit that explains how the bird arrived and why it must remain at the zoo. We hope that this eagle and its story will influence people so that they will not shoot eagles and will not tolerate others who might consider shooting eagles. Public opinion can be a strong influence on people. This incident, unfortunately, is a rather common one for eagles, because in today's world many of them are shot and wounded.

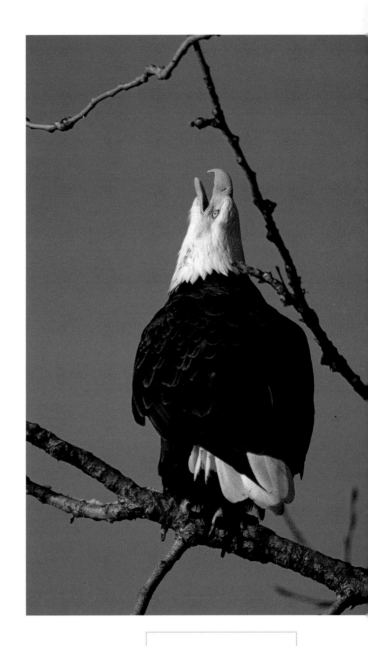

A bald eagle calling.
Washington.

The fact that many injured birds are unable to fly again is partly related to the structure of their bones. While the light, hollow bones of the eagle are very strong when intact, they are quite brittle and shatter when hit by a buckshot pellet or other projectile or bullet.

The Future

The bald eagle has become one of the strongest symbols of the changing attitudes of people in North America and shows their intent to reverse as much past environmental damage as possible. This is seen in legislation to protect eagles and in the increased enforcement of existing laws. Also playing a major role is the protection of nest sites throughout the bald eagle's range, but especially in the Southeast. Generally, the public's interest in the natural environment, including the reduction of pollution and the protection of habitat, has grown in much of the range. Environmental reform efforts are providing more areas suitable for the bald eagle to make a comeback, and the birds are responding positively. Unfortunately, many problems faced by these birds are still present. There will probably never again be sufficient suitable habitat or food supply to have the number of eagles that once lived here in North America. Yet bald eagles can recover to the point that they will again be seen on or near most of North America's major rivers and lakes. Gone will be the wilderness monarch that once filled the skies of North America, but at least some of these magnificent birds will soar above our lakes and streams for everyone to admire, respect, and enjoy.

OPPOSITE: Bald eagles roosting on a tree snag. Chilkat River, Alaska.

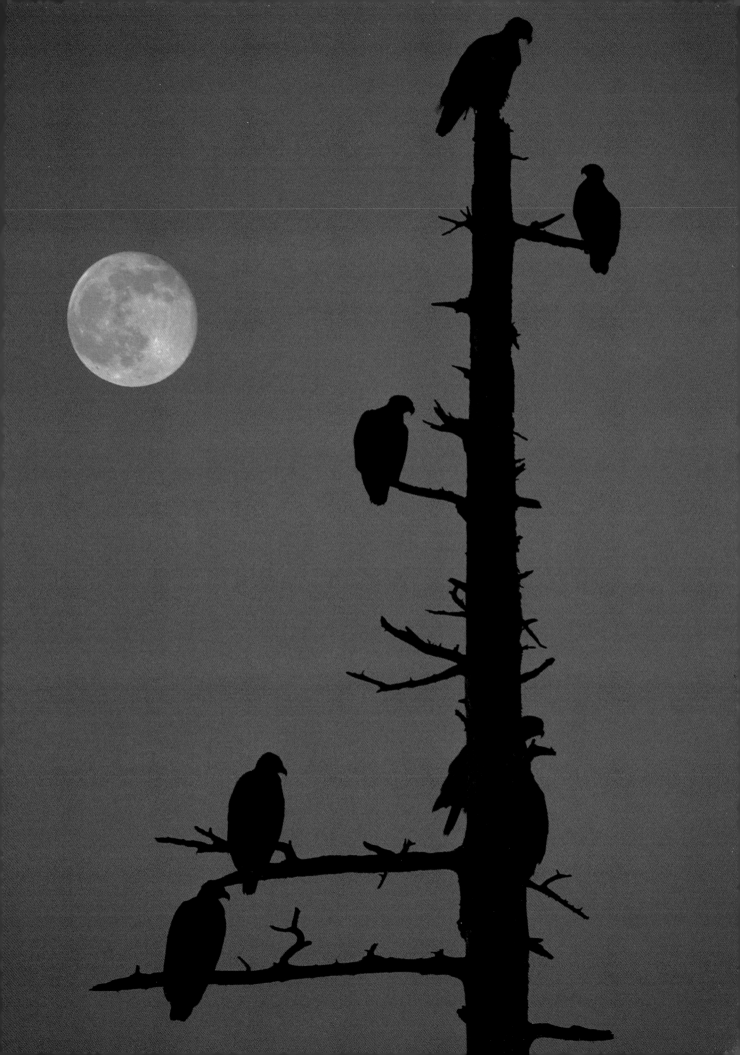

Landscape of a typical
bald eagle habitat.
Alsek Glacier, St. Elias
Mountains, Southeast
Alaska.

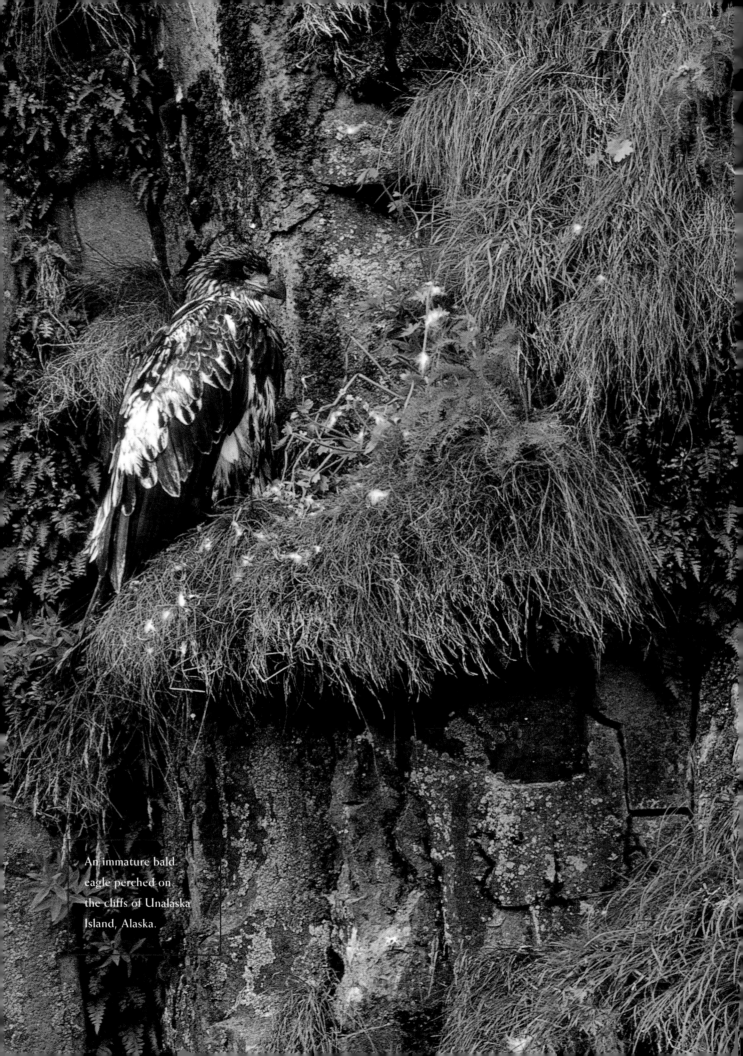

An immature bald
eagle perched on
the cliffs of Unalaska
Island, Alaska.

BIBLIOGRAPHY

Abbott, J. M. 1978. Chesapeake Bay bald eagles. *Delaware Conservation* 22:3–9.

———. 1986. Bald eagle breeding success in the Chesapeake Bay Region. Unpublished report.

Anderson, D. W., and J. J. Hickey. 1972. Egg shell changes in certain North American birds. *Proceedings of the 15th International Ornithological Congress,* The Hague, Netherlands, pp. 514–540.

Andrew, J. M., and J. A. Mosher. 1982. Bald eagle nest site selection and nesting habitat in Maryland. *Journal of Wildlife Management* 46:382–390.

Bagg, A. C., and S. A. Eliot, Jr. 1937. *Birds of the Connecticut Valley in Massachusetts.* Northhampton, Mass.: Hampshire Bookshop.

Bailey, F. M. 1928. *Birds of New Mexico.* Santa Fe, N.M: New Mexico Department of Game and Fish.

Bangs, E. E., T. N. Bailey, and V. D. Berns. 1982. Ecology of nesting bald eagles on the Kenai National Wildlife Refuge, Alaska. In Ladd, W. N., and P. F. Schempf, eds. *Proceedings of a Symposium and Workshop: Raptor Management and Biology in Alaska and Western Canada,* Anchorage, Alaska, Feb. 17–20, 1981, pp. 47–54.

Bent, A. C. 1937. Life histories of North American birds of prey, part 1. U.S. National Museum Bulletin 167, Washington, D.C.

Bortolotti, G. R. 1984a. Trap and poison mortality of golden and bald eagles. *Journal of Wildlife Management* 48:1173–1179.

———. 1984b. Sexual size dimorphism and age-related size variation in bald eagles. *Journal of Wildlife Management* 48:72–81.

———. 1984c. Physical development of nestling bald eagles with emphases on the timing of growth events. *Wilson Bulletin* 96:524–542.

Bortolotti, G. R., J. M. Gerrard, P. N. Gerrard, and D. W. A. Whitfield. 1985. Minimizing investigator-induced disturbance to nesting bald eagles. In J. M. Gerrard and T. N. Ingram, *Proceedings of Bald Eagle Days.* Apple River, Ill.: Eagle Valley Environmentalists, pp. 85–103.

Bortolotti, G. R., and V. Honeyman. 1985. Flight feather molt of breeding

Saskatchewan bald eagles. In J. M. Gerrard and T. N. Ingram, *Proceedings of Bald Eagle Days*. Apple River, Ill.: Eagle Valley Environmentalists, pp. 166–178.

Brodkorb, P. 1955. Number of feathers and weights of various systems in a bald eagle. *Wilson Bulletin* 67:142–143.

Broley, C. L. 1947. Migration and nesting of Florida bald eagles. *Wilson Bulletin* 59:3–20.

———. 1950. The plight of the Florida bald eagle. *Audubon* 52:24–26.

———. 1951. The plight of the Florida bald eagle worsens. *Audubon* 53:139, 141.

Brown, L. 1977. *Eagles of the World*. New York: Universe Books.

Brown, L., and D. Amadon. 1968. *Eagles, Hawks and Falcons of the World*. New York: McGraw-Hill.

Carson, R. L. 1962. *Silent Spring*. New York: Houghton Mifflin.

Cash, K. J., P. J. Austin-Smith, D. Banks, D. Harris, and P. C. Smith. 1985. Food remains from bald eagle nest sites on Cape Breton Island, Nova Scotia. *Journal of Wildlife Management* 49:223–225.

Clark, W. S. 1983. The field identification of North American eagles. *American Birds* 37:822–826.

Fraser, J. D. 1985. The impact of human activities on bald eagle populations—A review. In J. M. Gerrard and T. N. Ingram, *Proceedings of Bald Eagle Days*. Apple River, Ill.: Eagle Valley Environmentalists, 68–84.

Gainer, A. F. 1932. Nesting of the bald eagle. *Wilson Bulletin* 44:3–9.

Gerrard, J. M. 1983. A review of the current status of bald eagles in North America. In David M. Bird, ed. *Biology and Management of Bald Eagles and Ospreys*: 5–22.

Gerrard, J. M., and G. R. Bortolotti. 1988. *The Bald Eagle: Haunts and Habits of a Wilderness Monarch*. Saskatoon, Canada: Western Producer Prairie Books.

Gerrard, J. M., D. W. A. Whitfield, P. Gerrard, P. N. Gerrard, and W. J. Maher. 1978. Migratory movements and plumage of subadult Saskatchewan bald eagles. *Canadian Field-Naturalist* 92:375–382.

Gerrard, P., J. M. Gerrard, D. W. A. Whitfield, and W. J. Maher. 1974. Post-fledging movements of juvenile bald eagles. *Blue Jay* 32:218–226.

Green, N. 1982. 1981 status and distribution of nesting bald eagles in the contérminous United States. In T. N. Ingram, ed. *Proceedings of Bald Eagle Days*. Apple River, Ill.: Eagle Valley Environmentalists.

Grier, J. W. 1982. Ban of DDT and subsequent recovery of reproduction in bald eagles. *Science* 218:1232–1235.

Grossman, M. L., and J. Hamlet. 1964. *Birds of Prey of the World*. New York: Clarkson N. Potter.

Harmata, A. R., J. E. Toepfer, and J. M. Gerrard. 1985. Fall migration of bald eagles produced in northern Saskatchewan. *Blue Jay* 43:232–237.

Herrick, F. H. 1932. Daily life of the American eagle: Early phase. *Auk* 49:307–323.

Hodges, J. I., J. G. King, and F. C. Robards. 1979. Resurvey of the bald eagle breeding population of southeast Alaska. *Journal of Wildlife Management* 43:219–221.

Knight, S. K., and R. L. Knight. 1983. Aspects of food finding by wintering bald eagles. *Auk* 100:477–484.

Mengel, R. M. 1953. On the name of the northern bald eagle and the identity of Audubon's gigantic "Bird of Washington." *Auk* 65:145–151.

Nye, P. E. In press. A review of bald eagle hacking projects and early results in North America. Presented at International Symposium on Raptor Reintroduction, Raptor Research Foundation Annual Meeting, Sacramento, California, November 1985.

Senner, S. E. 1984. Why count hawks? A Hawk Mountain perspective. *Hawk Mountain News* 62:42–45.

Simmons, R., and J. Mendelsohn. 1993. Cartwheeling flights: Courtship display or aggression? *African Wildlife* 47(1):7–8.

Stewart, D. 1993. The good news and bad about Superior's eagles. *National Wildlife*, Aug./Sept., page 8.

Swenson, J. E., K. L. Alt, and R. L. Eng. 1986. Ecology of bald eagles in the greater Yellowstone ecosystem. *Wildlife Monographs* 95.

Waste, S. M. 1982. Winter ecology of the bald eagles of the Chilkat Valley, Alaska. In W. N. Ladd, and P. F. Schempf, eds. *Proceedings of a Symposium and Workshop: Raptor Management and Biology in Alaska and Western Canada*, Anchorage, Alaska, Feb. 17–20, 1981, pp. 68–81.

Welty, J. C. 1975. *The Life of Birds*, 2nd ed. Philadelphia: W. B. Saunders.

Wiemeyer, S. N. 1981. Captive propagation of bald eagles at Patuxent Wildlife Research Center and introductions into the wild, 1976–1980. *Raptor Research* 15:68–82.

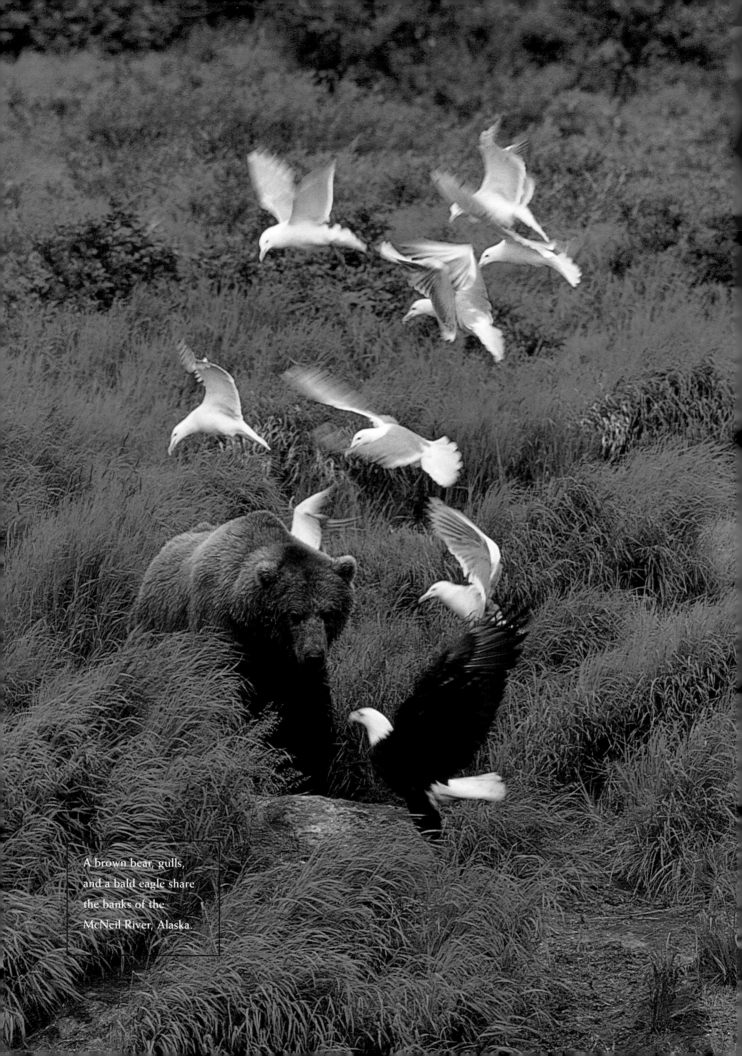

A brown bear, gulls,
and a bald eagle share
the banks of the
McNeil River, Alaska.

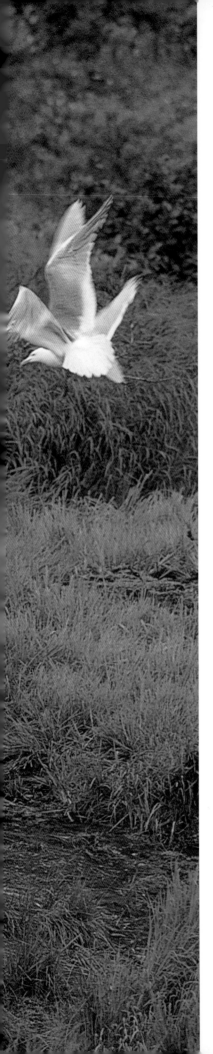

INDEX